WINGS OF RESISTANCE
THE GIANT KITES OF GUATEMALA

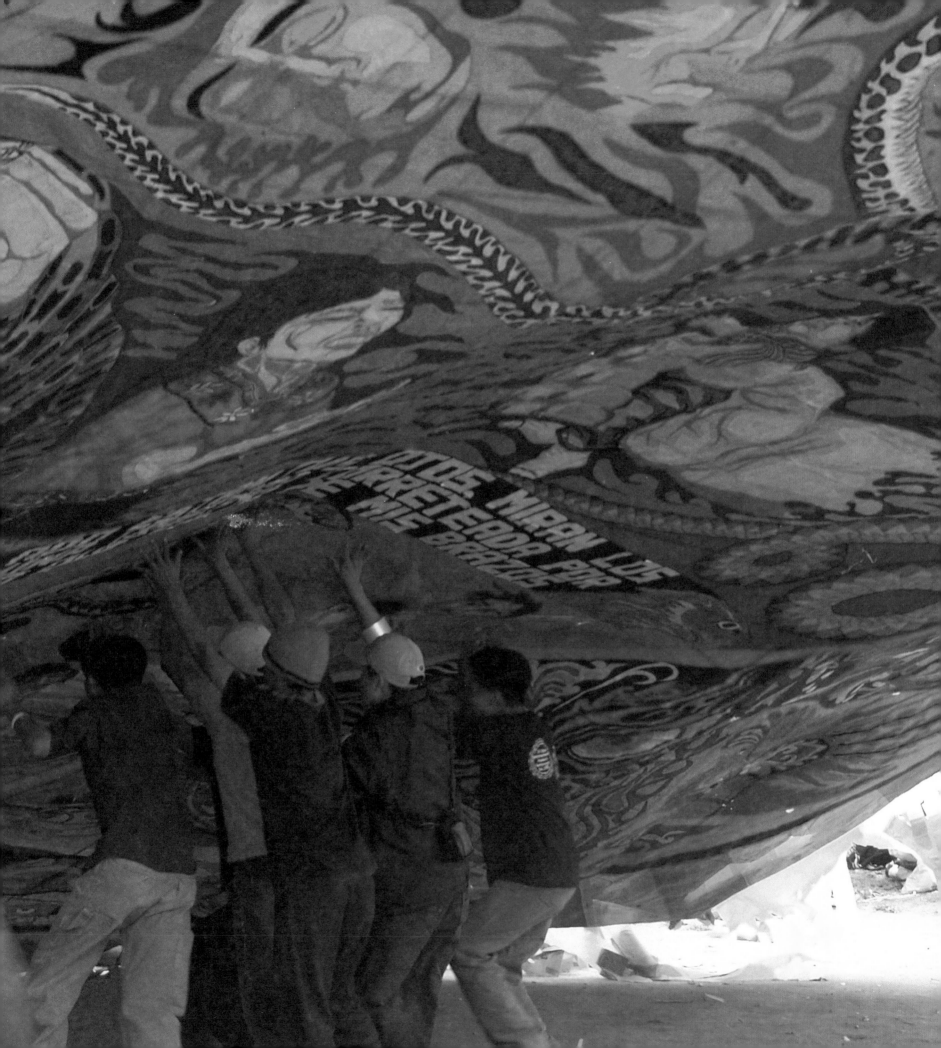

WINGS OF RESISTANCE
THE GIANT KITES OF GUATEMALA

CHRISTOPHER ORNELAS
SCOTT SKINNER
VICTORINO TEJAXÚN ALQUIJAY

DRACHEN FOUNDATION

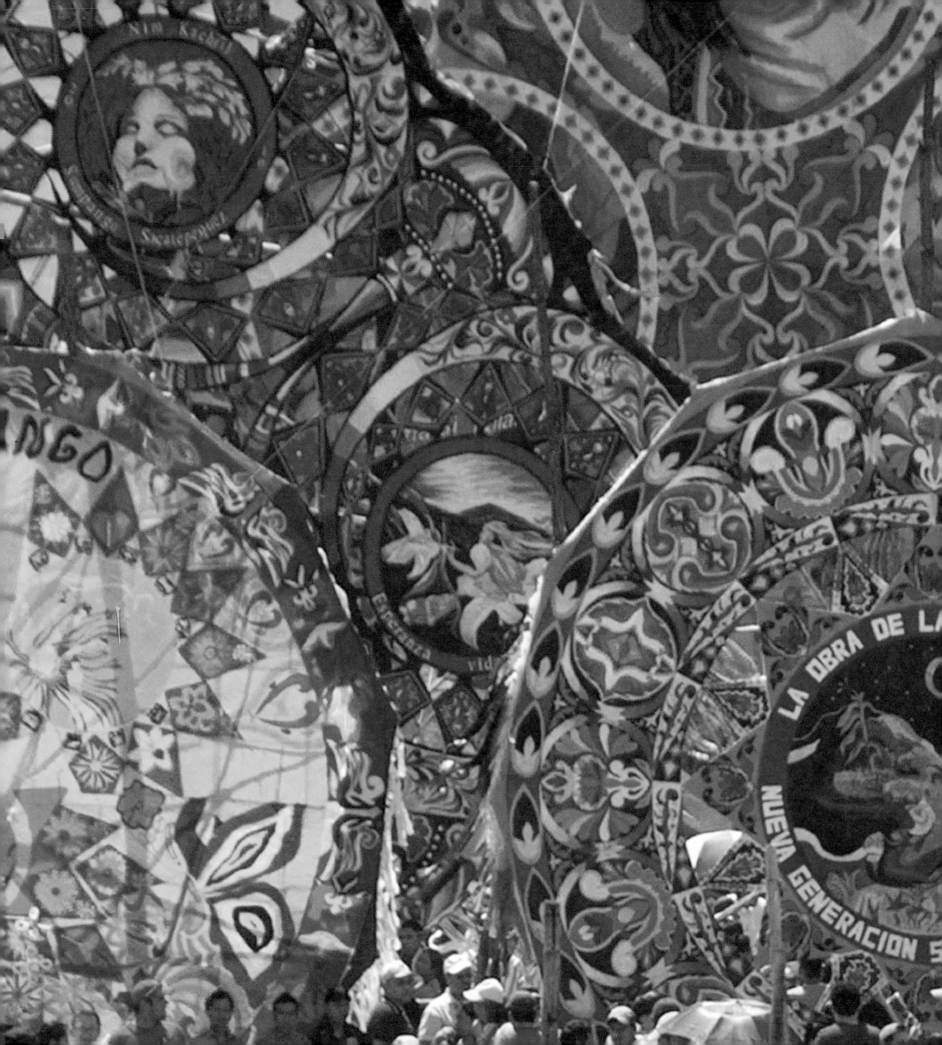

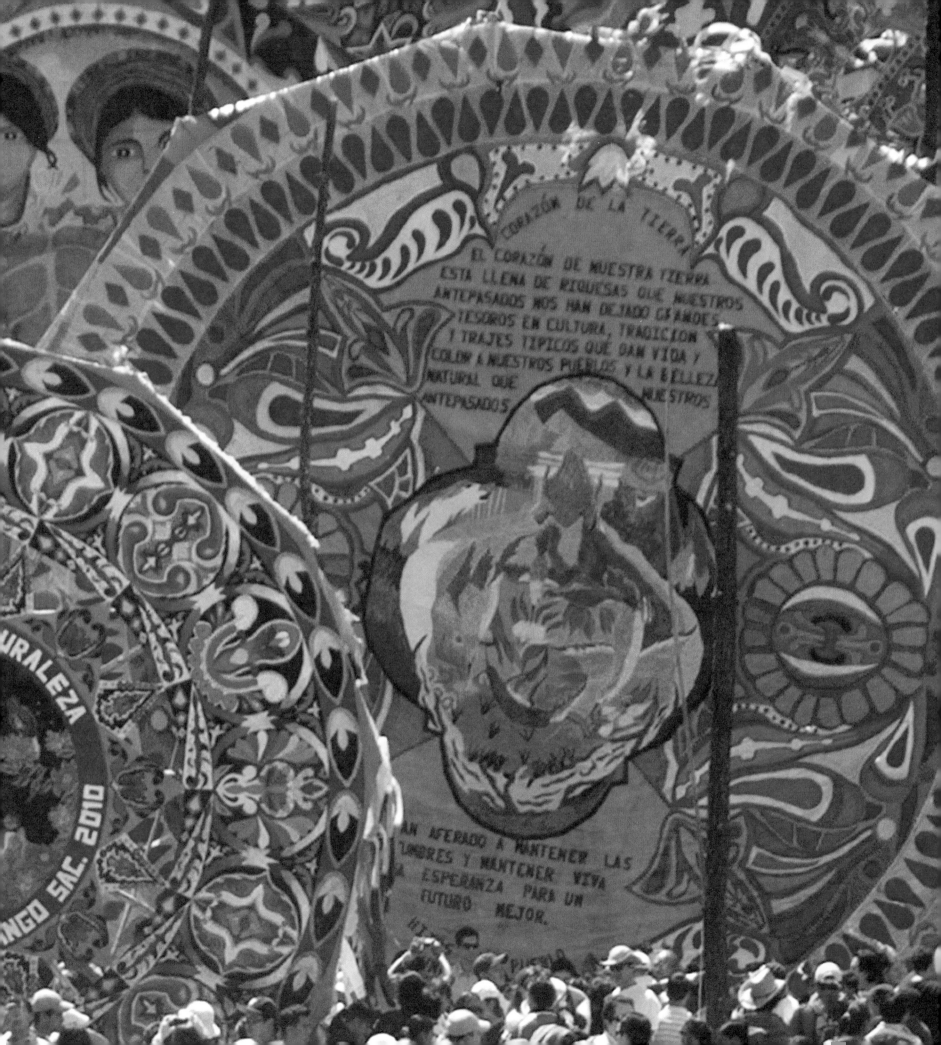

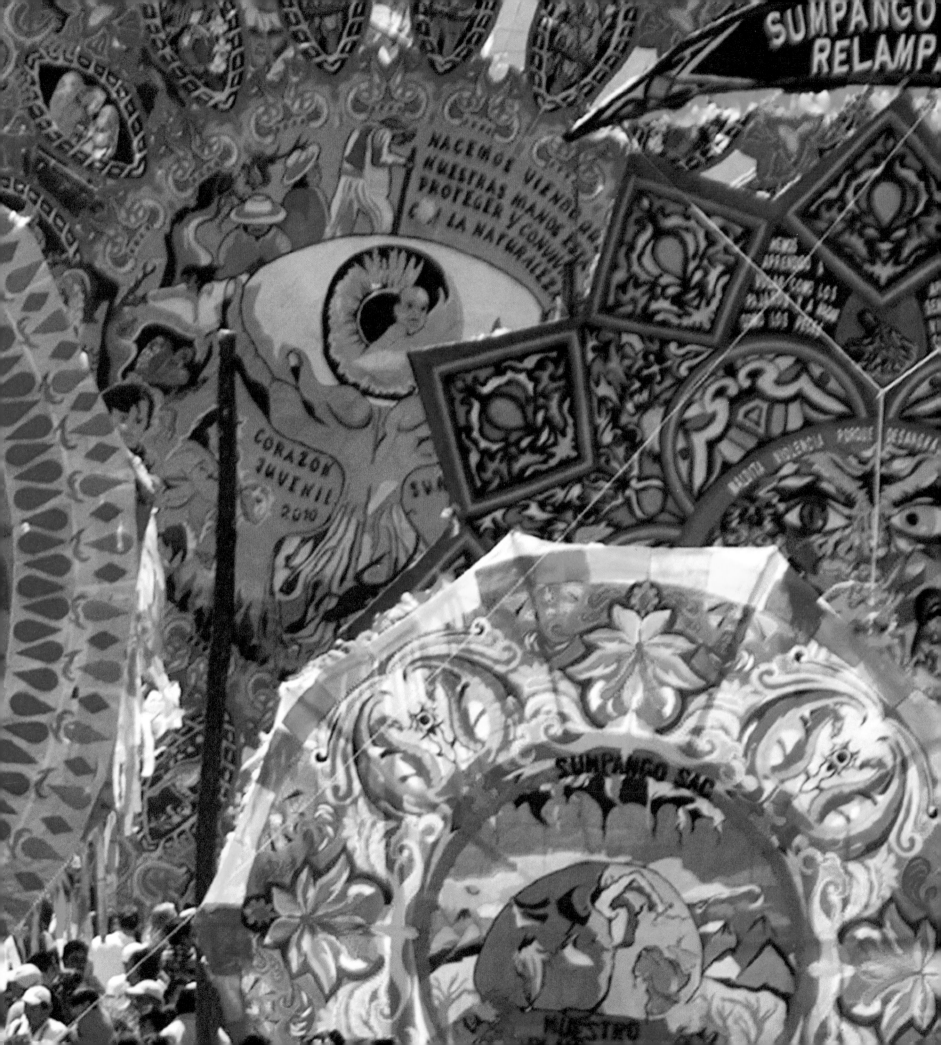

CONTENTS

INTRODUCTION 10
Scott Skinner

A CULTURAL WORLD OF KITES 14
 BALI, INDONESIA 15
 SHIRONE, JAPAN 17
 HAMAMATSU, JAPAN 19
 FANØ, DENMARK 21
Scott Skinner

DAY OF THE DEAD, GUATEMALA 22
Scott Skinner

WINGS OF RESISTANCE: Genocide in the Shadow of the Barriletes Gigantes 30
Christopher Ornelas

THE GIANT KITES OF SUMPANGO 54
Victorino Tejaxún Alquijay

APPENDICES 78
 A BRIEF HISTORY OF KITES 79
 IN THEIR WORDS 85
 CHRONOLOGY 86
 GLOSSARY 88
 KITE GROUPS 89
 EVOLUTION OF A GIANT KITE 90
 PORTRAIT OF A KITEMAKING FAMILY 92
 A GALLERY OF PHOTOGRAPHS 94
 IF YOU WANT TO GO 98
AUTHORS AND RESEACH CONTRIBUTORS 100
ACKNOWLEDGMENTS 101
PUBLISHING PATRONS 102
PHOTOGRAPHIC CREDITS 104

INTRODUCTION

Kites are flown in almost every country on Earth and have been described by aeronautical historian Tom Crouch as "man's oldest flying toy." They are flown in seasonal celebrations, to honor new births, in extreme sports, and simply for pleasure. They can be made with a discarded plastic bag and string or can be constructed of hundreds of dollars' worth of fabric and spars. The world's largest kite is the size of half a football field (213-foot wingspan and the qualifying area, as made, is 4,000 square feet), while the smallest is only two millimeters by two millimeters. Kites can be used to fish (perhaps the first functional use of kites), to carry cameras (for magical photographic perspectives), to cross continents (Antarctica as well as Africa), and to capture the imagination in art projects throughout the world.

In the United States, as children turn to electronic games and social media, kites remain a popular subject for teachers as they are a hands-on project that can produce an uplifting result. They are an effective hook to teach history, science, culture, and art. Almost everyone has a memory of kiteflying; the disaster of losing a kite to the local kite-eating-tree (à la Charlie Brown), or the success of teaming with a parent or grandparent to make a high-flying wonder.

In other parts of the world, kites occupy a more prestigious place in the local culture. For example, in Japan, where every region has at least one distinct kite shape, kites have been flown, continually, at seasonal festivals for between three hundred and four hundred years. It is common for kites to be flown

throughout Japan on May fifth, Childrens' Day (formerly Boys' Day). There are fighting kites in Nagasaki that probably came there with Dutch ships from India. There are kites in the far north that are flown on snow-covered rice paddies and are made with spruce spars instead of locally sparse bamboo. In Shirone, a balletic kite interplay between the farming towns of Shirone and Ajikata results in a tug-of-war between hundreds of towns-people from each side of the river. And, finally, in Hamamatsu, there is chaos of sight, sound, smell, and movement, as more than fifty teams launch, fly, and retrieve kites from the aerial battle.

In Bali, every step of the kitemaking process is accompanied by religious blessings to ensure successful flights and prosperous lives. The four traditional types of kites are flown by teams made up of adults and children, boys and girls. Additionally, creative kites are made and flown celebrating the strength of the kite tradition. The kite tradition in Bali is just one of many in Indonesia and, along with those of neighboring Malaysia, make up one of the most kite-culturally diverse regions on Earth.

On the small Danish island of Fanø, almost ten thousand kite enthusiasts come annually to fly kites. This is not an event steeped in history; rather, it started only twenty-five years ago when a group of friends traveled to the island to take advantage of its uninterrupted winds, early summer weather, and twelve miles of beaches. In the years since, the "kite meeting" has become the largest gathering of contemporary kites in the world. Kite enthusiasts arrive from all over the world to see the spectacle of a solid wall of color made up of hundreds of kites and to fly their own creations.

In addition to these notable landmarks on the world's kite landscape, there is another, perhaps more intriguing than all the rest: the *barriletes gigantes* [giant kites] of Guatemala. Here is a kite tradition that may, in its origins, pre-date the arrival of Europeans to the New World. The word for kite, in Mexico, is *papalote*, from the Nahuatl *papalotl* [butterfly]. In Mesoamerican culture it was thought that the souls of great warriors were transformed into butterflies, so indeed, it is likely that kites may have been invented to ceremonially create a physical object to support this belief. As in all histories of kites, it is generally impossible to date that moment of invention of a device constructed of natural materials and ephemeral in nature.

Now, almost five hundred years later, there is a definite tie to native culture in the tradition of kiteflying: it is thought that families' ancestors are able to return to earth via the kites' strings on November 1. This date, an auspicious one on the Catholic calendar, was probably forced upon the natives, yet the local tradition survived and is now celebrated alongside the Catholic one. In the cemeteries of Sumpango and Santiago, small rural towns located within an hour of Antigua, families gather, clean and decorate the graves of ancestors, eat and drink, and fly kites. In both Sumpango and Santiago, this family tradition has been taken to extremes by families and teams who build *barriletes gigantes* for the day.

In Sumpango, especially, the giant kites reveal another layer to the celebration—a dark one—that is related to the modern, political history of Guatemala. Here we see kites forty to fifty feet across, made of mature bamboo frames and countless pieces of humble *papel de china* [Chinese paper or tissue paper]. Floral and geometric backgrounds highlight artistic scenes of daily life. But in these scenes we see the plight of many in Guatemala: discrimination, poverty, abuse, and political persecution. These giant works of art are loud and clear political statements, made by the indigenous Maya, in a country rife with discrimination and corruption.

This book endeavors to show the unequaled beauty of the *barriletes gigantes*, to place them into the context of other great kite traditions, and to discuss their social and political importance. Researcher and historian Christopher Ornelas describes their social importance, the people who make them, and brings to light many of the daily pressures of Guatemalan life. Victorino Tejaxún Alquijay discusses the unique artistic traditions that have grown because of the kite tradition. He speaks of the teamwork, family pride, and political voice that the kites have enabled.

The resulting book is as diverse as the many uses for kites and the many world kite traditions; it travels from the innocent fun of flying a simple kite in the cemetery of Sumpango, to the teamwork of building and flying unique works of art, to the serious political messages that give voice to hope.

Scott Skinner

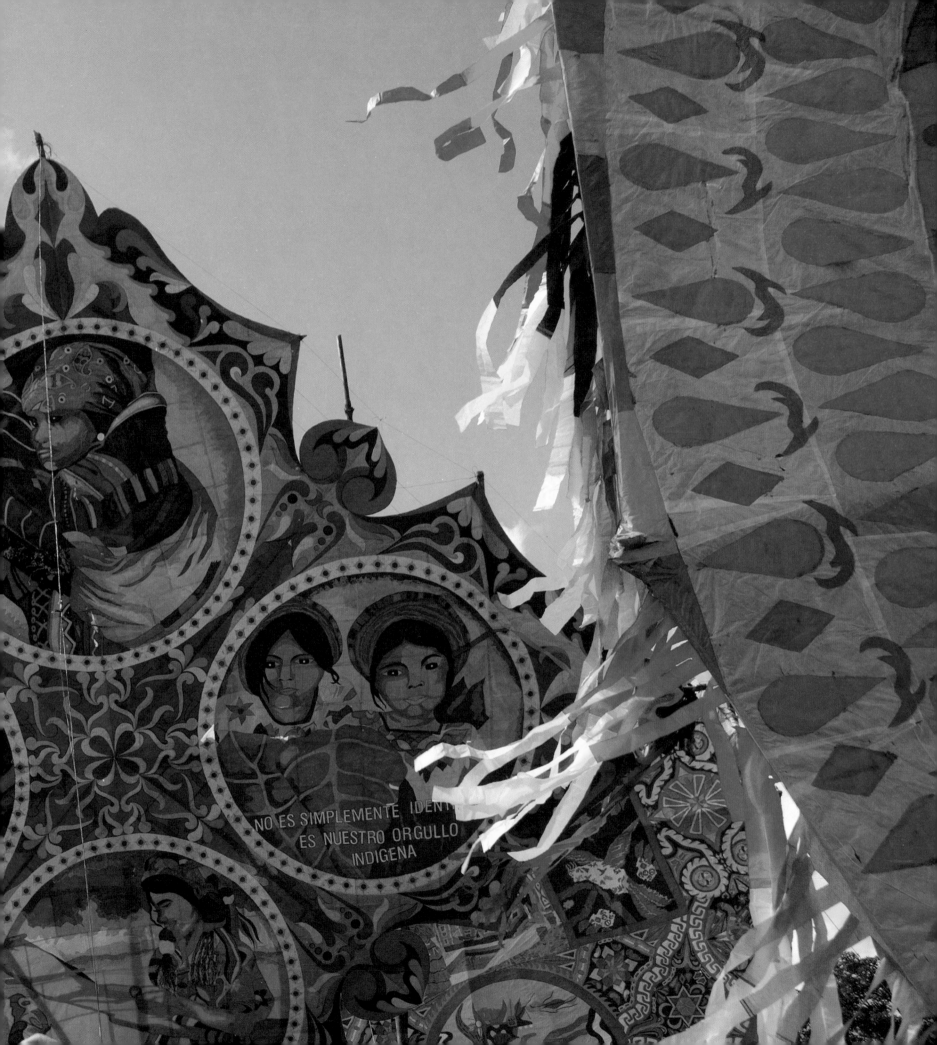

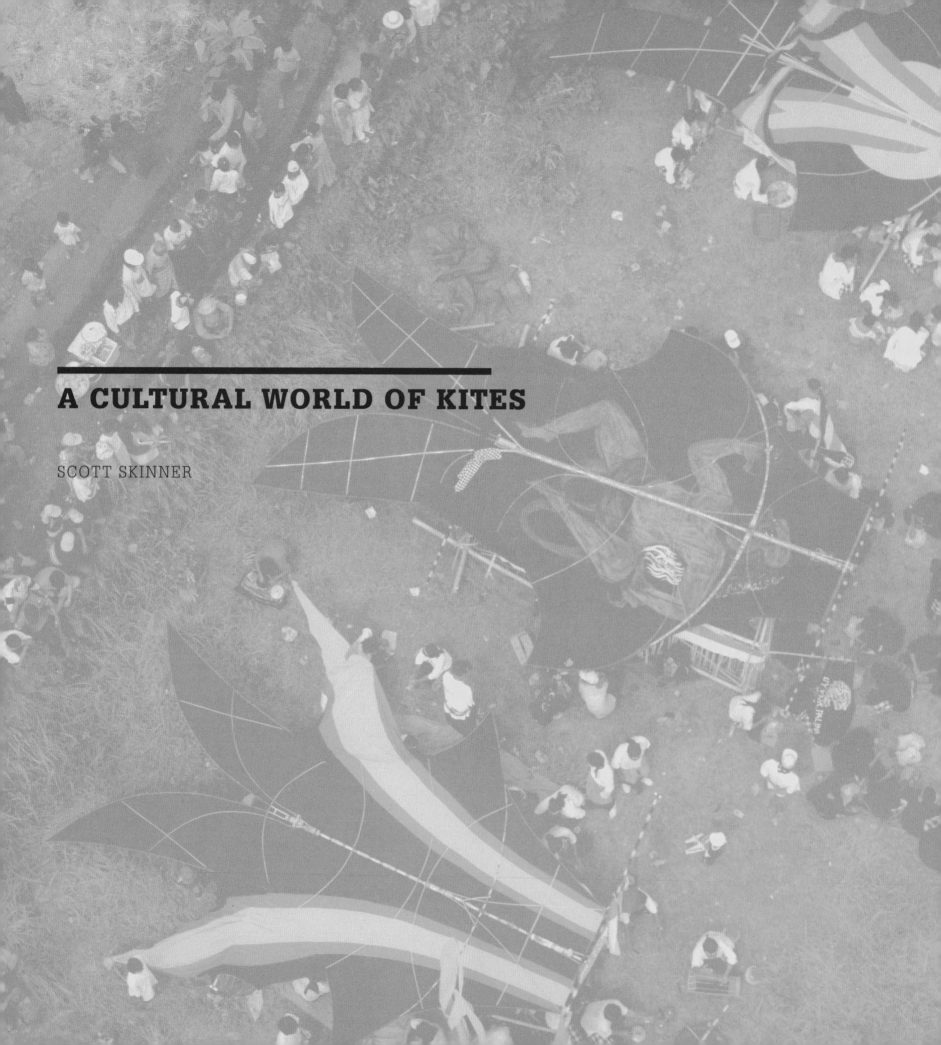

A CULTURAL WORLD OF KITES

SCOTT SKINNER

BALI, INDONESIA

Indonesia is one of the most kite-rich countries in the world. Every part of the archipelago has at least one style of kite associated with it, from the leaf kites of Sulawesi to the decorative kites of Java, to the fighting kites of South Sumatra. It is on the island of Bali that the kite culture reigns supreme. On this small island, ninety-five miles wide and about seventy miles long, live most of Indonesia's Hindu population, and Balinese Hinduism is a unique blend of Buddhist heroes and indigenous deities and sacred places. Religion in Bali is a complex belief system that embraces theology, philosophy, and mythology as well as ancestor worship, animism, and magic.

The island is also renowned for its art forms, especially painting, sculpture, woodcarving, and performing arts. Celebrations are held for many important occasions, from coming of age to cremation, and many ceremonial art forms are highly improvisational. They vary based upon the audience, the venue, and current sentiment. In almost all celebrations there are *gamelan* [Indonesian musical ensemble] orchestras that add music and rhythm to the moment. Add kites to this vivid artistic landscape, and you have a truly unique kite culture.

Three traditional kite shapes dominate in Bali: the *pechukan* [leaf], the *bebean* [fish], and the *janggan* [bird]. Each is made in traditional colors—red, black, white (and sometimes yellow)—by kite teams that design the specific color arrangement for their team's kites. Kite teams are made up of families, friends or neighbors and involve all members of the households. Bamboo must be cut, split and dried, cotton kite sails must be repaired or remade, final graphic designs must be decided upon and executed. There is a great deal of ritual in each step, as the kitemaking progresses before the flying festival. Families and friends meet, share food and drink, and work on kite frames, sails, or assembly. At each important step in the process, offer-

ings are placed on the frame or sail to bring the best of luck to the team.

As kiteflying days draw near, completed kites compete for every available indoor space as they must be protected from the elements and secreted away from rivals' eyes. The three shapes are each unique in flying characteristics and require varied skill levels in their construction. All agree that the *pechukan* is the most difficult to make; it is a symmetric sail that must be perfectly balanced and precisely bridled. The *janggan* is a forgiving flyer, but management of its long tail must be carefully coordinated before flying. These kites also feature an ornate headpiece that requires a skilled craftsman. Finally, the *bebean*, must be carefully made because the best of them actually mimic a fish as they fly. The well-made *bebean* flies in a continuous figure eight; flexing at the exact moment that a reverse in direction is needed. Each team has specialists with knowledge of each style. In fact, there is a fourth kite competition, for creative kites, and these are kept out of sight until the last minute. Their unlimited scope might include flying horses, mythic birds or dragons, or unexpected flying bulldozers and tanks. (Perhaps the most bizarre I've seen was a giant mosquito carrying a machine gun!)

On kiteflying days, kites are transported to the flying field, an area close to the coast where winds are steady. The kites are large; *bebeans* about sixteen feet tall and nine feet wide, *pechukans* about nine feet wide by five feet tall, and *janggans* about six and one-half feet wide but up to ninety-eight feet long. Flatbed trucks loaded with kites wind their way through crowds toward the flying field. Teams bring at least five of each type for flight in the festival, and these are used by teams to build impromptu shelters on the edges of the kite field. Soon, an entire "kite city" springs up, with kites used for three walls and the roof of each team's enclosure. The kite city is dominated by red, black, and

Left: A spectacular *janggan* in flight over Bali.

Right: Traditional *pechukan* kites.

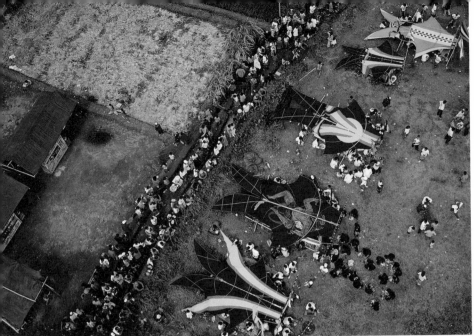

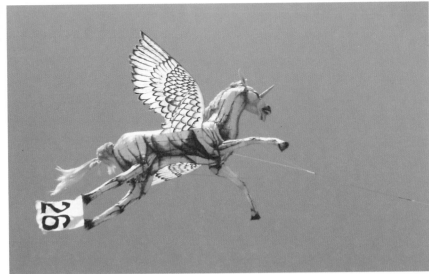

white with occasional spots of yellow sprinkled through. Wind-driven noisemakers on almost every post provide a constant accompaniment to the activity. As kites are readied for flight there are last-minute rituals and offerings, there is the raucous music of *gamelans*, smells of cooking food, singing, and high spirits.

Kites of each style are flown together in competition. They are judged for their stability, beauty, and flight angle and must fly for a specified time. During this competition time, teams make a formal procession to the reviewing stand, displaying their kites, banners, and team shirts. Depending upon the kite being flown, between ten and twenty team members might ready the kite for flight and then launch into the sky with the other kites. Once airborne, kite teams gather at their kite reel and celebrate the successful launch. Numbers of kites are in the air, but because they fly similarly, teams do very little maneuvering to avoid mishaps. The precisely made *pechukan* seem to fly beautifully together until one disturbs the airflow of another. That small disturbance is enough to cause instability and a crash is the inevitable result. *Pechukan* fliers stay well clear of their peers' kites.

The day's activities are most interesting when the *bebean* take to the sky. Figuratively shaped like a fish, with head, fins and tail, the flight of a *bebean* can hardly be believed. Here is a kite that is very stable—it flies steadily for hours at a time in varying wind conditions—yet as it flies, it constantly describes a horizontal figure eight in the air. At every moment, the observer expects the kite to continue in one direction and crash to the ground, but each time, back up it goes to its "stable" center. Evolution of this kite to its perfectly balanced and flexible state is a wonder of world kite design.

As the day continues, large teams, made up of young and old, take the field with their *janggan* kites. A stable flier when airborne, the *janggan* is difficult to launch in tight confines, which makes this an interesting moment. Teams lay out line,

arrange the tail, and station themselves along the flying line as they ready to launch. A sprint away from the kite as each member releases line gives the kite a rocketlike launch, followed by careful playing of line as the wind gently carries the *janggan* higher. These are highly celebratory kites, with white bodies and long tails displaying a traditional arrangement of black, red and white stripes. New teams may experiment with this color arrangement, but in most cases it is a traditional pattern that matches the team's patterns on the *bebean* and *pechukan*. Frenzied celebrations break out all over the field as *gamelans* play—trying to drown out their rivals—and teams retrieve fallen kites or celebrate successful flights.

As a time for rest between formal competitions, creative kites are launched and flown at least once every day. Most of these are made by individual craftsmen and can require hundreds of hours to make. As mentioned, there are no limits, here, and with the rich artistic and cultural traditions in Bali, anything goes! Indonesia has a great tradition of bird kites, dragon kites, and even flying sailing ships, but the competitive creative kites are not to be missed. Using bamboo, any three-dimensional shape can be fashioned, and over that framework either a silk or cotton sail cover made. Kites reminiscent of other cultures can be seen in this historical crossroads: *wau* [centipedes], as in neighboring Malaysia; kites with noisemakers; box kites; and fighting kites.

So here in Bali we see a kite tradition dominated by traditional kite designs but dependent upon families, friends, and neighbors to maintain it. With the rich artistic heritage of the island there is room in the tradition to experiment and be creative, but emphasis is upon the teamwork, ritual, and spirit created by execution of the traditional designs.

Left: An aerial view of the large *bebean* kites and kite teams in Bali, Indonesia.

Right: A spectacular competitive creative kite mady by Balinese enthusiasts.

SHIRONE, JAPAN

Two small farming villages awaken in early June; it is festival time, and soon kites will dominate the skyline. Kite teams from every neighborhood will don their *hapi* coats and begin the dance between Shirone and Ajikata. For almost four hundred years, the dance has taken place. The largest kites, *o-dako*, are rectangular and flown by teams of up to twenty people, while smaller hexagonal kites, *rokkaku*, are flown by teams of about a half-dozen. This is one of two Japanese kite festivals that is very much like the kite celebrations in Guatemala on its Day of the Dead. Just as in the small towns of Sumpango and Santiago, Guatemala, the people of Ajikata and Shirone work for an entire year to be ready for kite festival time.

O-dako in Shirone and Ajikata are made by amateur and professional kitemakers and can be up to eight meters high. Every team, which is comprised mainly of people from a particular neighborhood, has at least five to ten of these kites for use during the three-day festival. The graphic design of each is the same every year with minor variations—pictures of these kites in the 1930s show kites very much like those today. *Hapi* coats worn to identify team members often display the same traditional designs. Every kite is paid for by neighborhood team members and can be made to honor new births in a family, special moments in a family's history, or to honor familial ancestors. The kites are made of *washi* [traditionally handmade mulberry paper], which is often now machine-made and therefore less expensive. Bamboo is often kept from previous year's kites and used on the new ones. (You'll understand why soon!)

A festival day begins in Shirone, the larger of the two villages, with kites transported to the center of the city. Too large to lie flat on the back of trucks, the kites are flexible enough to be rolled and carried on flatbed trucks. *Rokkaku*, which are a maximum of three meters high, are small enough to be hand-carried or can be laid flat on trucks for transport. Once in the city, kites are erected and displayed on side streets, in front of stores, and along the soon-to-be parade route. The parade begins like parades everywhere, with local dignitaries, school bands, local service clubs, and the like. Smells of street food fill the air as kite teams begin their procession.

It is easy to identify specific teams (and often their sponsors) carrying their *rokkaku*. The circular-saw blade of the local sawmill might be the most identifiable.

As the larger *o-dako* take to the street, many are left rolled on their trucks to be used later in the aerial kite battles. But most teams carry at least one of their *o-dako* fully erected, dipping it for utility wires every block along the parade route. Kite teams gather around these kites for group photographs, a scene that has been repeated for the last 100 years. These two towns are almost completely dependent upon farming for income; this is not a wealthy part of Japan. Yet this kite tradition has been kept alive by the local townspeople who recognize its importance in raising the self-worth of its residents. The local kite museum (a modern building large enough to house the giant kites), holds a collection of kites from all over Japan and an indoor wind tunnel for kiteflying. There are even photographs from WWII showing the festival during the years in which kiteflying had completely stopped in most of Japan. The importance of the festival to both towns cannot be overstated.

In the early afternoon, kiteflying starts in earnest, and it is now that the aerial dance begins. The two towns have a swiftly moving river between them, with high levees on each side protecting both. The kiteflying occurs here, along the top of each levee; Ajikata launching kites from one side, Shirone from the other. As an observer, you very quickly learn several things: kite teams are not watching out for you, you mingle at your own risk, and anywhere on the levee you must be aware of kite lines, abrasive kite tails, or kites themselves. One of my best friends, a Kyoto kitemaker with years of experience, was almost knocked unconscious by an *o-dako* returning to the levee.

As you observe the ballet on each side of the river you finally come closer to understanding how the festival works. First, several *rokkaku* teams from each town lay out their kites and line,

Below: A series of antique Japanese postcards.

Left: A Shirone Kite team and their large Daruma kite from the 1930s.

Center: Kites from Ajikata and Shirone are destroyed as the tug-of-war begins, 1930s.

Right: Kites from Shirone and Ajikata prepare for aerial battle. over the river, 1930s.

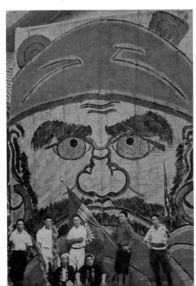

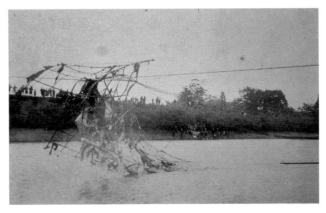

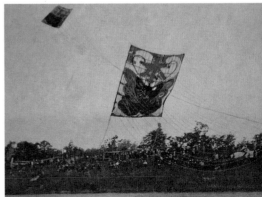

organize their teammates, and then launch their kites. Within a few minutes, there might be ten kites on either side of the river, flying in the relative safety of their side. If a signal is given to engage the other town's kites, I was never aware of it, but the passive flying on either side of the river soon becomes a pitched aerial battle between all the *rokkaku*. Some are unsuccessfully launched or flown badly, some are tipped by others' flying lines, some flying lines are cut, and some are entangled with a kite from the opposite side. These entangled kites give a preview of what's to come with the *o-dako*; as the kite lines are drawn taut by kite teams on either side of the river, a quick and furious tug-of-war begins—and ends—as the lines are pulled tight and snap. Both kites end up in the river and are destroyed, but the team claiming the most flying line from the opponent is the momentary winner. In the days of the festival, this is a scene that is repeated many, many times. Each team will lose dozens of its kites during the event.

When this frenzied *rokkaku* battle subsides, the tops of each levee clears, larger teams of the *o-dako* lay out their flying lines, erect their kite downwind as far as possible, and make last-minute adjustments to bridles, tails, and sails. When teams are ready, they launch their *o-dako*, usually one from each side of the river, but sometimes two or more. Now the real contest begins: made for the relatively light winds of the region, the *o-dako* are bridled to fly toward the opposite side of the river. The object of the contest is to successfully engage a kite from the other side, usually by flying over the bridle-lines of the opponent and then circling completely around him. This causes a tangle that is impossible to recover from. As the kites fall from the sky and teams from each side pull their lines taut, the kites' sails are first destroyed as they are doused into the river, but then the frames are crushed as well, as all the lines are pulled tight. Each *o-dako* is equipped with a large piece of wood that ensures that, once a full tangle has occurred, nothing will pull the kites apart except for the failure of the flying line.

And now we reach the climax of the dance: entire neighborhoods from each side of the river pull the kite lines taut and begin a coordinated tug-of-war with the other side. Hundreds of people—men, women, children, grandparents—pull until one of the kite lines breaks. Traditionally, these lines, about an inch in diameter, were handmade of hemp. It took the local rope makers almost the entire year to make the ropes used for the kite battle. Today, more and more teams use machine-made lines, but some teams still go to the expense of having handmade rope made for their kites. Like in the *rokkaku* battles, the winning team of each particular fight is the one that claims the most kite line from its opponent. Since the festival runs for several days, keeping track of these numbers is the job of a very large support network of volunteers and organizers.

Like the Day of the Dead in Guatemala, kite-festival time in Shirone and Ajikata is not just about kites. It is a time for local neighborhoods and groups to come together, work toward a common goal, share friendships, and enjoy life. Watching the choreography of the festivals' kite activity, the frenzied young people launching numbers of *rokkakus*, the slow ascent of just one *o-dako* on each side of the river, hundreds exhorting their mates to tug-of-war success, and the whole process repeated countless times over the course of the festival shows that this is a tradition not to be taken lightly. It is known throughout Japan and a source of great pride in Niigata prefecture, where other cities have rich kite traditions as well. It is a kite tradition known throughout the kite world and emulated, in part at kite festivals around the world, where contemporary kitemakers engage in (usually) lighthearted aerial combat.

HAMAMATSU, JAPAN

A second Japanese kite festival demonstrates the deep ties between cultural history and kites. It is the festival at Hamamatsu, which takes place during Japan's Golden Week. This weeklong festival, usually the first full week of May, is a time when almost all Japanese travel—to their ancestral homes, to popular vacation spots, or to historical sites around Japan. As an observer of the Hamamatsu festival; however, it appears that everyone in Hamamatsu stays home! Everyone, from small children to the oldest adults, seem to have a role in the festival.

The kite festival in Shirone, Japan is like a choreographed dance, with a noticeable rhythm, frenzied at times but then more mellow and refined. In Hamamatsu, the kite festival can only be described as an assault on the senses! Team musicians beat drums and play trumpets nonstop, smells of food come from every corner of the field, where teams rest, recoup, and regroup. Kites are carried to and from the field constantly, and are launched the moment they're ready. Their long, hemp tails drag along the ground, looking for an uncovered leg, and then fly into the air as the kite catches wind. Other kites come crashing down within arms' length while team members work to fly or retrieve kites. Dust is everywhere! Somewhere in this chaos there is order, and close observation shows how the action is coordinated.

It's important to know that Children's Day, formerly Boys' Day, is one of the notable days that occurs during Golden Week. Historically, Boys' Day was a time for families to celebrate their sons, so it is common to see *koi no bori* [carp banners] signifying strength, endurance, and determination throughout Japan. But almost as important, and a traditional boy's activity, is kite-flying. Hamamatsu is only one of many kite-centered festivals held during Golden Week, in fact, the Japan Kite Association chooses this time to meet every year. In Hamamatsu, the festival is rooted in this tradition; kites are made to honor any children born during the previous year and these children are the focus of the days' activities.

More than fifty neighborhoods have organized kite teams, and making up those teams are musicians, flag- and banner-carriers, kite-line handlers, kite handlers, kite-reel handlers, and kitemakers. Supporting these team members are other family members cooking and serving food and drink in team tents set up around the kite field. Amongst the chaos, kite teams first parade around the perimeter of the field—bands blaring, flags waving, and one small child in the center of it all! It is this child's kite that will be flown next. As the team regroups to its headquarters, kite lines are laid out, kites are walked to the downwind side of the field, elder kite masters make final bridle adjustments, and the kites are, finally, flipped right side up and launched. As they drag their hemp tails into the air, kites are worked higher up into the slightly stronger winds. Once in the wind, they are flown at great height almost a mile from their reel. With more than fifty teams on the field, this is a never-ending process and the casual observer can be caught by a kite line pulled tight, burned by a tail snaking across the ground, or smacked by a kite falling back to earth on an unsuccessful launch.

As an aside, these kites are called *machijirushi*, loosely translated as "neighborhood kites," and are adorned with traditional symbols chosen to represent each neighborhood. They are a simple-looking square kite but are intricately framed with split bamboo. The frames feature very narrow bamboo, used fully split or in half-round or full-round lengths. This is a very different kitemaking technique, but Hamamatsu was a region known for its fine bamboo arrow shafts, so its kitemaking took into account this environmental factor and has remained this way ever since. The historical importance of kites in this region was noted by *ukiyo-e* [woodblock prints] artists Hokusai and

An honored mother and child march under their kite prior to its flight.

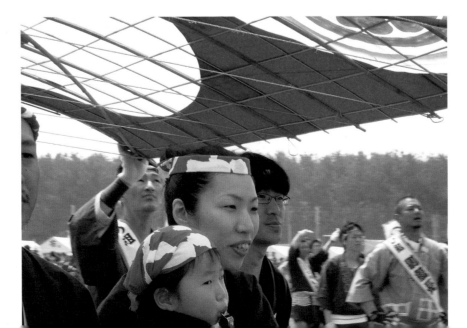

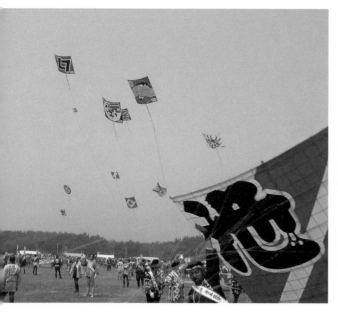

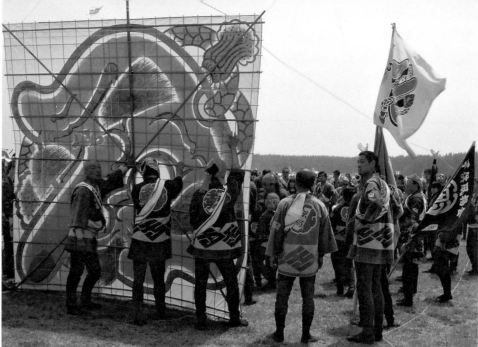

Hiroshige, who both featured kites in their images of this station along the Tokaido road.

As more and more kites fill the sky, the aerial combat begins in earnest. These kites are flown on very smooth hemp line, so the object is not to cut the lines of opponents' kites. Rather, when several kite lines have been crossed and drawn together, teams play their line rapidly in and out and the resulting friction on the kite line can cause high-flying kites to actually lose altitude. Teams watch this action closely and if their kite seems to be losing too much altitude, they quickly try to retrieve line and bring the kite back to the safety of the kite field. Retrieval of the kite line is accomplished by about six very fit teenagers who run in a tight circle, gathering line as they sprint. Some kites are lost, far beyond the edges of the field, and replacements are quickly brought into place and readied for launch.

If the field activities weren't enough to convince you of the cultural importance of this event, you must realize that the kite-flying is only part of the day's activity. In the early evening, kite teams gather in their neighborhoods and prepare their large *dashi* [like a parade float] for a parade that meanders throughout the city. The *dashi* have evolved to their current form over the past three hundred years. Today, they are large, heavy wooden structures that carry a group of traditional musicians (up to thirty-three feet high and weighing many tons) and are decorated with lanterns and lights. These were originally the humble hand carts that brought kites to the kite field. Teams made them more and more ornate, and soon, it required the entire team to pull the cart. Today, team members young and old pull the heavy ropes of the team *dashi* through the streets of Hamamatsu.

Left: Hamamatsu kites are launched above flying teams, bands, food tents, and observers.

Right: Experienced kite team members make final bridle adjustments on their kite.

By about 9:00 p.m., the teams pull their *dashi* to their own neighborhood and the party begins! Food, drink, song, and dance combine to make the evening complete. Beer and *sake* [rice wine] flow as team members greet old friends and welcome new ones. Families with young children, honored on the kite field, provide food for teammates and team pride is displayed by everyone wearing their team *hapi* [coat or jacket]. It is a strong statement as to the importance of team unity when you see young girls, hair in perfectly coiffed bouffants, and wearing high-style clothing, proudly wearing their team *hapi* over it all. The party works its way into the night until you realize that there are three more days of this!

When you see the level of participation—young, old, men, women, athletes, musicians, dancers, kite specialists—it strikes you how deeply important this festival must be to the residents of Hamamatsu. During Golden Week, when most Japanese travel from their cities to any number of destinations, these people stay home and participate in their own special tribute; to children, to neighborhoods, to ancestors, and to greater community. It is a tradition hundreds of years old and one that has evolved based upon its close ties to community.

FANØ, DENMARK

Unlike kite festivals in Bali or Japan, the International Kitefliers Meeting in Fanø, Denmark is only a little more than a quarter-century old. But it shows the power of kites to bring people together, in that it attracts kitefliers from all of Europe, Australia, New Zealand, the United States, and even Japan. It is the world's showcase for contemporary kite design, traction kites with their buggies and boards, and two- and four-line power-kiting in the strong winds off the North Sea. Started by fewer than a dozen German kite enthusiast friends, the meeting has grown so that it attracts over five thousand kite fliers every year.

I first experienced the magic of Fanø in 1991. Because the island is a popular summer destination for many Danes and Germans, the Kitefliers Meeting was scheduled in early June, before summer rates start for island lodging. Most people stay in beach houses—wonderful, well-planned cottages that have plenty of sleeping capacity as well as full kitchens and comfortable living spaces. In 1991, I stayed with German friends in one of the large and well-equipped campgrounds; with more than enough room and lots of camaraderie it would have been perfect, except for the weather. That year, the island had heavy overcast skies and almost perpetual rain from Sunday through Friday, virtually the entire week of my stay. It was not until that Saturday that the magic of Fanø was revealed.

Clear sunny skies, light, steady winds, and thousands of kites were the order of the day! Looking north and south along the twenty kilometer beach it was a wall of color, with kites of every description, flying above their very happy owners and makers. During the bad weather, there were many hearty souls flying state-of-the-art sport kites in the blistering winds, but in this good weather we had all of those people and more flying their latest creations, made of ripstop nylon (spinnaker cloth) with wood, fiberglass, or carbon-fiber spars. In this perfect wind, on this perfect beach, it was possible to fly as many kites as you had on the island. Once launched, the kites seemed to be nailed to the sky in the absolutely steady sea breeze.

So here is a modern festival with very few rules—the biggest is that you come here at your own expense and then enjoy the kiteflying in any way you want. It sparks the imagination in the same way that the centuries-old kite traditions of Asia do: it is a testament to creativity, brotherhood, and our fascination with flying objects. Fanø, Denmark has become a landmark on the world map of kiting destinations and in just more than twenty-five years, it is already known throughout Denmark as "the place to fly kites." It is not at all improper to think that in 300 years this will be Northern Europe's kite capital, like Bali, Shirone, or Hammamatsu.

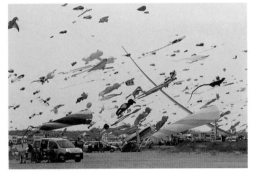

Left: Chaos of shapes, colors, sizes, and types of kites over the beach in Fanø, Denmark.

Right: An example of the highly innovative and spectacular kites in Fanø, this one is by German Wolfgang Schimmelpfennig.

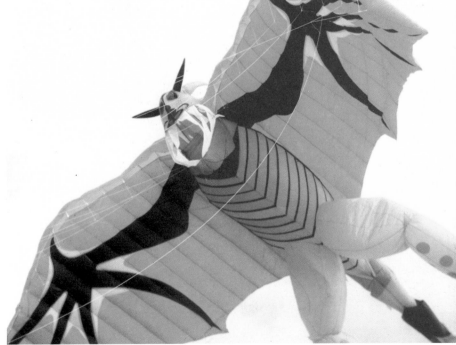

DAY OF THE DEAD, GUATEMALA

SCOTT SKINNER

The day starts early: before dawn, groups with giant kites climb to the city's soccer fields and dig holes for the large pine poles that will support their masterpieces. The *barriletes gigantes* are up to fifty feet across and, with their heavy Spanish cane and bamboo structures, will weigh hundreds of pounds. They will form the backdrop for a kiteflying day like no other in the world. Said to allow ancestors' spirits to visit the living via the kite lines, kites have been flown in Guatemala for generations and, today, the giant kites are a source of pride for the indigenous Maya. They carry social and political messages and have become a local art form. This is a kite tradition among the most amazing in the world.

Preparation begins months before November 1, All Saints Day on the Catholic calendar, and continues on November second, All Souls Day—more commonly known as Day of the Dead in much of Latin America. Kite teams travel to the rainforests near the Pacific coast and trek deep to find the fast-growing bamboo that will be used for their *barriletes*. This is a cooperative effort to ensure that all the giant kite teams will have material for their creations. The expense is prohibitive for every team to make the journey, so leaders cooperate to find transportation and manpower to accomplish the task. No simple undertaking, the trek brings risk to life and limb as bamboo is found, cut, and carried out of the forest.

Kite teams are made up of friends, relations, or neighbors and depend on every member's family to contribute paper, glue, tape, wire, or any other necessity. Within the group is a core that decides upon the theme for the year's *barrilete*, its shape, and the details of its surface design. Accurately drawn on graph paper, this image will be manipulated to the grand scale of the finished product. Team tradition can influence the final design, but for the most part, every year's creation is unique and distinct. Within the framework of the teams' designs are political, social, and environmental messages that will increase the importance of the kite. Making the kites is a platform for politi-

cal dissent, a source of ethnic pride, and a celebration of family, team, or neighborhood.

Weeks before the Day of the Dead, team members gather materials—mostly *papel de china* and *resistol* [white glue]—and begin work on small sections of the kite sail. On a gym or community center floor, the original design is enlarged to its actual size, transferred onto white paper with marker or pencil, and checked for accuracy to the original drawing. Repeating geometric edges, area borders, team motifs that are common to the design each year—all of these can be done in homes or workplaces by individual team members. These details will not come together until a night or two before the festival day. Family groups making smaller, but no less intricate designs, will work at home in the evenings on living room floors under the supervision of elders. Fine details might be worked on by the best artist in the house; for instance, in the Asturias' family's house, a portrait of their daughter, accomplished with great skill in *papel de china* and *resistol*, adorned the wall while work continued on other sail details. Later, the portrait would be incorporated as the Maya goddess into the group's final design.

In these final nights before the festival, there is a remarkable resemblance between this kite tradition and those in Bali or Japan. Groups work through the night, but social interaction and camaraderie appear to be just as important as completion. Groups eat together, laugh at nicknames given at others' expense, and bring together all the elements of their kite sail. On one of the very scarce floors large enough to lay out the entire kite, the team lays out its white-paper rendering. Premade sections are placed correctly and then work begins on all the undone areas. *Papel de china* is sacrificed in abundance as the final details appear. Spectacular realism is achieved by the most refined of the teams—they are literally painting with paper—and the resulting images, whether of mythical beasts or historical heroes, are incredibly realistic. The entire paper sail

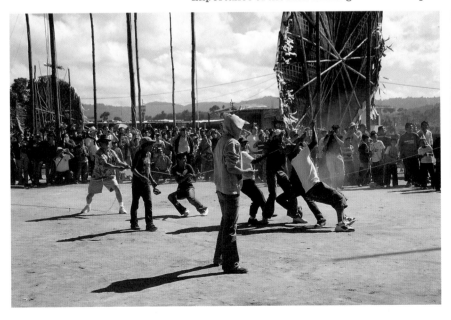

Left: Kite teams can be called upon for brute strength as well as artistic ability.

Right: The Asturias' family member portrait incorporated into the final kite design.

comes together under the supervision of team leaders and every detail is checked.

It should be noted that even the gluing techniques add to the realism of the final product. In some places, the top layers of paper are glued so that edges are emphasized; in others, it is dabbed to produce a rough texture; and in still others, it is laid in a pattern that duplicates the graphic pattern around it. It is not unusual for detailed areas to have three, four, or five layers of paper colors to accomplish a desired effect. Small details that you would expect to disappear on these large-scale pictures become important elements within the design. Large, repetitive design motifs that look overpowering on the gym floor look complementary and natural on the kite field. The artistic experience that dictates these decisions is one of the factors that set teams apart. The final indoor step toward kite-sail completion is to back the entire sail with black paper; this deepens the colors in bright sunlight. Then the back of the sail is crisscrossed with clear tape, which reinforces the sail and acts as a stop to tears (the same principle as the ripstop nylon used in contemporary kites). Now the sail is carefully folded for transport to the field. It is extremely important, when working at this scale, that the exact top and bottom of the sail is known. It will be aligned exactly with the kite frame on the field.

November 1 arrives, and teams make their way to the city's soccer fields situated on a hill just above the cemetery. The link to the cemetery is an important one, as native belief is that ancestors' spirits will travel down the kite lines to visit their living relatives. Throughout the cemetery, families clean and decorate gravesites, plan picnics, and gather to celebrate the day. Children fly kites from every corner of the cemetery. Above them on the soccer fields, teams begin to organize their efforts for the day. Kite frames are laid out, checked for symmetry, and lashed together. One athletic team member shinnies up the pine poles and lays ropes over large nails; they will be used as crude pulleys to raise the giant kites. Late in the morning, the kite sail arrives, and the entire team lifts the finished kite frame. The sail is carefully unfolded under the lifted frame; team leaders ensure that it is properly aligned and undamaged. Once in position, the frame is laid onto the sail and the sail is attached. Handfuls of *resistol* are spread on the edges, and they are folded over the framing line running along the circumference of the frame. *Papel de china* is pasted on the kite's edge and cut to make the decorative *flecos* [fringe].

It is now time to raise the kite into place. This is a process repeated over a dozen times by the *barriletes gigantes* teams to make the dramatic backdrop to the festival. The giant kites are no longer flown—safety concerns as well as the reality of light winds make this unreasonable—but they stand as testament to the importance of the festival. They will be judged for their craftsmanship, beauty, and theme by a panel of festival judges. Team members man ropes behind the kite and long poles in front as the front edge is lifted. As the kite is lifted higher, poles in front push, and ropes behind pull to raise the kite to its resting place in front of its pine supports. An uncoordinated effort brings the kite to rest with its sail at a slight angle, a mistake that can't be undone. As more and more *barriletes* are raised, the

Left: A giant kite frame of bamboo and Spanish cane is lifted and placed over the paper sail.

Center: As a kite is raised, the festival panorama takes shape.

Right: Rolls of *papel de china* are glued to the bottom edges. They will be cut to make the *flecos*.

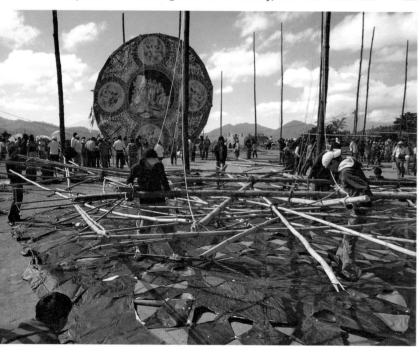

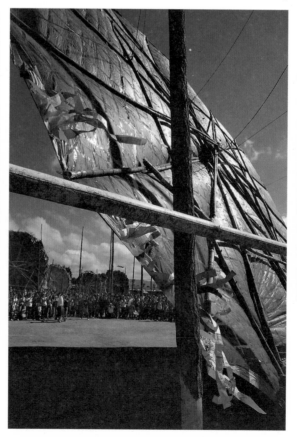

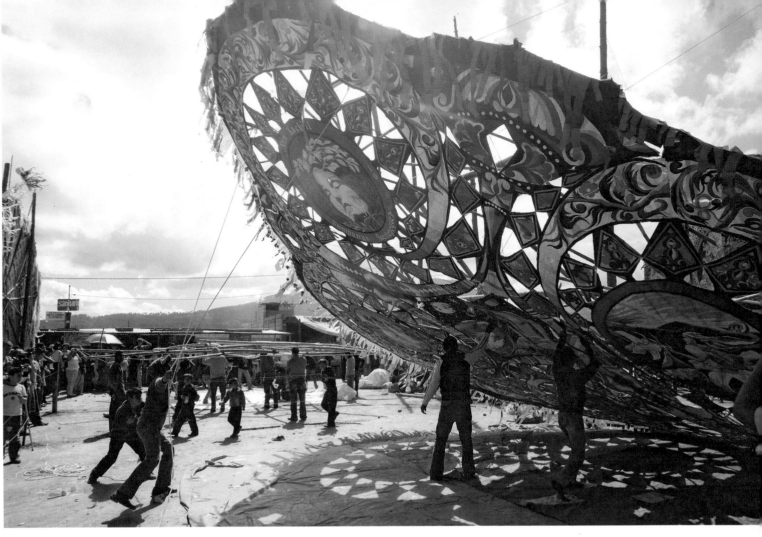

A giant kite raised successfully.

spectacle is immense. Each is a masterpiece, but together they are a sight that is unlike any in the world. In front of this backdrop are smaller kites, some made by children, others by neighborhood groups, some by families, others by friends. These kites will be flown and judged throughout the day as the huge crowds are moved for launch and retrieval. Throughout the day there are energetic bands, dance groups, and a festival queen and her court that bring the action to a head. On the hillside opposite the cemetery, families picnic and fly store-bought kites. Many are traditional hexagons, but a variety of modern designs and motifs are sent airborne.

As evening begins to descend, a group of Maya spiritual guides gather in the cemetery to perform ceremonies honoring the dead. Spanish Catholics would probably have called these religious people *brujos* [witches], but they are allowed into the Catholic cemetery to perform their rites. Offerings of rice, beans, tortillas, and local liquor are all placed upon the ground with decorative flowers, while the spiritual guides pray aloud, honoring ancestors and the recently deceased. Wax candles are handed to attendees and are melted in a participatory spirit. As an observer, I suspect that this is a fragile public ceremony, one that has been driven underground before but is now at least tacitly approved by the government. Marimba music accompanies

the ceremony and soon becomes the centerpiece of celebrations that continue into the night.

On the kite field, when the *barriletes* are brought down, tradition holds that the sails be removed from the frames and then burned. If following tradition, the kite had a life of only one day, the Day of the Dead. But today, recognizing the cultural importance of these works of art, teams carefully remove the sails and store them away. These sails will not be used again, but they exist as an archive for scholarly study and as a testament to the teams' creativity.

This single day in the kite world is like no other: it is a day steeped in tradition and brought into the twenty-first century by young, creative groups. It is a day where the ephemeral nature of kites is literally on display; kites come into existence and are destroyed within the day's twenty-four hours. It is a gallery where artistic paper kites display history, nature, and mythology while making bold political statements.

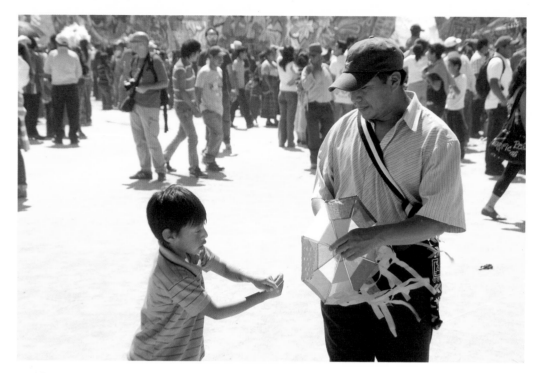

Amidst the chaos of the day, a father and son prepare for launch.

THE INGENUITY OF
THE BARRILETE

From a kiteflier's perspective, several comments should be made. First impressions that the materials (sail and frame) are crude or unrefined are quickly changed when you observe the fine details in the groups' work. Paper layering, gluing, and backing cannot be fully appreciated until the final work is erected on the kite field. The cumbersome and far-from-perfect-looking frame is carefully and ingeniously laid out and made symmetric using a rope-measurement system that is accurate and economical (in both time and material). Aerodynamically, these *barriletes gigantes* are very simple flat kites; they would require strong wind; a long, drag-producing tail; and plenty of space to fly safely. In today's festival, they are not flown, but it is obvious that teams take pride in the fact that they *could* be.

The heavy frames of the large kites stand in stark contrast to the light, fragile frames of the six- and ten-foot kites. These kites use local Spanish cane (*Arundo donax*) and a local bamboo, (*phyllostochys bambusoides*), that is very weak and brittle. On the small kites, in the typically light winds of the season, the frames provide adequate strength for successful flying, and many family teams show great skill in sending the kites very high. A single crash, however, and the frame usually ends in a shambles; the kite is irreparable. The heavy bamboo of the large kites must be transported to Sumpango from great distances

and is reused and shared by teams. In fact, it is the size and length of these bamboo poles that limit the size of the *barriletes gigantes*.

Like traditional kite festivals in other regions of the world, the traditional kite form is the starting point for many kitemakers. Here in Guatemala, many thousands of hexagonal and octagonal kites are sold for children, mimicking the form of the *barriletes gigantes*. But professional and amateur kitemakers alike make a variety of kites in the shape of birds, bats, insects, and other creative designs. From fighter jets to butterflies, kites capture the imagination of children and adults, and become a celebration of nature, human spirit, fantasy, and national pride.

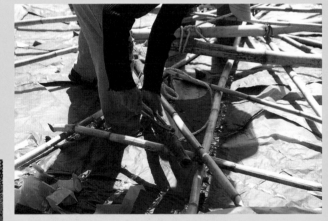

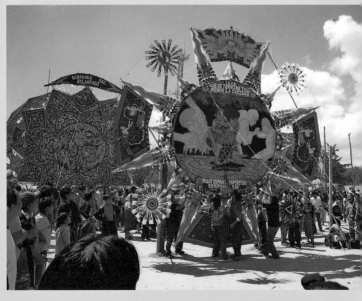

Clockwise from upper right:

The heavy Spanish cane and bamboo frame of a *barrilete*, ready for the kite sail.

Within the constraints of a geometric frame, many innovative approaches appear.

A giant kite with the Acatenango volcano in the background.

27

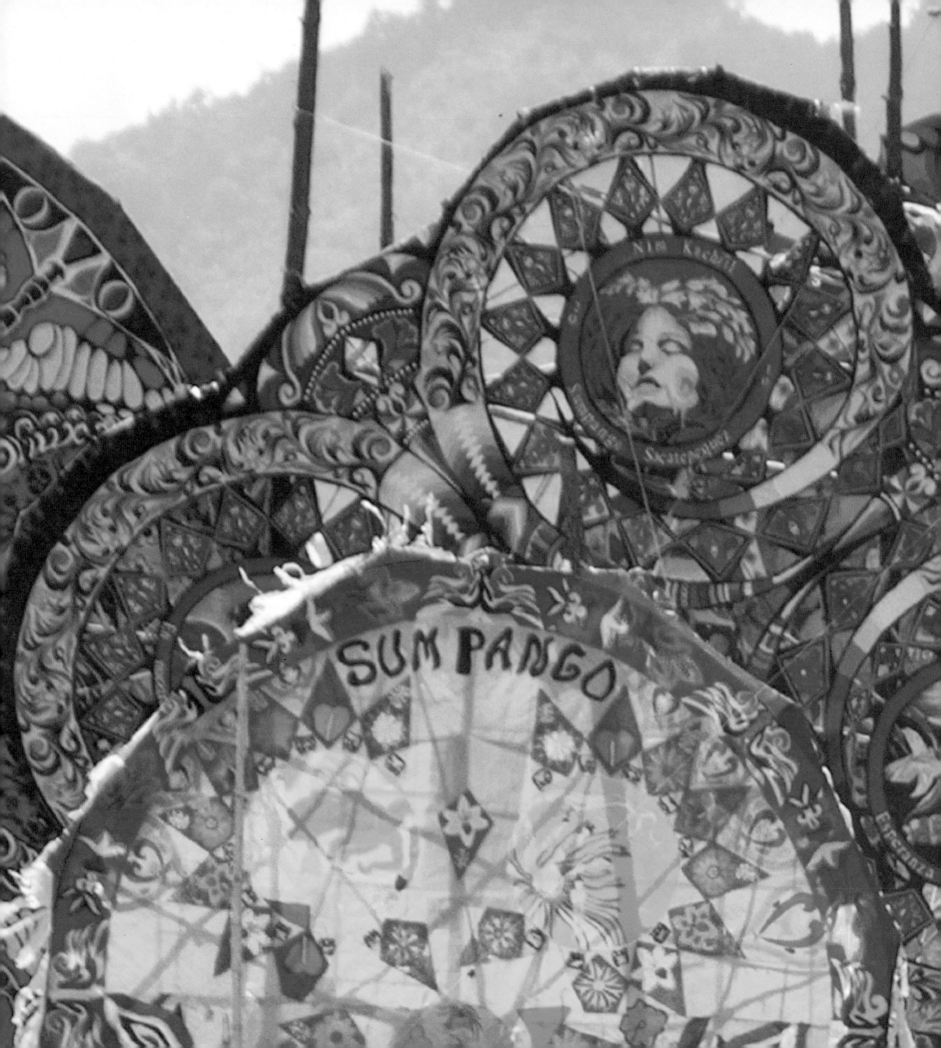

WINGS OF RESISTANCE
GENOCIDE IN THE SHADOW OF
THE BARRILETES GIGANTES

CHRISTOPHER ORNELAS

When we are flying kites, the string is a symbol of life being flown up into heaven, so that there is contact between the heart of the earth and the heart of heaven. It doesn't represent the life of one person, but the lives of many people.

—Maria Solis Ajq'ij, Maya spiritual guide

In the central highlands of Guatemala, the town of Sumpango, Sacatepéquez has revived an old Maya custom of flying kites for the Day of the Dead. The volcanic mountains of the Sierra Madre surround this town of thirty thousand people. Every year in the months of October and November, the people of Sumpango prepare for an enormous kite festival that takes place on November 1. During that one day, fifty thousand people from across Guatemala inundate the soccer fields above the town's *camposanto* [cemetery]. Everyone gets swept up in the uproarious celebration of kites and the dead.

The kites are enormous. The largest measure forty-five feet in diameter and can weigh as much as two hundred pounds. Smaller kites, measuring twenty feet high, are flown in a death-defying race down the side of a mountain. Injuries can occur when the giant kites come crashing down unexpectedly. Teams of young men, some with as many as thirty, labor for months creating just one kite. But even more incredible, the kites are covered with intricate drawings made from thousands of sheets of brilliantly colored tissue paper. Their diaphanous sails light up like stained glass windows when raised against the sun. Each one tells a story, fervently imagined and painstakingly depicted, about life and death in postwar Guatemala, and of a genocide long since forgotten in the eyes of the world.

A dirty war against communism unfolded in Guatemala between 1960 and 1996. During the war, more than two hundred thousand people were killed in what has since been recognized by the United Nations as a state-sponsored genocide. Another fifty thousand were "disappeared," with no trace or record of their remains. The peace accords gave blanket immunity to the military and the political architects of the war. To this day, no military officer or politician has been convicted for human rights abuses committed during the war. The recent history of the country is like a gaping wound on the national consciousness, and unresolved grievances lie festering below the surface.

The violence of the civil war and the struggle to remember the genocide carried out against Maya indigenous communities acted as a catalyst for the transformation of the Sumpango Kite Festival. Today, the kites not only acknowledge and denounce violence, but they remap the way in which history is told. The *barrileteros*, the kitemakers, tell a story of the war from their perspective, forcing people to talk about history on their terms.

This essay will trace the history and evolution of the *barriletes gigantes*, from their roots in the Day of the Dead to the modern-day kite festival. It will explore what the kite tradition was before the festival and what it is today, documenting the radical changes that occurred over the last thirty years in response to the war and the escalating violence in postwar Guatemala.

The first half of this essay addresses the origins of the kites and their connection to Day of the Dead. It examines the importance of Day of the Dead in contemporary indigenous communities by exploring its roots in the pre-Colombian cult of the dead, and the syncretism of indigenous religious practices and Catholicism. The second half of this essay examines the kites in the twentieth century, and their transformation from folk art into a vehicle of protest.

In the early 1970s, the kites were small and decorated with basic geometric designs. They had no images and no political meaning. Today, the kites stand fifty feet high and are covered in elaborate "paintings" made from tissue paper exploring history, religion, and politics. They are no longer folk art in the traditional sense. Instead, they are now paper murals, laden with political narratives intended for a mass audience.

This chapter endeavors to answer why the kites changed and, more important, what it means for a small indigenous community in rural Guatemala to depict images of genocide on the wings of a kite.

All interviews were conducted in confidentiality, and the names of the interviewees, with the exception of government officials, have been altered to protect their identities.[1]

Los Barrileteros, The Kitemakers

In the two months leading up to the Day of the Dead, life in Sumpango revolves around kitemaking. The *barrileteros* work in large teams, some with as many as thirty members. The teams have unique and often fantastical names such as *Hijos del Maíz* [Sons of Corn], *Internacionales Audaces* [the Audacious Internationals], and *Gorrión Chupaflor* [Sparrow Hummingbirds]. Some names are in English, such as *Los Happy Boy's* [sic]. They work in dusty warehouses, camping out for long nights on chilly cement floors. Others work in homes or municipal buildings—anywhere they can find space. Some boys bring pillows or blankets to use as kneepads because the hundreds of hours spent kneeling and pasting pieces of *papel de china* onto the sails of the kite can cause serious aches and pains. The groups are mostly composed of boys and young men who labor for several hours every night, and sometimes until dawn—all for the sake of a fragile work of art that will only be seen for a day!

The word *barriletero* is derived from *barrilete,* the Guatemalan word for kite. Words for kites differ greatly across the Spanish-speaking world. In Colombia, Ecuador, and Peru the

1. In 2007, the author lived in Sumpango for two months documenting the creation of the barriletes gigantes and conducting oral histories with the *barrileteros*. This project was made possible through the support of the Yale University Art Gallery and the Drachen Foundation. Photo documentation of the kites and the transcripts of the oral histories can be found in the Drachen Foundation Archive.

kite is known as a *cometa*; in Mexico it is called a *papalote*; in Puerto Rico and Cuba it is known as a *chiringa*. In Spain and Latin America, there are more than twenty different names for kites, including: *pandagora* (Paraguay), *lechuza* (Nicaragua), *papagayo* (Venezuela), *pizchucha* (El Salvador), *volantín* (Chile), *pipa* (Brazil), and *milorcha* (Aragón, Spain).

Cultural Context of the Kite Festival

The majority of people in Sumpango are Kaqchikel-Maya, one of twenty-one language/ethnic groups in present-day Guatemala that trace their roots to the ancient Maya civilization. It predates the Spanish conquest, like many indigenous towns in this region. The town's name is derived from *tzompantli,* the Nahuatl word for "skull rack."[2] Ancient ruins still exist in the nearby hills, small and unexcavated.

The present-day Sumpango is a ramshackle town of cinderblock houses with scraggly rebar spokes sticking out of the roofs. It is dusty, and most of the roads are made of dirt or hewn from jagged stones. Most of the walls are gray and unpainted. Most inhabitants are farmers; fields of corn, coffee, and black berries line the hillsides surrounding the town. From outward appearances, Sumpango is rather unremarkable—almost indistinguishable from other small indigenous towns that make up rural Guatemala.

In the town plaza, women dressed in *hüipiles* [a traditional blouse worn by Maya women] wash their clothes at a large communal well, often with babies wrapped tightly around their backs.[3] Grizzly old men lead nags through the streets, their backs piled high with baskets of corn, hay, or kindling. In many a *tortillería,* you can hear the soft sound of hands clapping as women flatten small masa balls into doughy corn tortillas.

However, in this same town, almost every young person has a cell phone, often with a built-in MP3 player. Nearly every home has a television, and many have satellite dishes. Young boys spend hours at Internet cafes playing video games, talking with friends on AIM (AOL Instant Messenger), downloading music, or watching YouTube videos. Because of its close proximity to the capital, Sumpango is an interesting contrast of traditional and modern.

On the Origins of Guatemalan Kites

In contemporary Guatemala, flying kites for the Day of the Dead is a tradition practiced by many indigenous communities in the central highlands. The oral history of elders in Sumpango attests that the tradition goes back for many generations, and the elders in Santiago, Sacatepéquez, claim that their kite festival originated at the end of the nineteenth century. Like the history of many folk traditions, the origins of the kites are steeped in myths. Some say that townspeople first created kites to scare away evil spirits, and others say they came about as a way to guide the spirits of deceased loved ones down from heaven. The true origins remain a mystery, and little historical evidence attests to the existence of kites prior to the twentieth century. However, there are a few theories as to how kites first emerged in the central highlands.

The most common theory explaining the origin of Guatemalan kites is linked to the Franciscans or Jesuit missionaries. In the sixteenth and seventeenth centuries, Portugal established a large network of missions in the Far East alongside colonial trading posts from India to China. Many of the same missionaries were later sent to establish missions in the Spanish Philippines and the Americas. A long history of regular commerce and trade between Spanish America and the Far East is well documented. Portuguese trade vessels and merchants from across the Far East would trade their goods in the Spanish colony of the Philippines. The trade route between Manila and Acapulco, known as the Manila Galleon, was an extremely lucrative facet of colonial commerce. The route began operation in 1550 and continued regularly for more than 250 years until the end of the colonial era.[4] It is highly plausible that either merchants or missionaries inadvertently introduced kites to the Americas upon one of these many voyages.

2. Nahuatl was the language of the Aztecs, a fact that seems to indicate a possible connection between the Aztec Empire, centered in the Valley of Mexico, and the far-flung Maya tribes of highland Guatemala. However, it was also not uncommon for the Spanish to incorrectly attribute Aztec names to newly encountered indigenous communities. Tzumpantli refers to a wooden structure that the Aztecs used to display the skulls of sacrificial victims. The Hueyi Tzompantli (great Skullrack) of Tenochtitlan, the capital of the Aztec empire located in present-day Mexico City, held an estimated 60,000 skulls. Ortíz de Montellano, "Counting Skulls: Comment on the Aztec Cannibalism Theory of Harner-Harris," *American Anthropologist,* no. 85 (1983): 403–406.
3. Hüipiles are the traditional blouses worn by Maya women. They are typically handmade on back looms and are brilliantly colored in complex geometric or floral designs. Every village has its own unique pattern. While most men no longer wear traje, traditional dress, Maya women across Guatemala proudly wear their native clothes, and it has become a symbol of indigenous identity.
4. *30th International Congress of Human Sciences in Asia and North Africa, Asia and Colonial Latin America,* ed. Ernesto de la Torre (Mexico City: El Colegio de Mexico, 1981).

The central square of Sumpango, Sacatepéquez.

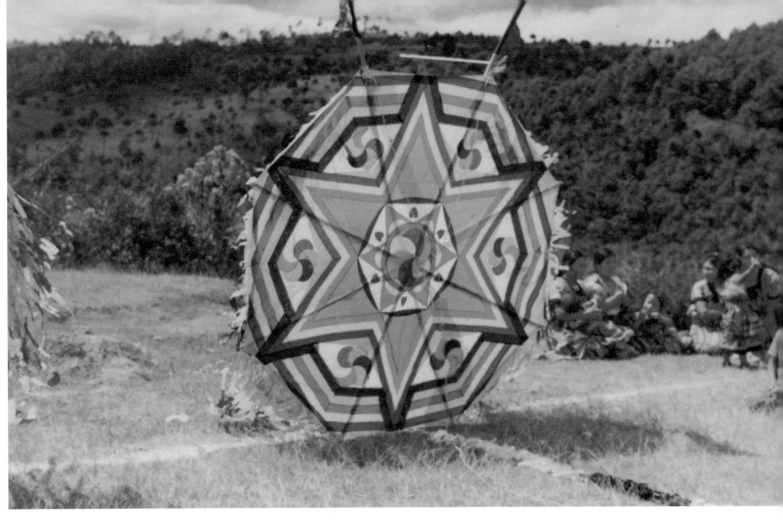

Happy Boy's (1983).

Another, more intriguing theory is that the pre-Columbian cultures invented their own version of kites independently. Perhaps these cultures made kites in reverence to the gods, such as Huitzilopochtli, the Aztec god of war who took the shape of a hummingbird, or Itzpapalotl, the obsidian-butterfly goddess whose face appeared as a skeleton. Certainly, these cultures revered winged creatures such as hummingbirds, eagles, butterflies, bees, and even winged serpents. The possible origins of a pre-Columbian kite is fascinating, if unlikely, and brings to light aspects of pre-Columbian cultures often overlooked by historians.

Because most aspects of pre-Colombian culture were irreparably lost or altered after the Spanish conquest, the study of pre-Colombian crafts depends largely on written descriptions of Aztec and Maya culture left by colonial missionaries. An inquiry into these manuscripts has uncovered several paper-made objects that could help guide the search for a pre-Columbian kite. At the very least, these items, culled from Spanish sources after the conquest, illuminate the material and impermanent aspects of Mesoamerican culture. They also give clues as to why indigenous communities would choose to adopt kites as part of their funerary rituals, if the missionaries in fact introduced kites during the colonial period.

Kites are known to have originated in China as early as 1000 BCE, or perhaps even earlier in the south seas of Polynesia, and from there they spread across Asia. Kite historian Clive Hart claims that, once introduced, "kites rapidly acquired religious, magical, and ceremonial significance in many of those parts of the world. In at least some civilizations, including the Polynesian, kites seem to have had some function as symbols of an external soul." By coincidence or not, this association of kites with spirituality and the human soul is true of contemporary Guatemalan kites.

Many legends explain the birth of kites, including the story of a Chinese farmer whose hat took flight with the wind. But Hart suggests that kites were born from the not uncommon meeting of cloth banners and the wind:

> My own speculations on this matter have centered on the similarity of the kite to the pennon or banner, and on the custom in many places of allowing banners to stream out in the wind either from a cord or from a flexible rod. In past centuries the personal banner was common among eastern dignitaries, while in fifteenth- and sixteenth-century Europe, the distinction between it and the kite was still

33

somewhat blurred. It would seem quite natural to make a banner more clearly visible by stiffening it with light rods placed across it. Once this has been done the kite has virtually been invented (Hart 1982).

The Franciscan scholar Bernabé Sahagún describes a strikingly similar account in his epic work *The General History of the Things of New Spain* (the Florentine Codex). The Florentine Codex constitutes the largest account of pre-Colombian culture in post-conquest Mexico. During the month of *Quecholli,* Sahagún describes strips of paper that blew in the wind that served as offerings for the dead:

> They also put these same papers, dripped with rubber and hung from cords, before the same images; the papers were tied together, and the air moved them because the cords on which the papers were hanging were tied to the ends of some rods or scepters that were fastened in the ground, and between the tips of the rods the cord was tied (Sahagún book 1, chapter 21, ∬9, 72f).

In this case, it seems as if the papers were hanging from rods, rather than flying independently in the wind. The images to which Sahagún refers were anthropomorphic figures of mountain deities who held power over the winds and rain. It is not direct evidence of a kite; however, this quote illustrates the use of paper—carried upon the wind—as a medium between the dead and the Gods.

The importance of paper and paper-made objects in the pre-Columbian culture cannot be overemphasized. In ancient Mexico, paper took on religious meanings, similar to traditions in China where paper is burned during funerary rituals.[5] In Mexico, paper tipped with rubber was burned as an offering to the gods. Elaborate paper decorations and costumes were worn in ceremonies, and immense quantities of paper were used in keeping records of tribute and commercial transactions. The Codex Mendoza identifies forty-two centers of papermaking in the Aztec empire, and two places, Amacoztitlan and Itzamatitilan, produced half a million sheets of paper in tribute every year.[6] In Nahuatl, the language of the Aztecs, more than 200 terms exist that refer to paper, including the term *amapantli* [flags made of paper]. While it is difficult to determine the exact purpose of these objects, it is certain that some objects had aerodynamic properties.

In another Aztec festival where slaves were sacrificed, Sahagún describes a type of paper called *amapatlachtli* [stretched paper], which was attached to brightly colored quetzal birds and tied with red strings.[7] The exact purpose of this object is unclear, and whether "stretched paper attached to a bird" is a correct translation of the original Nahuatl. Many of the religious rites documented in the Florentine Codex were not witnessed by Sahagún but were gathered from a diverse range of informants twenty-five years or more after the Spanish conquest in 1521. By the time of its completion in 1590, many of these rituals had already died out.

Sahagún also mentions paper butterflies adorned with drops of *ulli* [a plant extract]. Pre-Colombian cultures highly revered butterflies; thousands of images of them exist in Aztec, Zapotec, and late Maya art. One reason may be in the annual migration of monarch butterflies to the valley of Mexico each year. During the months of October and November, millions of monarchs from across North America converge on central Mexico, transforming the coniferous forests of the Sierra Madre into a spectacle of glittering orange. The word for butterfly in Nahuatl is *papálotl*. Not coincidentally, the word for kite in modern day Mexico is papalote, and is derived from this word:

> In Aztec culture, the butterfly, known as 'papálotl,' represented heroes and important people who had died; it was also a symbol of people who have their house in the sky, of fallen warriors, of those sacrificed on a sacrificial stone, or women who die in childbirth. The souls transformed themselves into butterflies or hummingbirds with vibrant feathers (know as *tizapapálotl* and *ivipapálotl,* respectively). They would suck the nectar of the flowers and they would return to earth after four years to visit the flowers . . . the souls of women who had died giving birth returned at night, the night butterfly, were representatives of the moon—and they were phantom spirits (Carlos Beutelspacher, Las Mariposas Entre los Antiguos Mexicanos [Mexico City: Fondo de Cultura, Economía, Ciencia y Tecnología, 1989]).

5. Hanz Lenz, *Mexican Indian Paper; its history and survival.,* trans. H. Murray Campbell (México: Editorial Libr-os de México, 1961): 19–29.
6. Bodil Christensen, *Brujerías y papel precolombino* (México: Ediciones Euroamericanas, 1972).
7. Quetzal: (Pharomachrus mocinno) these brilliantly colored long-tailed birds, typically found in Central America, were revered by Mesoamerican cultures. Their feathers were used in headdresses and in other ceremonial objects; they were symbols of the god known as Quetzalcoatl or Kulkulcan, the winged serpent. Lenz, *Mexican Indian Paper. . .* , 30.

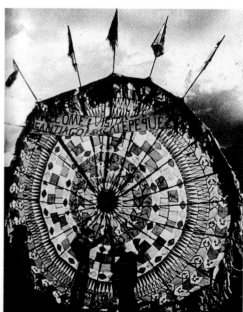

A photograph from the Santiago kite festival circa 1976.

No doubt the perennial migration of monarchs gave flight to the imagination of pre-Columbian cultures, and imbued the butterflies with special meanings. If butterflies were understood to be spirits of the dead, their return year after year offered a logical parallel to the return of the dead spirits to Earth. Perhaps the creation of paper butterflies and paper attached to birds were attempts to capture the majesty of flight. Given its prominent role in many ceremonies related to the wind, including banners hung from strings to be lifted by the air, it is evident that pre-Columbian cultures were fascinated by the aesthetic and aerodynamic qualities of paper. Therefore, it is not difficult to imagine the possibility that kites originated independently in Mesoamerica, and the theory of its origin merits further research.

The Cult of the Dead in Mesoamerican Cultures

The cult of the dead played a pivotal role in pre-Columbian religion. Mesoamerican cultures believed the dead to be intercessors to the gods, and the cult of the dead played an important role in the rites of the religious calendar. Numerous days were dedicated to honoring the dead, and many of the customs associated with these days closely parallel contemporary rituals, such as giving offerings of food or decorating graves with flowers and paper ornaments.

The pre-Columnbian calendar designated several occasions to commemorate the dead, held during the months of *Quecholli*, *Tepilhuitl*, *Tlaxochimaco*, and *Xocatl Huetzi*. The Aztecs set aside certain days for people who had died in different ways. Priests held ceremonies to honor warriors and women who had died in childbirth in the month of Quecholli. The initial celebrations of this month roughly coincided with All Saints Day in the sixteenth century. At these times, families placed small arrows and pine torches, along with two cakes of amaranth, on the graves of loved ones.[8] Their spirits entered into the paradise of Tlaloc, the god of water, and became transformed into butterflies and hummingbirds.[9] Communities made offerings to the mountain gods, and they called upon the spirits of the dead to seek favor with Tlaloc to ensure an abundant harvest.[10]

Reverence for the dead was an important facet of Mesoamerica religion, evident in the pre-Colombian art and writing. The temple complexes of many Maya cities served as tombs and shrines to revered rulers, such the funerary pyramid dedicated to Janaab' Pakal in Palenque. Pre-Colombian religion was pantheistic, and the devotion to the dead arose from a belief in the dead as intercessors to the gods.

A Note on the Primary Source Material

Accounts of pre-Colombian death rituals by Franciscan and Dominican missionaries in the sixteenth century give modern scholars a basis for understanding pre-Columbian religion. However, many more accounts of Aztec culture exist than those pertaining to the Maya. One reason for this is because the Spanish encountered Aztec civilization at its peak in 1519. In contrast, the Maya abandoned their classical lowland cities, such as Tikal or Palenque, in the tenth century CE, and the last great Maya city, Chichen Itzá, was abandoned in the thirteenth century.[11] Furthermore, Central Mexico was the epicenter of an

8. Nutini suggests that these cakes were possibly the pre-Columbian equivalent of tamales. They were made as offerings and to be eaten on the day of a ceremony. Hugo G. Nutini, Todos Santos in Rural Tlaxcala: A Syncretic, Expressive, and Symbolic Analysis of the Cult of the Dead (Princeton, NJ: Princeton University Press, 1988): 53–77.
9. Ibid.
10. Ibid.
11. Mary Ellen Miller, *The Art of Mesoamerica* (New York: Thames & Hudson Inc., 2001).

This kite by *Herencia Maya* (2005) depicts a distraught Maya villager sitting on top of a razed home; he is surrounded by four ancient Maya glyphs. The epigraph on the kites states *"Guatemala, un pais destrosado"* (Guatemala, A Ruined Country).

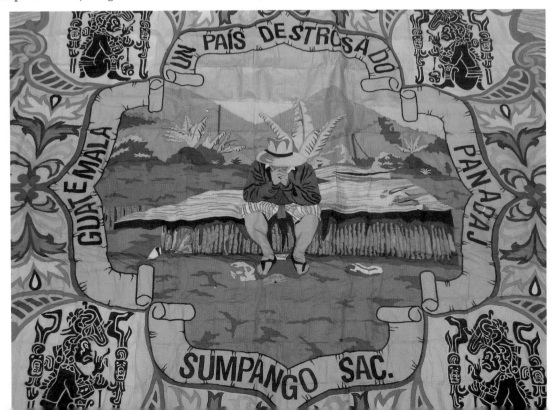

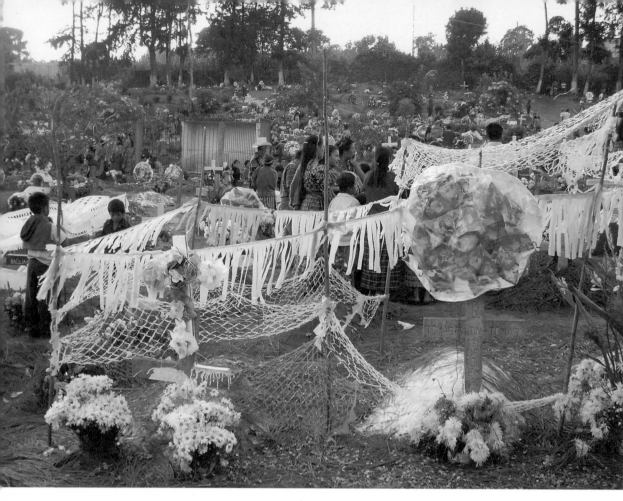

The graves of the Sump-
ango cemetery are lavishly
decorated with garlands and
flowers for Day of the Dead.

intensive spiritual conquest instituted by the Catholic Church
and later became the center of the Spanish colonial world. The
far-flung regions of the Yucatan and Guatemala were the back-
waters of the Indies. They were poor in mineral deposits and
received fewer missionaries and less funding from the Church.

The missionaries sent many Aztec books or codices written
near the time of the conquest to Europe. The Maya also left a
huge written record, as evidenced in their art and architecture;
however, almost all examples of Maya writing on paper were
destroyed by Fray Diego de Landa, the bishop of the Yucatan
from 1571 to 1579.[12] This event he described in detail in his
account *The Yucatán Before and After the Conquest*: "we found
a large number of these books in these characters and, as they
contained nothing in which could not be seen as superstition
and lies of the devil, we burned them all, which they regretted
to an amazing degree and which caused them great affliction."[13]
Today, the three known surviving codices are the Dresden
Codex, the Madrid Codex, and the Paris Codex, named for the
European cities where they now reside.

Syncretism and the Day of the Dead

The legacy of the ancient Maya can be seen across the modern-
day geography of Guatemala, Southern Mexico, and parts of El
Salvador, Honduras, and Belize. In Guatemala, the kites form
part of a funerary custom forged by the syncretism of ancient

Maya religious beliefs and Catholicism. The interweaving
of these two religious worldviews occurred over centuries.
Between the 1550s and early 1700s, Franciscan and Dominican
friars worked zealously to convert Maya communities to Chris-
tianity.[14] Many contemporary scholars contest the extent of the
conversion process.[15] Nonetheless, Maya communities assimi-
lated and appropriated many components of Catholicism, fus-
ing them with indigenous rituals and belief systems to create
an entirely distinct religious practice. The Catholic Church
actively facilitated this process by erecting churches on top of
sacred shrines and temples and by employing aspects of the
native pantheistic worldview to explain concepts such as the
Holy Trinity. Elements of indigenous religion were not entirely
lost, but became cloaked in Catholic symbolism. Thus, Catho-
lic saints took on the vestiges of old gods, and certain liturgical

12. Ibid., *Maya Art and Architecture* (New York: Thames and Hudson , 1999).
13. Inga Clendinnen, *Ambivalent Conquests: Maya and Spaniard in Yucatan,
1517–1570* (New York: Cambridge University Press, 2003): 70.
14. Shinji Yamase, *History and Legend of the Colonial Maya of Guatemala*
(Lewiston, NY: Edwin Mellen Press, 2002): 180–192; Carol A. Smith, ed.,
Guatemalan Indians and the State: 1540 to 1988, ed. Carol A. Smith (Austin,
TX: University of Texas Press, 1990): 35–52.
15. Jean Molesky-Poz, *Contemporary Maya Spirituality: The Ancient Ways
Are Not Lost* (Austin, TX: University of Texas Press, 2006): 1–9.

holidays, such as All Saints Day, were celebrated with a strikingly non-Catholic gusto.

Nominally, the Catholic holidays of All Saints Day and All Souls day are celebrated in Guatemala as *Todos Santos* and *Día de los Difuntos,* respectively. These Roman Catholic liturgical holidays hold a special place in many indigenous communities across Guatemala and Mexico; however, its contemporary expression is markedly different from its Catholic origins.[16] During these days, the spirits of the dead are said to return to earth where they are welcomed by their loved ones with a feast. Families create altars in their homes and offer food and drink. The cemeteries and tombs are covered in yellow marigolds and *papel picado,* colorful tissue paper banners cut with intricate designs.

In contrast to modern-day Western attitudes of death as grim and scary, in many indigenous communities, death is understood as part of the natural process of life to be embraced with joy and humor. The Day of the Dead represents the most important holiday of the yearly cycle in many communities. In Guatemala, only the celebration of patron saints' days are observed with as much intensity, perhaps because the saints themselves are perceived as lesser deities with the power to intercede before God. In the folk Catholic traditions of many indigenous communities, the spirits of the dead are also semi-deified. The dead are venerated, and they are asked to intercede to guide the living.[17]

The contemporary manifestation of the Day of the Dead is by no means a pre-Columbian ceremony preserved intact from the sixteenth century. Instead, it is an example of the syncretism of Spanish and native cultures that took place over centuries. As Maria Solis Ajq'ij, a Maya spiritual guide, made clear to me:

> The celebration of the Day of the Dead has nothing to do with the *cosmovisión* [cosmogeny]. In the *cosmovisión,* the Day of the Dead is celebrated every twenty days, not every year like in the Catholic Church. The ancestors are with us. The celebration *Ajmaq* is the Day of the Dead—a day in which one asks for things and appreciates. When one person does a ceremony, they use candles of Cebo. They will say Juan Carlos, here is your light so that you may light your way along the road, and with this light may you guide me. Because they are with us (Interview with the author, transcript, Drachen Foundation).[18]

The sense of respect and devotion accorded to the dead in indigenous communities is potent. In homes across Guatemala, shrines to deceased loved ones are tended to throughout the year. The dead are never far from the living, and they can intercede "in all the problems of life: debts, economic problems, lack of work, lack of ability to help the community," explained Father Bascilio Chacach Tzoy, a K'iche' and Catholic priest. At these times, "one asks the intercession of one's grandparents—the dead—to help. So the dead are in communion with the community; we are able to ask them for help. First it is God, then the dead."

Indigenous communities may have adopted the custom of flying kites from Franciscan missionaries; however, their evolution into sacred objects is a part of the syncretic process of adaptation to and evasion from the overarching forces of Hispanic culture. Syncretism was a means of survival for indigenous communities. The destruction of nearly all aspects of Maya culture was in part due to the war, famine, and disease. Perhaps this is best explained in the words of Solis as she describes the contemporary traditions of her community:

> According to the tradition that we have—the tradition and the translation from grandparents to grandchildren—the tradition came after the Spanish invasion, because before there were not traditions. Before, it was a culture—the actual living Maya culture—the *Cosmovisión Maya* or Chilam Balam, the Annals of the Kaqchiqueles. The Spanish brought together all of the codices that were written and burned them. It took them four days and four nights to burn everything. Imagine how many books there must have been. There was astronomy, anatomy, sociology, and archaeology. All of this came to an end and colonialism arises. But never did our ancestors completely obey the Spanish. They continued practicing our traditions. They said, "No, we cannot lose this. This tradition is ours." (Interview with the author, transcript, Drachen Foundation).

In order to preserve their culture, the colonial Maya adopted new forms to express ancient beliefs.

Today each community has its own distinct Day of the Dead tradition. In the towns of Sacatepéquez, Guatemala, along with a few isolated villages of Juchitán, Mexico,[19] flying kites became an integral part of those festivities. Perhaps these communities sought to preserve an ancient belief in the spirit of the dead as

16. Elizabeth Charmichael and Chloe Sayer, *The Skeleton at the Feast: The Day of the Dead in Mexico* (London: British Museum Press, 1991): 14–24.

17. Charmichael, *The Skeleton at the Feast...*, 14–24.

18. Molesky-Poz explains Maya cosmovision "as marked by various types of knowledge, traditions, and institutions, [which] provides a template of movement in which human existence and the cosmos are interrelated and harmonic," *Contemporary Maya Spirituality...*, 133.

19. In the Isthmus of Tehuantepec there is a region known commonly as la Zona Huave where people fly kites to celebrate the Day of the Dead and, incredibly, to fish. Located on a arid barrier island alongside dangerous waters of the Pacific, the villagers of San Mateo del Mar and Santa Maria del Mar have developed an ingenious way of fishing with kites that allows them to catch up to 300 kilos of fish per kite! Christopher Ornelas, "Adrift en el Istmo: A Kite Journey to Juchitán," *Discourse from the End of the Line* (Drachen Foundation) 1, no. 3 (December 2008): 23–31.

butterflies, or to venerate the dead as intercessors to the gods. Kites may have been used to conceal these beliefs from a hostile society.

Furthermore, the syncretism of Spanish and Maya culture that occurred during the colonial period did not end. It continues to this day and is not limited to the Spanish/Maya dichotomy. The adaption and appropriation of imagery, from ancient Maya glyphs to Salvador Dalí paintings, are essential elements of the contemporary kite festival. The *barrileteros* use allegories and symbols to allude to hidden meanings, and to make harsh social commentary more palatable to the public eye.

The Kite Tradition in the early Twentieth Century

In the region of Sacatepéquez, the tradition of flying kites for the Day of the Dead goes back longer than anyone can remember. The tradition has been passed down for generations, from father to son. According to legend, the kites are made to scare away evil spirits. In ancient times, bad spirits, restless and wondering, would invade the cemeteries every year on November 1. They would disturb the good spirits resting in the earth, forcing them to wander about, causing havoc and dismay. After many years, the villagers became tired of this annual occurrence and asked a traveling Maya priest for his advice. The priest told the townspeople to make kites and that the sound of the wind crashing against the paper would scare away the evil spirits. The villagers took his advice, and from that year onward, kites could be seen flying over Sumpango on November 1, with their colorful *flecos* flapping in the wind.

Before the Sumpango Kite Fair began, young people flew kites not just for Day of the Dead, but also for the entire month of October and November. During these months, "the sky would be filled with kites . . . and we didn't just fly them in the cemetery," recounted Albino Quisquinay, one of the members of *K'onojel Junan*, the group that founded the kite festival, "but we flew them in the main street and all over the town."[20] The kites were comparatively small, about ten feet long, had simple geometric designs made from bold and brightly colored tissue paper (see page 33). They made two different kinds of tails, the *cola de caña,* from the dried sugar cane stalk, and the *patzunga,* from scrap pieces of cloth.

"Before the kite festival began," declared Quisquinay, "we made kites in many different shapes, including lanterns, quetzals, stars, and diamonds." The ornamentation had specific styles: blades, bedroll, *Hüipil, marimba,* and *pico.* Children either bought a kite or made it themselves, using materials fab-

ricated from local plants: *ceboyín* for glue, *maguey* fibers for string, and the sticks for the frame came from a plant fittingly called *caña de hueso* [bone-cane] or *cola de coyote.* Quisquinay also remembered the different kite-games he once played as a child:

> At that time it was also common for kids to attach special features to their kites such as a *zumbadora,* which was a piece of paper attached by string to the top of the kite. It stuck out like an antenna and made a *zum* or vibrating sound when flown. Kids invented many games to play with kites, including *Chichguate*—a game to steal someone else's kite! Kids would attach string to a few rocks and when someone else's kite came close by [they] would throw the rock, pull the kite string down, and steal the kite. In fierce battles, *navajas* [razor blades] were attached to the tails and used to attack other kites. It was great fun to try to cut someone's kite loose (Interview with the author, transcript, Drachen Foundation).

As religious objects, the kites are rich in metaphors. Some say that the kites help guide the spirits back to earth, which is why they are often flown on November 1, to guide them down, and again on November 2, to guide them back up. Sometimes, people send *telegramas,* blank telegrams, on the string of the kite up to heaven. One Maya spiritual guide explained to me that the string of the kite represents a human lifespan. This is also true in Maya *cosmovisión,* where time is often referred to as a string: "Why did David die so young? Because he had a very short string."[21]

The tradition of giant kites is not unique to Sumpango. In fact, the idea of giant kites may have originated in Santiago, Sacatepéquez, a nearby community also renowned for its annual kite festival, although this is a hotly contested matter. According to the town's elders, their kite competition began in 1899. Images of kites from Santiago in 1976 show that the Santiago kites were already highly developed by the time Sumpango began its kite competition two years later. The kites of Santiago incorporated regional textile patterns and were decorated in a range of complex geometric designs. The kites from that era appear to be between fifteen and twenty-five feet in height (see page 34). The giant kites of Santiago possibly lent inspiration to the *barrileteros* of Sumpango to start their own kite competition, but once it began, the kite festival of Sumpango developed along its own trajectory.

The Founding of the Sumpango Kite Festival

In 1976, a massive earthquake struck Guatemala. It leveled entire towns across the highlands and destroyed most of the buildings in Sumpango. In 1978, a culture and sports club known as *K'onojel Junan,* which means "everyone is equal" in

20. Albino Quisquinay, interview with the author, October 2007, transcript, Drachen Foundation.
21. For an explanation of cosmovisión see note 18; Maria Solis, interview with the author, October 2007, transcript, Drachen Foundation.

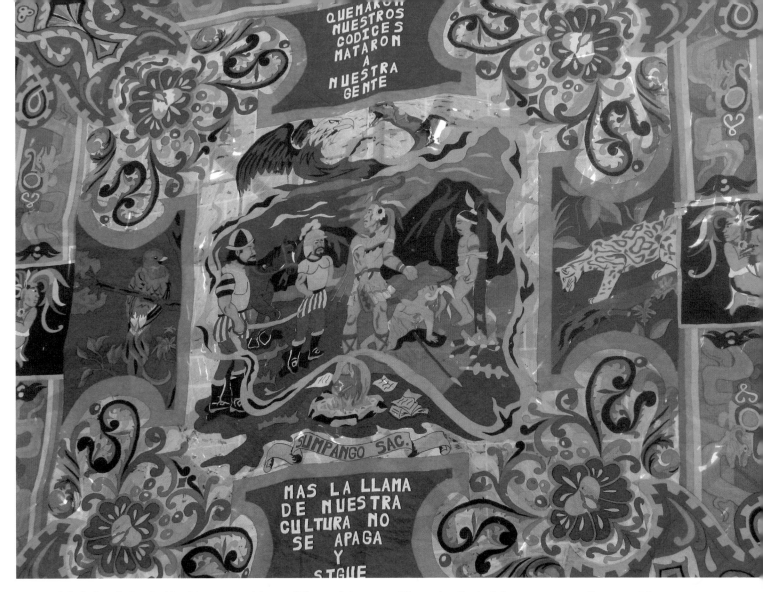

QUEMARON
NUESTROS
CODICES
MATARON
A
NUESTRA
GENTE

SUMPANGO SAC.

MAS LA LLAMA
DE NUESTRA
CULTURA NO
SE APAGA
Y
SIGUE

The epigraph on this kite by *Corazón del Cielo* reads *"Quemaron nuestros codices, mataron a nuestra gente, mas la llama de nuestra cultura no se apaga y sigue viva"* [They burned our codices, they murdered our people, but the flame of our cultures lives on].

Kaqchikel, decided to hold a kite competition to lift people's spirits in the wake of the disaster. The earthquake inadvertently gave rise to indigenous solidarity movements across the country. In order to meet the needs generated by the catastrophe, indigenous communities assumed political and social responsibilities otherwise controlled by the government. *K'onojel Junan* began as a political group organized in opposition to then mayor Lorenzo Xicón. José Santos, one of the founding members, described how it came together:

> People were very outraged by the injustices of the mayor; a lot of people went out into the streets to protest. Eventually we found a lawyer to represent us. There was something like forty people. That's where the idea to form a group began, initially to fight against the injustices of the mayor. We gave it the name *K'onojel Junan*. We wanted to bring a little bit of happiness to the pueblo. Everyone was very sad, especially after the earthquake of 1976. That is when the first kite contest began. Of course, the kites already existed, but not the contest (Interview with the author, transcript, Drachen Foundation).

Thus, the festival began as a small competition among friends. Victor Tajín, another founding member, described the events of that first year:

> We were a small group of kids. We were living during the time of the violence, and there was a lot of fear and sadness about what was happening in our country. But we didn't have any money and we didn't have support from any institution . . . we made kites of just one or two meters and flew them out in the fields. Not very many people came, but we had fun and decided to do the kite contest again the next year (Interview with the author, transcript, Drachen Foundation).

In the late 1970s, *K'onojel Junan* changed its name to *Grupo Tikal* out of concern that the former name might be mistaken for a communist organization. This was a common fear during the period. When the festival began, Guatemala was in the middle of a protracted internal war with a patchwork of left-wing insurgent guerrilla groups, loosely organized and based in the northwest highlands. Tajín makes reference to the war as *la*

violencia. Fear of communism and fear of government retaliation against suspected "subversives" was a pervasive fact of life.

Although Sumpango did not experience the kind of brutal massacres that occurred in other indigenous villages, knowledge of the violence weighed heavily on the minds of the community. By the mid-1970s, the war had dragged on for over a decade, but the most brutal chapters were yet to come. When the members of *K'onojel Junan* started making kites in 1978, they could not have foreseen the terror that was about to be unleashed across the country by a cadre of military officers intent on "resolving" the conflict once and for all.

Historical Context of the Birth of the Kite Festival

From 1960 to 1996, a brutal civil war raged in Guatemala. During this time, the Guatemalan state, with the assistance of United States military aid, battled leftist guerilla insurgents, reportedly led by Cuban-trained revolutionaries. The conflict originated as a dirty war against communism set against the backdrop of Cold War hostility between the United States and Soviet Russia. However, successive military regimes used the "war against communism" as a pretext to successfully wipe out all forms of political opposition, including labor unions, student activist groups, Catholic Action groups, and indigenous solidarity movements. The military systematically targeted people belonging to these organizations. Even those merely suspected

of aiding guerilla groups were kidnapped, tortured, and murdered. Retribution for acting against the government was swift and lethal.

The country's indigenous communities disproportionately experienced the brunt of the killing. They constitute a majority of the country with an estimated population of six million (according to a government census that historically undercounts indigenous communities—the actual figures may be higher). They largely outnumbered *criollo* or *ladino* communities since colonial times, a fact that has long provoked fears of a Maya uprising.[22] Centuries of deeply ingrained racism, coupled with military paranoia of a pan-Maya rebellion, fueled the wholesale slaughter of Maya communities.

22. *Criollo* translates to Creole and refers to individuals of Spanish descent who were born in the Americas. In colonial society, race was understood within a broad spectrum known as the *castas* or *castes*. Native born Spaniards and Creoles were the most privileged caste, followed by various degrees of mix-raced people of Native American, Spanish, and African descent. Lastly, Indigenous people were the most marginalized and impoverished of the castes. The term Ladino came into popular use after independence to refer to anyone who was not Native American and not Criollo, and is a term largely defined by cultural identity, rather than physiognomy. Many "full-blooded" Native American people identify as Ladino, rather than as Maya, thus complicating any facile assertion about the racial makeup of the country. For futher discussion of the castas, see Ilona Katzew, *Casta Painting: Images of Race in Eighteenth-century Mexico* (New Haven, CT: Yale University Press, 2004).

Guatemala Weeps and Struggles, Searching for its Peace, states this kite by *Hijos del Maiz* from 2007. This scene depicts a family returning to the scene of brutal massacre. Butchered bodies lie on the ground and a third body is hanging from a tree. The epigraph below reads "*Guatemala no ha dejado de sufrir por la cruel violence en donde perdimos nuestros seres queridos, dia tras dia*" [Guatemala continues to suffer under cruel violence, in which we lose our loved ones day after day].

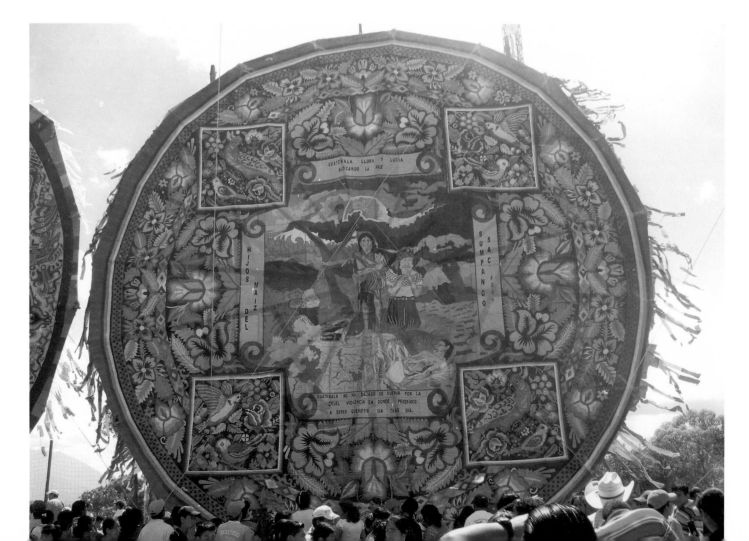

The conflict that lead to the civil war originated two decades earlier in 1954, when a military coup orchestrated by the Central Intelligence Agency overthrew the democratically elected president Jacobo Arbenz. The Arbenz government marked a rare democratic opening in Guatemala and ushered in a decade of political reforms, free elections, and economic redistribution. This came to an abrubt end when the United Fruit Company convinced the Eisenhower Administration that Arbenz constituted a "red menace" after the government had partially appropriated United's unused land holdings. Fearing the spread of communism, the United States successfully masterminded a military invasion under the leadership of Colonel Carlos Castillo Armas, ushering in four decades of military rule.[23]

This marked the beginning of a period of increased political instability in Guatemala and was later followed by a series of military coups. Despite this, U.S. military assistance continued flowing, even as "unrest over the new regime's crusade against not just the Marxist left but against much of civil society (including unions, universities, churches, peasant cooperatives, and journalists) exploded into rebellion."[24]

The insurgency had its roots in the revolutionary movements of the 1960s and was largely a coalition of student organizations, labor unions, and rebel factions of the military. These groups became radicalized, first in response to the forcible suppression of all civil opposition groups by the military dictatorship, and later by atrocities committed by the state in the early years of the conflict, including the scorched-earth campaign of 1966–1970 that killed eight thousand civilians in an effort to drive out a few hundred guerrillas.[25]

By the 1970s, the Guatemalan government stood at the point of collapse. The ranks of the insurgency swelled as government repression against reformist politicians increased, coupled with a radicalized church, a revived labor movement, and indigenous activism. The state lashed out in spectacular and brazen acts of violence. In 1978, the military murdered dozens of unarmed *Q'eqchi* peasants who were petitioning for land titles in Panzós and, in 1980, it firebombed the Spanish Embassy after students and peasants occupied the building to protest the growing hostility in the highlands.[26]

By 1980, a number of insurgent groups, consisting of the EGP, FAR, ORPA, and the PGT, had firmly established themselves in the highland regions of the country. These groups later consolidated into an umbrella organization called the National Revolutionary Union of Guatemala (URNG). The insurgency gained widespread support from the local indigenous communities in certain areas. After the insurgency had claimed a particular region, some communities blocked the highway with trees and debris to keep the military from easily returning. However, support for the URNG was far from universal, and many communities wanted nothing to do with the insurgency or the war.

In 1982, a coup brought General Efraín Rios Montt to power. An evangelical Christian and a member of a new class of modernizing officers emerging in the military, Rios Montt oversaw a new and systematic approach that sought to address the socioeconomic roots of the crisis. He envisioned a wide-reaching plan that linked national security to development and outlined specific stages, including "temporary suspension of indiscriminate urban death squad violence, improvement in the administrative functions of the government, and an anti-corruption campaign—all designed to increase the legitimacy of the state."[27] Long-term goals included political liberalization and the demilitarization of the state.

However, the goals of this new strategy—codified in a National Plan of Security and Development—were predicated on the total destruction of the insurgency. Military paranoia, compounded by deeply ingrained discrimination, conflated Indians with communists. The military suspected all indigenous communities of being communist sympathizers who supported the insurgency. Francisco Bianchi, secretary of the then de facto president, Ríos Montt, affirmed the logic underlying this plan when he declared, "The guerrillas won over many Indian collaborators, therefore the Indians were subversives, right? And how do you fight subversion? Clearly you had to kill Indians because they were collaborating with subversion."[28]

Thus a new policy was put in place in which communities and regions were identified by color based upon their presumed level of involvement with the insurgency: white for communities with no rebel influence; pink for communities with limited connections to the insurgency, in which suspected members were to be killed but the rest of the community left unharmed; red indicated total destruction—everyone was to be executed and the village razed. According to a military statement, the insurgency based its strategy on the premise that "the sea is to the fish what the population is to the guerrillas." Therefore, in order to totally wipe out the insurgency, the military first had to "drain the sea."[29] The detailed annexes and appendixes of this plan spelled out the calculated slaughter of hundreds of indigenous communities.

23. Stephen Schlesinger and Stephen Kinzer's, *Bitter Fruit: The Untold Story of the American Coup in Guatemala,* provides a ground breaking investigative analysis of the Coup.
24. Kirsten Allison Weld, "Reading the Politics of History in Guatemala's National Police Archives," PhD Thesis, Faculty of the Graduate School , Yale University (New Haven, 2010): 31.
25. The Human Rights Office of the Archdiocese of Guatemala, *Guatemala: Never Again! The Recovery of Historical Memory Project REMHI* (Maryknoll, NY: Orbis Books, 1999): 192.
26. Etelle Higonnet, ed., *Quiet Genocide: Guatemala 1981–1983,* ed. Etelle Higonnet, trans. Marcie Mersky (New Brunswick, NJ, 2009): 7.
27. Ibid. 8.
28. Higonnet, Quiet Genocide. . . , 25.
29. Human Rights Office of the Archdiocese of Guatemala, *Guatemala: Never Again!* . . . 230.

Documenting Genocide in the Truth Commission Reports

The violence of the 1980s was unprecedented in Latin America. Between 1981 and 1983, an estimated 100,000 people were murdered. During this time, the Historical Clarification Commission (CEH) documented close to 600 collective massacres, which entailed the destruction of entire villages. In many departments, close to 80 percent of the population fled their homes, and whole villages were left abandoned. The majority of the killing occurred in the indigenous communities of El Quiché and Baja Verapaz; however, it was not exclusively localized to this region. Across the country, in rural communities and in urban areas, more than 45,000 people suspected of communist subversion were disappeared and tortured; most were never heard from again and, to this day, their whereabouts remain unknown.

After the war, two complementary truth commissions, the first sponsored by the Catholic Church, known as the Recovery of Historical Memory (REMHI), and the the CEH, sponsored by the United Nations, worked in tandem to meticulously document the violence committed during the war. Together they collected thousands of testimonials and amassed huge quantities of data dating back from the beginning of the war in 1960 until the very last massacres in 1995. The reports concluded that more than 200,000 people were killed during nearly four decades of fighting. The purpose of the reports was not just to collect survivor testimonials, but also to clarify the underlying causes of the violence and to identify the institutions that were held responsible.

Accounts from the REMHI report provide evidence of the gruesome and heinous nature of the killings committed during this time:

> We went for five or six months without tasting a single tortilla. My mother and father died; their remains were left on the mountain. They hacked the children to pieces with machetes. If they found sick people, bloated with the cold, they finished them off. Sometimes they set them on fire. I feel it deep in my heart. We have been dragging the dead; we had to bury them in our flight. My mother died in Sexalaché, and my father somewhere else. The bodies were not together; they were scattered all over, lost on the mountain. When the patrol came, they hacked them apart with machetes, and some were drawn and quartered. Well, we waited until they had finished killing them, and then we went back to look for them. We found them and gave them a burial of sorts. And there were people who died that it was impossible to bury (Case 2052, Chamá, Alta Verapaz, Proyecto REMHI: Nunca Más, 16).

The CEH report identified patterns of terror employed by the military, including evidence of "multiple ferocious acts preceding, accompanying, and following the killing of victims. The assassination of children, often by beating them against the wall or by throwing them alive into graves to later be crushed by the bodies of dead adults; amputation of limbs; impaling victims; pouring gasoline on people and burning them alive; extraction of organs; removal of fetuses from pregnant women."[30] Although prohibited from naming names by the peace accords, the reports are a damning indictment of the military and of the political leadership of Guatemala in the 1980s.

The REMHI report concluded that military and paramilitary forces were responsible for 89 percent of the killings, while the CEH report concluded they were responsible for 93 percent. The CEH report framed their findings using the specific wording of the Geneva Convention's definition of genocide, arguing that by attempting to destroy an entire ethnic community, either in part or in whole, by targeting leaders of that community, and by targeting non-combatants, including women, children, the sick, and the elderly, the Guatemalan government had committed genocide against Maya indigenous communities. The CEH report underscores the claim that Guatemala is one of the most underreported cases of genocide in the world.[31]

The Evolution of Kites in Response to Violence

Over the course of three decades, the kites transformed dramatically in style and content, as kite groups responded to the effects of the war. Artistic rivalry ensued as the groups attempted to outdo one another with more compelling messages. Images reclaiming Maya identity began to appear in the early years of the festival. They featured images of ancient Maya ruins juxtaposed against contemporary traditions. In the past decade, the *barrileteros* directly addressed the war in epic narratives depicting violence, loss, and renewal. The kites also increased in size and shape. In the 1970s, they were typically not more than ten feet high; today, some kites measure close to fifty feet. The kites today are a medium of protest against a broad range of social problems. Galvanized by the injustices of the civil war, the kitemakers use kites to speak out against the discrimination of indigenous communities and the continued violence plaguing postwar Guatemala, all of which is emblazoned in tissue paper.

The evolution of images on the kites occurred incrementally over several decades. Images began to appear soon after the kite competition started in the 1978. These playful images included

30. Higonnet, *Quiet Genocide:...*, 10.
31. Ibid.

everything from butterflies and flowers to Bugs Bunny and The Smurfs. By the mid-1980s, the kites had become an expression of pride in the town's Maya ancestry. Images celebrating Maya culture gradually replaced foreign imagery. Elaborate vignettes featuring scenes of *costumbres* [customs], began to appear. These included images of weddings and baptisms alongside symbols of Maya culture, such as the quetzal or the jaguar. Later, pre-Colombian iconography began appearing on the kites. The kitemakers appropriated ancient Maya glyphs and juxtaposed images of Maya gods alongside contemporary scenes (see page 35).

In the mid-1990s, the kites bloomed into a pictorial literature with themes ranging from religion to politics. The kitemakers started refining their messages. They made kites in response to other kites. Images began to directly address the violence. Demands for a peaceful Guatemala proliferated. Some kites forcefully demanded an end to discrimination and racism against indigenous communities. Other kites adopted themes valorizing the role of women—arguably a response to the dehumanizing use of rape as a weapon by the military. Luis Herrera, one of the former kitemakers from *Gorrión Chupaflor*, argued that his group took the lead in igniting this transformation: "About ten years ago . . . the groups started doing images that had more international relevance. The group *Gorrión Chupaflor* started and then everyone else followed. Now there are political and cultural images."[32]

The idea of the kite as protest and the kite as art emerged during this period. It is debatable which group originated these ideas, but once introduced, the idea of the kite as protest swiftly

Los Happy Boy's, *Guatemala is Dying: No More Murders*, 2004. This kite depicts a family gathered in a cemetery strewn with crosses and freshly dug graves. To the right, a man who appears to be bludgeoned or shot in the face lies dying on the ground.

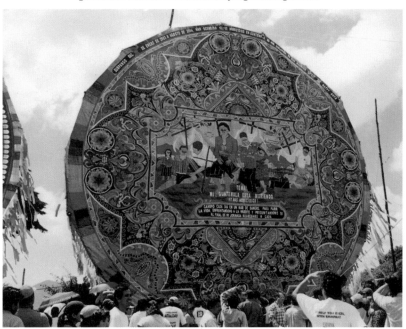

changed the way the *barrileteros* perceived their craft and their role as artists.

By the time the government and the URNG signed the Agreement on a Firm and Lasting Peace in 1996, the kite festival had reached an artistic crescendo. The images of the kites explicitly condemned violence and injustice, discrimination and inequality. The group *Gorrión Chupaflor*, among other groups including *Los Happy Boy's*, played a pivotal role in this transformation:

> When we began to work, we encountered a certain amount of rejection—not from outside but from inside the groups. They weren't completely in agreement with what we were doing. But we didn't care because art is an expression of oneself. When we began . . . it was kind of reevaluation of the kite as art. We began to experiment and began using different themes. From there, other groups appropriated the idea of the kite as art. When they began to realize this—to consider their work as art—the quality of their work began to rise. That is when the municipality began to take the contest seriously—they became conscious of the value of supporting the kites. From there, the *Comité* was formed and year by year the event became more professional. The culture began to change and the identity of Sumpango became strengthened. We began to specialize. The groups developed expertise in the use of tissue paper. All of the groups think of themselves as artists of tissue paper (*Gorrión Chupaflor*, with members of the team and the author, transcript, Drachen Foundation).

A change in the perception of the form actually changed the form, and something new began to develop. The kitemakers, while celebrating tradition in content, actually broke with tradition and began experimenting with the kite as a work of art.

The *barrileteros* invented new techniques for working in tissue paper. The images became more painterly and realistic. The visual narratives were expanded to include multiple themes. The kitemakers took on epic narratives, such as the Spanish conquest, and linked them to the contemporary struggle of indigenous communities for justice and social equality.

A 2007 kite from the group *Corazón del Cielo* showed a Maya warrior reacting in outrage as Spanish conquistadores toss Maya codices into a fire. In the background, Indian captives lay dying, while another is being burned alive (see page 39). The theme of this kite was slavery and marginalization. Mario Xicón, a member of this group, explained the subtext underlying this work:

32. Luis Herrera, Interview with the Author, transcript, Drachen Foundation.

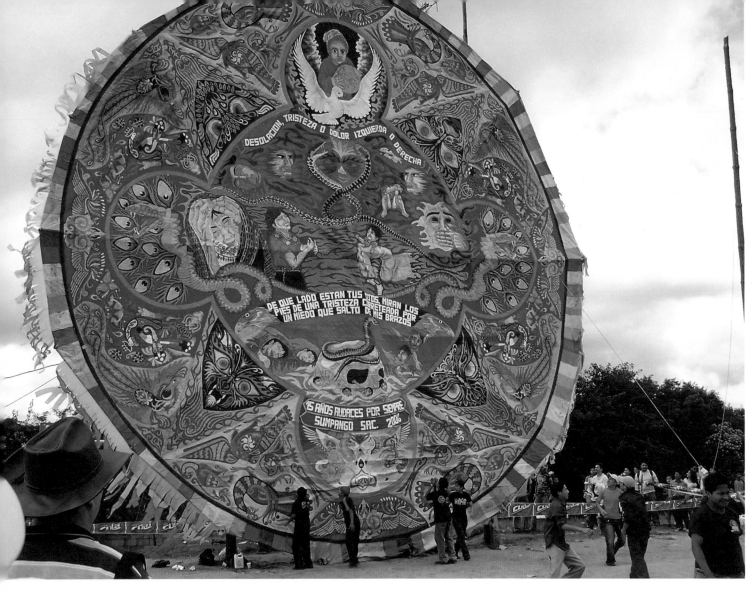

Today the government marginalizes us. They ignore us. We ask for help and it doesn't come. As *Indigenas* we have to be respected, the language has to be respected. There are certain groups of people in government who continuously want to marginalize the indigenous groups. If they go to the capital of Guatemala and talk to people on the street, if you ask them simple questions they look at you funny. They say, "You're Indian." (Interview with the author, transcript, Drachen Foundation).[33]

The theme of the conquest is popular because it addresses the roots of racism. Furthermore, the kitemakers skillfully use the conquest to introduce the narrative of genocide into the public discourse. Thus, the colonial massacre of Maya people at the hands of the Spanish becomes an allegory for understanding the contemporary violence of the war.

Initially, the *barrileteros* cloaked overtly political messages in symbolism intended to disguise their subtly dissident meanings. Even after the war, the government brutally silenced opposition organizations or individuals calling for the punishment of

war crimes. This fact was perhaps illustrated most dramatically in the blatant political assassination of Juan Gerardi, the bishop who ran the Office of Human Rights of the Archbishop of Guatemala (ODHAG) and the life force behind the REMHI project. Two days after the commission's findings were made public in April 1998, Gerardi was found brutally bludgeoned to death in his garage.[34]

Violent attacks on human rights advocates persist to this day. Unit for the Protection of Human Rights Defenders in Guatemala (UDEFEGUA), a nonprofit organization that monitors violence against human rights advocates, reported 305 attacks on human rights defenders in 2010. UDEFEGUA also reported that attacks on human rights

Internacionales Audaces. This kite depicts a horrific scene of children drowning in a sea of blood and a child being ripped from its mother's arms, 2006.

33. The term Indio, Indian, in Spanish, carries strong pejorative connotations. Most people in Sumpango consider it to be a derogatory word, and instead use the word indígena to describe people of indigenous descent.
34. Francisco Goldman, *The Art of Political Murder: Who Killed the Bishop?* (New York: Grove Press, 2007).

defenders increased by more than 500 percent between 2000 and 2010.[35] In this light, the kitemakers were initially cautious about making openly political statements in regard to human rights abuses committed during the war.

Kitemakers began to address the killings of indigenous communities during the war in the last decade, and soon after, more kites began directly depicting acts of violence. Brutal images depicting dead and butchered bodies or mass graves developed around 2004 or 2005 (see page 40). By this time, the kitemakers were in open competition with each other to see who could produce the most evocative and arresting kite. The messages of social justice were intended to push limits. The kitemakers were literally daring each other to see who would go farther, accounting for the surprising frankness and graphic nature of the imagery.

The proliferation of dead bodies did not happen because of increased political tolerance for dissent or opposition. Instead, the *barrileteros* were responding to the increasing levels of violence in the country characterized by gang warfare, urban death squads, and military campaigns against narco-trafficking. In 2007, a joint study between the United Nations and the World Bank ranked Guatemala as the third most murderous country in the world. Between 2000 and 2009, the homicide rate climbed steadily, and ultimately reached 6,400. The current murder rate is now higher than the final years of the war, and only 2 percent of crimes result in a trial of any kind.[36]

Guatemala is Dying: No More Murders bluntly declares a kite made by *Los Happy Boy's* in 2004 (see page 43). In this scene, a family sits in a cemetery strewn with crosses, on one side a man lies on his back with blood pouring profusely from his mouth, while another man wearing a Red Cross shirt attempts to save his life. Innumerable crosses indicate that this is, perhaps, the scene of a mass grave, and the caption below makes clear the precariousness of life in postwar Guatemala: *I walk every day in a sea of blood; to bear life, I confront death, while I ask myself if at the end of my journey I will return home.*

The kites of Sumpango are a passionate response to both the crimes of the war and the spiraling violence of contemporary Guatemala. Like the truth commission reports, they too are powerful tools of resistance but from a community rather than an institution. The CEH and REMHI reports were crafted within a legal framework, and their purpose was to provide an objective assessment of the scale and nature of the violence as a first step toward national reconciliation. In contrast, the kites are subjective, nontechnical, and community oriented. Instead of depicting violence from a legal perspective, they provide a gut-wrenchingly raw and personal acknowledgment that a crime has been committed by showing images of mutilated bodies accompanied by grieving loved ones. "Stop this!" they proclaim. They urge the viewer to act, to remember.

A Close Reading of a Contemporary Giant Kite

Desolation, Suffering or Pain, Right or Left, declares a kite by *Los Internacionales Audaces* (2006) above a scene depicting faces and bodies floating in a river of blood. The faces of two men stare at each other from either side of two giant snakes locked in battle, fangs bared (see page 44). Images of horror-stricken faces and a crouching man tied to puppet strings are subsumed in the carnage. At the heart of the illustration, a woman reaches out in agony as her child is stolen from her arms by an enormous hand. *No matter what side you're on, look at the sad pursuit my feet have seen for a fear that springs from my arms,* reads the statement below, as another snake appears, crowning a giant skull. The skull is partially submerged in an ocean of drowning children, frantically grasping for help as the corpses of their dead mothers lie on the ground in a pool of blood.

Through the images of this horrific and evocative scene, the *Audaces* carefully crafted a story about the war—its intent—and about the spectacle of violence. The faces of two men, disembodied, fixed in anger, and the words above referring to "right or left," allude to the ideological conflict and paranoia at the root of the war. This is further reinforced by the image of two serpents, hopelessly intertwined, representing the duality of the conflict between communism and capitalism. On the right, a disembodied arm holds the handle of marionette strings over a dejected-looking indigenous man—a symbol of the manipulation and exploitation of indigenous labor. They are all engulfed in a backdrop of blood literally depicting the hemorrhaging of society.

But the core of the kite is about the intent of the violence: the killing of women and children and, as a consequence, the destruction of the future. The images of women bleeding to death, of a woman whose child is stolen from her arms, and of children drowning are not simply portraits of victims. They are portraits of particular victims: the innocent ones. Maya men fought in the war, and others died in communal massacres, but they are not depicted here. These images are intended to provoke pity. The kitemakers are speaking not just about the presumed innocence of the victims, but also about the nature of the violence. Women and children were not casualties—they were targets. The military strategy intentionally targeted communities, families and, most important, children in a paranoid

35. La Unidad de Protección a Defensora y Defensores de Derechos Humanos (UDEFEGUA), UDEFEGUA Guatemala , 2009, http://www.udefegua .org/ (accessed March 24, 2011).
36. David Grann, "A Murder Foretold: Unravelling the ultimate political conspiracy ," *The New Yorker,* April 2011: 42–61; Weld, Reading the Politics of History . . . 192.

effort to eradicate not only "subversives," but to eliminate an entire society.

Equally important is the way in which the violence is framed. The giant skull crowned by a snake, the blood oozing from bodies, and the look of agony in the mother's face are all images of spectacle. During the war, acts of violence served a dual role: to execute enemies and to terrorize. The military turned violence into a spectacle to induce psychological torment, to humiliate victims, and to erode community relationships. The military facilitated intra-communal conflict. Boys were forcibly recruited and made to engage in massacres and executions of neighboring villages. During a massacre, the military would gather together everyone in the village and force them to watch as "subversives" were executed. The methods of killing were selected to maximize the spectacle of brutality: the military hacked people to death with machetes, gang-raped women in front of their husbands and families, and poured gasoline over the condemned to burn them alive.

The kitemakers employ images of violence, but they do not revel in blood and gore and are careful not to perpetuate the spectacle of terror. The depiction of violence on the kite, though horrific, is guarded. The violence is couched within an overarching framework of equally spectacular and mystical imagery: owls, feathered serpents, hummingbirds, and majestic Quetzals. These winged creatures, often found in Maya folk art, are perhaps guardian spirits keeping watch over the dead. These images play an important role, even though they are seemingly at odds with the serious subject matter. In effect, they hinder the depictions of violence from easily reopening psychological wounds by providing a sense of harmony amid chaos. Ordered in perfect symmetry, they soften the blow of recalling otherwise traumatic memories.

Although this kite was produced a decade after the signing of the Oslo Peace Accords in 1996, the haunting reminder of a bloodstained landscape is a sign that the painful memories of those years live fresh in the minds of Guatemalans. The horrific scenes portrayed by the *Internacionales Audaces*, far from being artistic embellishments, pale in comparison to actual survivor accounts of the genocide.

Conclusion: Remapping Memory

Many of the kites express messages about the violence of the country, poverty, egoism, and lies. These sentiments are expressed through the images shaped on paper: about the life we live in this country, about education, about human rights and the marginalization of people. Also, the life we live together, the suffering and sacrifices, just as much as the happiness.

—Mario Xicón, member of *Internacionales Audaces*

One of the biggest struggles faced by indigenous communities today is the question of memory. The *barrileteros* are in a battle over what gets to be remembered and how. The kites not only force public acknowledgment of human rights crimes, but they frame the way that history is written. As part of the peace accords, the Law of National Reconciliation granted immunity from prosecution to members of security forces and members of armed opposition groups who perpetrated deliberate and unlawful killings. However, the law recognizes "the reparation rights of victims, and exemption from criminal responsibility is not to apply in cases of forced 'disappearance', torture and genocide."[37] The right to seek justice for crimes against humanity is contingent upon the interpretation of history. Therefore, those with the power to construct history have the ability to demand justice—or obstruct it.

The question of who gets to write history should not be taken lightly. In her book *Regarding the Pain of Others,* Susan Sontag claims that "collective memory, strictly speaking, does not exist." Instead:

What is called collective memory is not remembering but stipulating: that this is important, and this is the story about how it happened, with pictures that lock the story in our minds. Ideologies create substantiating archives of images, representative images, which encapsulate common ideas of significance and trigger predictable thoughts, feelings. . . . The point of creating public repositories for these and other relics is to ensure that the crimes they depict will continue to figure into people's consciousness. This is remembering.[38]

Sontag's commentary on the purpose of archival photographs provides an appropriate analogy for understanding the imagery of the Sumpango kite festival. Archives of images not only document but also choose what gets to be remembered. Similarly, when the kitemakers create narratives about the war, racism, and social inequality, they are outlining the terms for public debate.

Tapping into the power of public discourse, the *barrileteros* initiated a dialogue about the intent of the war. Because of the Law of Reconciliation, the term *genocide* carries legal repercussions and is rarely used. The state actively denies responsibility for human rights abuses that occurred during the war, and the military continues to frame the conflict as a civil war in which both sides inflicted atrocities, even though this was resoundingly disproved by the CEH and the REMHI reports. Combined with the increase of attacks on human rights defenders, these

37. Cociliation Resources, http://www.c-r.org/our-work/accord/guatemala/chronology.php (accessed March 18, 2011).
38. Susan Sontag, Regarding the Pain of Others (New York: Farrar, Straus and Giroux, 2003): 86–87.

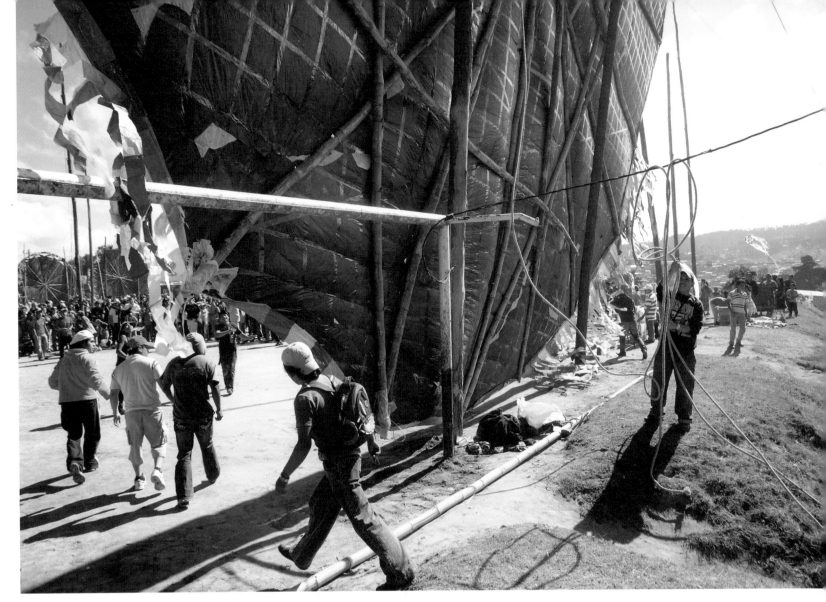

Groups gather to see their work raised for the first time. Preparations for the festival involve a massive amount of organizing and group coordination.

forces provide a serious obstacle to those who wish to remember the genocide.

Although the atrocities of the war defy facile comprehension, a narrative can help people understand. Because they are made year after year, the kites give the *barrileteros* the opportunity to continually tell new stories and to reinterpret old ones. The kites do not offer a singular consensus about the war. Instead, they provide an evolving reflection and reevaluation of what it means to be Maya in postwar Guatemala. Rather than reinforcing the narrative "of death, of failure, of victimization. They invoke the miracle of survival."[39]

EPILOGUE: The Influence of the Maya Movement on the Barrileteros

The terror inflicted by the military during the civil war had a paralyzing effect on indigenous communities across the country. The brief emergence of solidarity movements that began in

39. Sontag, *Regarding the Pain of Others. . .* , 85–88.

the 1970s came to an abrupt end. Many leaders of indigenous communities, even those spared from the massacres, were specifically targeted and disappeared. Any talk of Maya solidarity was akin to communist propaganda. The violence silenced all intercommunity dialogue and put a stranglehold on community attempts at self-empowerment. After the war, communities endeavored to regain stability and to heal from trauma inflicted by the violence.

The early 1990s marked a period of transition to a more democratic and open society, triggered in part by larger events happening around the nation and the world. The year 1992 marked the five-hundred-year anniversary of Columbus's voyage to the Americas along with a heightened awareness about the rights of indigenous peoples around the world. That year coincided with the completion of the UN draft on the Declaration on the Rights of Indigenous Peoples (submitted in 1993 but not fully adopted until 2007) and the awarding of the Nobel Peace prize to Rigoberta Menchú, Guatemala's most renowned advocate of indigenous rights. There were efforts on the part of

human rights organizations and indigenous solidarity movements to organize and reach out to the public consciousness. The anniversary provided a target date to focus their energies.

During this same period, Maya solidarity movements sprouted across Guatemala, leading to a rejuvenation and reaffirmation of Maya identity, popularly known as the Maya Movement, the Pan-Maya movement, or Maya Nationalism. Largely in response to the genocide of the 1980s, many leaders of these movements sought to promote pride in Maya identity, and they advocated unity across language and ethnic divides. The *barriletes gigantes* emerged in the context of this movement, and not coincidentally, the kites are infused with many of the movement's ideals of pan-Maya solidarity and of indigenous *revindicación* (the claim or demand for indigenous rights).

A major focus of the movement revolved around the study and preservation of Maya languages. Maya public intellectuals strongly advocated for educational reforms allowing for the study and teaching of regional languages in indigenous communities and developed new linguistic centers. The push for educational reforms was complimented by a new historical consciousness. Maya intellectuals scrutinized the ways "Mayas were written out of national history" and wrote about the "urgency to imagine new histories."[40]

Maya intellectuals placed a special emphasis on chronicles of culture, especially the history and resistance to the Spanish invasion.[41] They sought to develop a Maya nationalist identity by reaffirming links between the contemporary Maya and their pre-Columbian past.[42] "For the first time, Mayas are speaking for themselves about themselves," declared social scientist Demetrio Cojti Cuxil, "it is not that someone is speaking on our behalf, defending us, but that we ourselves are developing visions of our own identity and questioning everything, from a colonialist church to our relationship with the state."[43]

The writings of Maya public intellectuals provoked an open debate about who can claim the authority to "craft representations of ongoing social and political realities and who gains the position to represent others in public affairs."[44] Maya intellectuals sought to undermine anthropological scholarship that portrayed the hegemony of Ladino culture as inevitable.[45] Western scholars and anthropologists no longer had the privilege of speaking on behalf of the Maya, but instead had to contend with critiques of their work by Maya academics.

The movement provoked harsh criticism on the right and the left, and especially from some Latin Americanists in U.S. universities. The critics decried it as inherently separatist, with the potential to renew ethnic polarization and hostility. They also claimed that it promoted an inauthentic "Mayanness" that was politically manipulative. They argued that urban Maya intellectuals had no right to speak on behalf of rural Maya, and even constituted a third ethnicity that was neither indigenous or ladino. Journalist Mario Roberto Morales, a self-proclaimed leftist and one of the movement's strongest critics, portrayed it as fundamentalist and an "elite construction promulgated by intellectuals who do not represent the masses of impoverished "indios."[46]

Leftist intellectuals strongly criticized the movement for evading the "real" politics of Guatemala by focusing on cultural issues. They condemned it for idealizing Maya community life and for not addressing more material concerns of poverty and land reform, which should be first priority. They argued that the movement, with its focus on education, scholarship, and cultural preservation, did not have widespread appeal or effect.

The kites present an interesting twist on these arguments. They are not an example of scholarly discourse from an educated elite. Instead, they are works of art from a rural community that espouse Maya solidarity and reflect on historical consciousness. For scholars looking to understand the social ramifications of the Maya Movement, the kites provide strong evidence that the ideals of the Movement did have a lasting and potent effect on rural Maya communities. This area is ripe for further investigation.

Financing, Marketing, and Logistics of the Festival

As the festival expanded and matured, the municipality realized the need to provide institutional support to the kitemakers. The Standing Committee for the Preservation of Kites (*Comité*) was created in 1991. Its basic purpose was to organize the festival and to guarantee its continuation into the future. The *Comité* served as a kind of extension of the municipality and helped to give a small economic support to each of the groups. It also administered the competition and awarded prizes. Since this time, the *Comité* has largely guided the expansion of the festival and is responsible for most of its marketing. However, other factors including international tourism, the United Nations Educational, Scientific and Cultural Organization (UNESCO), and, more recently, the National Unity of Hope (UNE) (the political party of President Alvaro Colom), have also played an important role in determining how the festival is perceived and marketed.

40. Kay B. Warren, *Indigenous Movements and Their Critics: Pan-Maya Activism in Guatemala* (Princeton , NJ: Princeton University Press, 1998): 3–33.
41. Ibid.
42. Edward F. and R. McKenna Brown Fischer, ed., *Maya Cultural Activism in Guatemala,* ed. Edward F. and R. McKenna Brown Fischer (Austin, TX: University of Texas Press, 1996): 14.
43. Molesky-Poz, *Contemporary Maya Spirituality . . .*, 25.
44. Warren, *Indigenous Movements . . .*, 3–33.
45. Ibid.
46. For the meaning of Indio see note 32; for an understanding of the colonial racial terminology see note 22; Warren, *Indigenous Movements . . .*, 21.

The majority of financing for each kite comes from the kitemakers themselves. The estimated cost for a forty-foot kite is 44,000 to 60,000 Queztales (Q), or about $5,700–$7,800, including labor. Everyone in the group is expected to pitch in his part to cover this enormous cost. The municipality, through the *Comité*, distributes a small amount of funds to each group. The groups are divided into three categories according to size. A group in Category A, the largest size, will get about Q1,000 in support from the *Comité*. Making the kites is an extreme economic burden, and it is the biggest problem facing most of the groups.

Many people in the group are students and depend on their families for support. Groups composed of all school-age boys sometimes find patrons to help fund their kites. They send a letter to local businesses asking for donations. People with jobs are expected to pitch in a little more, but few people earn hefty paychecks. Xavier, one of the kitemakers from *Agrupación Barrileteros*, works for the municipality as a works-project assistant, where he makes Q30 per day ($4) and Q300 every two weeks ($40). The little he makes goes to help his family pay the bills, and not much is left for anything else.

In 1998, the Ministry of Culture of Guatemala declared the kites of Sumpango a National Patrimony. However, it did not go so far as to provide funding for the kitemakers or for the festival. In 2000, UNESCO declared the kites an Impermanent Cultural Patrimony of the world. That year, UNESCO published an article on the kites and the theme for the fair was a "Celebration of Peace." These declarations created a sense of validation among the municipality and the kitemakers, and they lead to broader recognition of the kite festival nationally and internationally. They also lead to a steady increase in tourism.

Today, an estimated 50,000 people attend the festival, flooding the streets of Sumpango and providing an economic boom to the local economy. The undertaking of the festival is a major task, and the *Comité*'s budget for 2007 estimated the cost of the festival at over Q175,000. The lack of government support has forced the municipality to seek private sponsorship to cover the cost of security, traffic patrols, loudspeakers, bandstands, etc. The Gallo Corporation, which has the monopoly on Guatemala's beer industry, is the largest supporter, and their banners are highly visible throughout the festival. Revenue from the event goes to support the municipality.

Tourism is an integral element of the contemporary festival, an aspect that is harshly criticized by Guatemalan journalist Mario Roberto Morales. His condemnation of the Maya Movement for the marketing of Maya culture could also be applied to the festival:

> It is clear that the market does not annul ethnic prejudice or discrimination. But what it does is to convert them into merchandise, into tourist attractions. And, thus, as fat and thin sell their humanity, considered defective, to the cinematographic market, marginal, subaltern, Indian cultures rapidly become "otherness," sold to tourism as part of the New Age wave, with its esoterics for tourists in a hurry. In this scheme, the ideological construction of Mayanism [mayanismo] is nothing more than a product for the academic funders' market, on the one hand, and, on the other, a basis for the game of democracy and for the tourist market. All of which is fine. But it should not be branded as such because if Mayanism wants to sell itself to us as superior fundamentalism, we won't buy it (*Siglo Veintiuno,* July 7, 1996).

Morales's comments of the movement as "fat and thin" and as "selling their humanity" are deeply dismissive and cynical. He sets up a false dichotomy of "authentic Maya" versus "fake Maya," in which any form of culture or scholarship supported by either the "funders market" or the "tourist market" is inherently duplicitous. By Morales's standards, all scholarship pertaining to the Maya, including this essay, would thereby be tainted by economic interests. Ironically, by not selling their work, the *barrileteros* are among the few individuals who could actually meet his twisted standard of authenticity.

Contrary to Morales's claims, the increase in tourism does not automatically "inauthenticate" the messages on the kites. Aside from its economic impact, tourism provides a larger audience for the kitemakers' message. The kites are meant to be seen, and the *barrileteros* want their messages to be heard not only by people in Sumpango, but also by people across the country and around the world. The festival serves as an open forum in which community expressions of history, political dissent, religious beliefs, and artistic creativity are valued and appreciated. The kites evolved as an open dialogue between members within the community, and between the community and the outside world. Far from promoting an image of the "timeless Maya," the festival itself is a new and experimental development in Maya culture.

The festival has also captivated the attention of international kite enthusiasts, many of whom have traveled to the festival and invited the *barrileteros* to participate in kite fairs around the world including in France, Colombia, and the United States. The fairs garnered the kites even more attention and worldwide admiration. Thus, many of the groups now preserve their kites both for their own sake and in case they are asked to exhibit them elsewhere. Wrapped in bed sheets or trash bags, they are usually stored in the home of one of the group members, perhaps underneath a bed or in a musty back room.

The kitemakers have received offers for the kites, but most of the groups are unwilling to sell. Everyone in the group owns each kite collectively, thus requiring everyone's agreement

before it could be sold. However, considering the amount of backbreaking work and sweat put into the kites, few bids could match even their production costs. The kitemakers see themselves as artists, and they are proud to show their work in fairs and exhibitions. They know the immense cultural value of their work and are hesitant to sell the kites, especially given the implications this would have to critics such as Morales.

Recent Developments in the Kite Festival

In recent years, actions on the part of the UNE, the political party of President Alvaro Colom, may pose a threat to the freedom of expression of the *barrileteros*. The UNE began sponsoring an alternate kite festival in 2009, held one week after the Day of the Dead. It has has also promoted a kitemaker association separate from the *Comité,* called *Associación Barrileteros.*

For the past three years, the Guatemalan Ministry of Culture and Sports distributed an estimated Q100,000 (approximately $13,000) in funds to support the festival in Sumpango. Reportedly, the political leaders in charge of distributing these funds directed them to the *Associación Barrileteros* for the establishment of an alternate kite festival, rather than directing them to the *Comité* or to the municipality. The alternate festival is made up of many of the same groups who participate in Sumpango's November 1 festival. Unlike the event on November 1, each group is paid an undisclosed amount for participating. The kites are on display, mostly for tourists, and there is not a second kite competition. The attendance of this festival is much smaller than for the November 1 festival.

The leadership of the alternate festival consists of individuals from both outside and inside of Sumpango who are closely linked to the UNE. In 2011, the municipality did not receive any funding from the government for the production of the November 1 festival, which cost the town an estimated Q100,000–140,000. An anonymous source from one of the kite groups claimed, "this party (the UNE) is channeling funds designated to the municipality and the *Comité* by the Ministry of Culture and Sports for the organization of the festival and is diverting it to a parallel festival that they developed on a separate date, leaving the town and *Comité* without resources, and further diminishing the small allocation given to each group."

According to this source, the creation of the alternate festival stems from political rivalry between the mayor of Sumpango and the UNE. It also appears to be a backlash against the *Comité*'s strict policy for not allowing commercial slogans or party affiliations to appear on the kites. For its part, the *Comité* attempts to remain strictly apolitical and is funded directly by the municipality. The creation of the alternate festival appears to be an attempt by the UNE to sidestep the regulations of the *Comité,* while simultaneously capitalizing on the festival and taking greater control of its message.

Other recent developments have also affected both the town and the festival. Approximately five years ago, several children reportedly disappeared from the town. They have not been found and their whereabouts are still under investigation. Following the disappearances, a lynch mob attacked and killed two individuals, a man and a woman suspected of committing the crimes. Finally, the authorities arrested ten women charged with murdering of the couple. These women are currently in prison and awaiting judicial process. The disappearances of the children and the subsequent hysteria that led to the killings sent a deep shockwave through the town. The consequences of this event had a visceral effect on the *barrileteros*.

Over the past several years, kitemakers shied away from depicting graphic imagery of corpses or bloodied bodies that were once prominently featured on the kites as late as 2007. Images from the 2010 festival reveal a focus on cultural themes. Very few groups addressed themes of social justice or included images protesting violence. These changes appear to reflect a decisive shift in tone and content away from earlier messages of social protest. Although there is no direct correlation between the mob killings and this new trend, it appears as though the *barrileteros* intentionally toned down their message in response to the sense of anxiety and paranoia felt by the town as a consequence of this event. There is a palpable fear that this may happen again.

A sense of uncertainty about the future is no doubt exacerbated by the larger political instability that is gripping the nation. The threat of violence and extortion from organized crime is now the major threat facing Sumpango and Guatemala as a whole. Extortion is increasing, although it has always been part of life in the town. No one knows who is responsible for these crimes, and no one dares to denounce them. Guatemala is now a safe haven for drug cartels escaping from Mexico and Columbia. Its defective and corrupt central goverment make it an ideal transit point from which to operate with impunity. The cartels now control large sections of the northern Petén, and recent reports indicate alliances between the Zeta cartel, one of Mexico's most notorious drug cartel's founded by defectors from the Special Forces unit of the Mexican military, and the Mara Salvatrucha (MS-13), the murderous transnational criminal gang who originated with El Salvadorian refugees in Los Angeles and has since spread across Central America and the United States.

These new developments may have the potential to significantly tone down the political tone of the kite festival. This can already be seen in the kites from 2009 to 2010. In light of the mob killings, kitemakers are perhaps more hesitant to show graphic images of dead and bloody bodies. These choices may also indicate a generational shift among the *barrileteros*. The new generation of kitemakers is more distant from the violence

of the civil war and the politics of early kitemakers. Many of the groups are now focusing on themes about the environment, but they include messages about the the importance of cultural heritage and peace. The kite groups still greatly value the artistry and imaginative possibilities of kites. With the constant threat posed by the drug war and political instability of the state, the kitemakers are perhaps turning inwards—using the art of the kite to escape the problems of everyday life. Despite the unmitigated violence plaguing contemporary Guatemala, the simple joy of kitemaking still brings hope.

The Spirit of the Kitemakers: Following Tradition and Breaking With It

When I interviewed kitemakers about why they make kites, they would inevitably respond *"Pues, es una tradición"* [well, it's a tradition]. But given the importance of tradition to the *barrileteros*, the rapid change and evolution of the *barriletes gigantes* over such a short period of time is extraordinary. The constant experimenting, tinkering, and one-upmanship that characterizes the kite competition led to a continual break with orthodoxy. Today, no theme is untouchable and no design is off-limits. The *Comité* officially prohibits a few things on the large kites, such as cartoon characters, slogans in favor of political parties, and materials other than *papel de china*. It encourages the groups to feature traditional *costumbres*, but it does not have control over what the groups design. Many groups regularly challenge the rules. The kitemakers are guided by tradition, but they are not governed by it.

The images on the kites follow in the populist spirit of mural painting. Not only does the style intentionally mimic the brushstrokes of a painting, but the kites are also designed to communicate and be read by *el pueblo,* the great mass of poor and often illiterate farmers who make up the majority of indigenous communities like Sumpango. The *barrileteros* disseminate their ideas through epic narratives, much like the great Mexican muralists of the twentieth century. The popular readability of the kites does not dilute their message; instead it makes them more potent. Drawing upon familiar stories and symbols, the *barrileteros* provide an astonishingly acute summation of history, while simultaneously denouncing the social ills facing Guatemalan society. They communicate in a visual language that does not require words in order to be read.

If the kites were not so easily destroyed, they would be highly sought after by art collectors and museums around the world. But the beauty of the kites is that they cannot be fully appreciated inside of a museum. They are a living art form brought to life by the wind. The roar of the audience and the glow of *papel de china*, bathed in sunlight, are elements of drama that cease to exist once the kites are preserved in the artificial light of a museum. To prolong that life in an airtight glass case would be like embalming a corpse. Instead, the kites are an ephemeral art, intended to live for only a day.

Many *barrileteros* cited *convivencia* [living together], as the second most important reason as to why they make kites. The kitemakers enjoy working together in a group, and accomplishing something as a group. The kites give the boys time *para fragar* —to play and hang out with friends. Strong social bonds are created during those frantic days working on the kites. Some *barrileteros* even describe kitemaking as a spiritual release:

> People ask, well how much did you get paid? How much earnings did you get? But we have learned that the earning is spiritual—it is our internal equilibrium. We work eight hours during the day to make money. At night I get to work in a completely different situation on something more delicate and with more finesse. I am an auto mechanic. I think my spiritual equilibrium is found at night. There are no other spaces to be creative (*Gorrión Chupaflor,* with members of the team and the author, transcript, Drachen Foundation).

A new community ethos arose out of kitemaking. During the day most *barrileteros* work, or have family obligations and other responsibilities to attend to—making kites is the one time they are free to be creative. The night is special for the *barrileteros*. It is the time when they start their day. As one kitemaker from *Gorrión Chupaflor* told me, while others are asleep and dreaming, they are busy at work. But the *barrileteros* are "dreaming too—only awake," creating! The night signifies the life that they live together. It is a world in which they are free to imagine and live out their dreams on the sails of a kite.

Bibliography

30th International Congress of Human Sciences in Asia and North Africa. *Asia and Colonial Latin America.* Edited by Ernesto de la Torre. Mexico City: El Colegio de Mexico, 1981.

Beutelspacher, Carlos. *Las Mariposas entre los Antiguos Mexicanos.* Mexico City: Fondo de Cultura Económica, 1988.

Carmack, Robert M., ed. *Harvest of Violence: The Maya Indians and the Guatemalan Crisis.* Norman, OK: University of Oklahoma Press, 1988.

Charmichael, Elizabeth, and Chloe Sayer. *The Skeleton at the Feast: The Day of the Dead in Mexico.* London: British Museum Press, 1991.

Christensen, Bodil. *Brujerías y papel precolombino.* México: Ediciones Euroamericanas, 1972.

Clendinnen, Inga. *Ambivalent Conquests: Maya and Spaniard in Yucatan, 1517–1570.* New York: Cambridge University Press, 2003.

Conciliation Resources. http://www.c-r.org/our-work/accord/guatemala/chronology.php (accessed March 18, 2011).

Diaz Castillo, Roberto. *Artes y artesanías populares de Sacatepéquez.* Guatemala , Centroamérica: Editorial Unversitaria , 1976.

Figueroa, Celso A. Lara. "The Ancestors in San Agustin Sumpango, Life and Gigantic Kites: In Search for the Roots of Peace." By Culture Project of Peace in Guatemala/ UNESCO. Cooperación Italia, 2000.

Fischer, Edward F. and R. McKenna Brown, ed. *Maya Cultural Activism in Guatemala.* Austin, TX: University of Texas Press, 1996.

Gage, Thomas, and Authur Percival Newton. *The English-American: a new survery of the West Indies, 1648.* Guatemala City: El Patio, 1946.

Garciagodoy, Juanita. *A Reading of Mexico's Días de muertos.* Niwot, Colorado: University Press of Colorado, 1998.

Goldman, Francisco. *The Art of Political Murder: Who Killed the Bishop?* New York: Grove Press, 2007.

Grann, David. "A Murder Foretold: Unravelling the ultimate political conspiracy." The New Yorker, April 2011: 42–61.

Hart, Clive. *Kites: An Historical Survey.* Mount Vernon, NY: Paul P. Appel, 1982.

Higonnet, Etelle, ed. *Quiet Genocide: Guatemala 1981–1983.* Translated by Marcie Mersky. New Brunswick, NJ, 2009.

Hoepker, Thomas. *Return of the Maya; Guatemala—A Tale of Survival.* New York: Henry Holt and Company, 1998.

Katzew, Ilona. *Casta Painting: Images of Race in Eighteenth-century Mexico.* New Haven, CT: Yale University Press, 2004.

La Unidad de Protección a Defensora y Defensores de Derechos Humanos (UDEFEGUA). UDEFEGUA Guatemala. 2009. http://www.udefegua.org/ (accessed March 24, 2011).

Lenz, Hanz. *Mexican Indian Paper; its history and survival.* Translated by H. Murray Campbell. México: Editorial Libros de México, 1961.

Lovell, George. *A Beauty That Hurts: Life and Death in Guatemala.* Austin , TX: University of Texas Press, 2010.

Miller, Mary Ellen. *Maya Art and Architecture.* New York: Thames and Hudson, 1999.

——. *The Art of Mesoamerica.* New York: Thames & Hudson Inc., 2001.

Molesky-Poz, Jean. *Contemporary Maya Spirituality: The Ancient Ways Are Not Lost.* Austin, TX: University of Texas Press, 2006.

Montellano, Ortíz de, and R. Bernard. "Counting Skulls: Comment on the Aztec Cannibalism Theory of Harner-Herris." *American Anthropologist,* no. 85 (1983): 403–406.

Nutini, Hugo G. *Todos Santos in Rural Tlaxcala: A Syncretic, Expressive, and Symbolic Analysis of the Cult of the Dead.* Princeton, NJ: Princeton University Press, 1988.

Ornelas, Christohper. "Adrift in el Istmo: A Kite Journey to Juchitán." *Discourse from the End of the Line* (Drachen Foundation) 1, no. 3 (December 2008): 23–31.

Sahagún, Bernardino de. *Florentine Codex: Genearal History of the Things of New Spain.* Translated by Aurthur J.O. Anderson and Charles Dibble. Vol. 1. 13 vols. Santa Fe; Salt Lake City: School of American Research; University of Utah, 1950–1982.

Sandstrom, Alan R., and Pamela Effrein Sandstrom. *Traditional Papermaking and Paper Cult Figures of Mexico.* Norman, OK: University of Oklahoma Press, 1986.

Schlesinger, Stephen, and Stephen Kinzer. *Bitter Fruit: The Untold Story of the American Coup in Guatemala.* Garden City, NY: Doubleday & Company, Inc. , 1982.

Smith, Carol A., ed. *Guatemalan Indians and the State: 1540 to 1988.* Austin, TX: University of Texas Press, 1990.

Sontag, Susan. *Regarding the Pain of Others.* New York: Farrar, Straus and Giroux, 2003.

The Human Rights Office of the Archdiocese of Guatemala. *Guatemala: Never Again!* The Recovery of Historical Memory Project REMHI. Maryknoll, NY: Orbis Books, 1999.

Warren, Kay B. *Indigenous Movements and Their Critics: Pan-Maya Activism in Guatemala.* Princeton, NJ: Princeton University Press, 1998.

Weld, Kirsten Allison. "Reading the Politics of History in Guatemala's National Police Archives." PhD Thesis, Faculty of the Graduate School, Yale University, New Haven, 2010.

Yamase, Shinji. *History and Legend of the Colonial Maya of Guatemala.* Lewiston, NY: Edwin Mellen Press, 2002.

THE GIANT KITES
OF SUMPANGO

VICTORINO TEJAXÚN ALQUIJAY

Introduction

In every family, the departure of loved ones from this earthly life leaves behind an essential absence. Each year on November 1 and 2 in the local cemetery in the town of Sumpango, this absence becomes vitally important, as the families gather with their deceased through memories and rituals.

The aroma of incense wafts around the colorful flowers as prayers rise, asking for the eternal rest and peace of the deceased souls and for their good example to continue guiding the growth of family life along a positive course. Each family carries out these rituals in their own way; collectively, they are a reflection of a communitywide respect for the memory of the dead and the path walked during their earthly life.

The *barriletes gigantes* enter into the picture as part of the ancestral devotion with which each gravesite is decorated on these days, as a means of communication with the ancestors in the Maya cosmogony.

According to traditional legend, the sound produced by the wind hitting the *papel de china* is essential to maintain the peacefulness of the graveyard for the rest of their loved ones who lie there during the feast days declared by the Catholic Church.

It is an expression seeped in religious syncretism. The kite becomes the vehicle of expression of combined Maya cosmogeny and Catholicism. The unresolved analytical explanations lead us to this syncretism as the foundation for many cultural practices prevalent in the contemporary communities of Mesoamerica.

Examining these Giant Kites of Sumpango from an artistic perspective connects us to their anthropological and sociological surroundings, since the majority of the town's residents turn out for the performance of this cultural expression.

Traditionally inherited as a playful game, this cultural expression, after being organized as a festival, acquires new values generated by the very population and led by those directly responsible for manufacturing the kites.

In this essay on the art of the Sumpango kites, we review the pre-Hispanic history of the town from the first indications of the human presence in the area, to the arrival of Spaniards in the territory of Guatemala. We will spend some time on the etymological origins of the name of Sumpango and the changes or alterations resulting from its being written down. We will then look at the possible explanations for the presence of the kites and their relationship with the culture of the community. Then, we will look at the details of the Festival's origin and the reasons for its organization, entering into a discussion of the development and evolution of the kites from artistic and cultural points of view, attempting to understand the essence of the changes brought about by several important people and groups during the 1978 celebration of the Festival.

We will analyze the content of the messages and look at the contemporary proposals for the structure of *la armazón* [frame], while heeding that the kitemakers' knowledge regarding use of materials in the creation of the majestic kites allows the town of Sumpango to set an international standard of contemporary national art and culture.

I would like to express my deep appreciation for the support and openness of all those individuals and groups who made gathering this information possible and who contributed several of the images from previous years to accompany this text.

Victorino Tejaxún Alquijay
Tzumpango Sacatepéquez [Súmpango]
Lajuj Toj [March 31, 2010]

Sumpango: Historical Information about its Origins

Sumpango is a town in the central *departamento,* or state, of Sacatepéquez, located twenty-six and one-half miles from the capital city of the Republic of Guatemala, almost fifteen miles from the state capital of Sacatepéquez, Antigua, Guatemala, and seven and one-half miles from the state capital of

Left: A family decorates the grave of a deceased family member, garnished with pine leaves and colorful flowers, celebrating the Day of the Dead on November first.

Right: Families gather in the local cemetery to honor their dead.

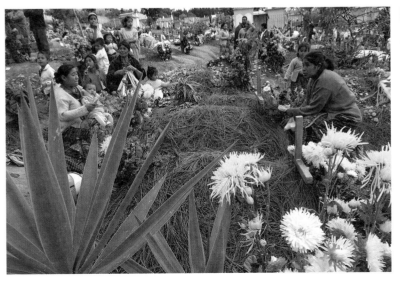

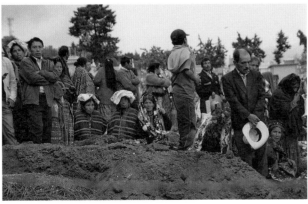

Chimaltenango. More than 90 percent of its population is of Maya Kaqchikel ancestry. The town has easy access to three urban centers, which facilitates commercial and cultural exchange in the population, a characteristic that makes Sumpango an important town in the rural areas of Guatemala.

Sumpango is a town with pre-Hispanic origins and, according to the information gathered by the National Kaqchikel Survey in 1990 and other archeological information, it was part of the region of towns made up of *Los Chojomá,* derived from the Kaqchikel word *Chahón,* translated into Spanish as *roza* [clearing] or *limpia de matorrales* [removal of brush]. Located in the eastern region of the Kaqchikel territory (currently the Kaqchikel territory spans the states of Sacatepéquez, Chimaltenango, Sololá, and several towns from the states of Escuintla and Suchitepéquez in the central region of the republic of Guatemala), it was known during the Spanish colonial period as the town of Sacatepéquez (from the Nahuatl word *zacatle,* meaning "grassy place") during the Terminal Post–Classic Maya period (1300 CE). This region is currently comprised of the towns of San Martín Jilotepeque, San Juan, San Pedro, San Lucas, and Santiago Sacatepéquez.

The towns of Chojomá were rivals of the towns of Iximché, according to a quote by Barbara E. Borg to Carmack in *Historia General de Guatemala, Volume 1 1999,* "During the Terminal Post-Classic period, the Chojomá region was alternately dominated by those of Iximché and in rebellion against them." During the expansion and domination of those from Iximché, "The Chojomá were the last to be subjugated shortly before the conquest" (E. Borg, 1999). In further studies into the presence of people in the territory of Sumpango, archeologists found evidence from the Early Pre-Classic (800 BCE) and later periods prior to the arrival of the Spanish conquistadors (*Final Report from the Kaqchikel Archeological Survey,* pp. 15–19 CIRMA 1990).

As is mentioned by Fuentes y Guzmán in *La recordación florida,* Sumpango was one of the first towns conquered by the Spanish during the subjugation of the Iximché. The arrival of Dominican priests to the town to convert the population was recorded both in the Kaqchikel language and in Spanish (*Final Report from the Kaqchikel Archeological Survey,* pp. 15–19 CIRMA 1990).

During the subjugation of the towns by the *encomienda* [the legal system used to regulate native labor], Sumpango was handed over to Francisco Castellos; from 1549 until 1551 the property of the town was jointly held by the crown and Juan Álvarez and, beginning in 1551, it was a town "of the crown" paying tribute directly to the Spanish kings. The total tribute recorded in 1561 was 464 individuals paying and 89 exempt (elderly, injured, widows, sacristans) who paid their tribute with local products: corn, wheat, chickens and Indian servants;

these servants asked to be exchanged for twenty bunches of cocoa (*Kaqchikel Archeological Survey,* CIRMA 1990).

In regards to its etymological origin, there are different stories depending on the particular linguistic, anthropological, or historical criteria emphasized.

The Tzompantli

Derived from the Nahuatl word given by the natives of the Mexican towns that made up the army of Pedro de Alvarado during the invasion and conquest of Iximché, the word *Tzompakco* means "*Place of the Tzompantli.*" These were the racks used by priests for arranging human skulls and offering them to the gods (Arriola 1973: 563–567).

The Tzompantli is an altar of Aztec origin probably brought by the Nahuatls and Olmecas during the pre-Hispanic period; it represents "the most obvious manifestation of the political and religious control exerted by the Aztecs." The presence of these structures inside the ceremonial grounds was evidence of their importance from a religious point of view, but also of the subjugation of the other groups (*Matos Moctezuma,* pp. 124, 2000).[1]

According to its linguistic etymology from Kaqchikel, Sumpango means "Place below the Stomach" or "Leather Stomach" and is derived from the terms *Tz'um,* which means "leather" and *Pen* or *Pan,* meaning "stomach."

1. Matos Moctezuma mentions the Tzompantli altars as definite altars or place of skulls: "generally they are decorated with skulls or crossbones," "these structures must have greatly impressed the Spanish." These descriptions were extracted from the texts written by the authors of chronicles during the conquest of Mexico.

These altars were made of human skulls in the shape of a hanger, typically found in cities and ceremonial centers; these were skulls of enemy warriors killed in combat or sacrificed, dedicated to *Mixcoatl,* in the festival of *panquetzalistli,* in the festival of *tlacaxipehualitzli* in honor of the god Yacatecuhtli, as discovered in Aztec cities. Nevertheless, archeological findings also provide evidence of the Tzompantli in Maya cities like those at Chichen Itzá, located "inside the central plaza, to the east of the ball court" (Matos Moctezuma 2000).

Matos also refers to "the presence of the tzompantli in the Florentine Codex associating it directly with the structure of the Ball Game, also relating it with the Popol Vuh in the game-Tzompantli-decapitation; when one of the (divine) brothers is decapitated after losing to the lords of the underworld and his skull is placed in the center of the Ball Court." Archeological studies affirm that the discovery was of Toltec origin, during the time when they dominated Chichen Itzá.

By making this analogical relationship with the name of Sumpango, it is noted that the communities of Chojomá were rivals of their counterparts in Iximché from the Terminal Post-Classic Period to the arrival of the Spanish: "the Sacatepéquez placed allies on their borders, with the goal of protecting themselves from Iximché; in this way, they established fortresses around San Juan, San Pedro, Santiago, San Lucas Sacatepéquez and Sumpango." They also established a free trade zone called Boq'o or Chimaltenango (W. Borge, 1999), which allowed the Tzompantli to be exchanged between the two hostile groups and perhaps allowed for their construction and the role of this altar as a religious element of subjugation or a means to delimit territory between both regions.

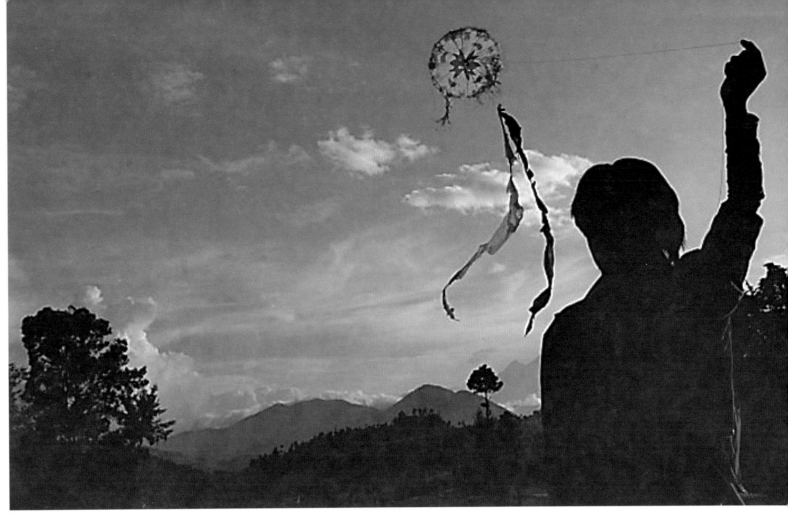

"Marvin" raises his kite during an October afternoon in 2010 at the cemetery at Sumpango Sacatepéquez.

As we research Maya Cosmology, we find that the word *Tz'um* consists of a transitional stage after death, to transcend to a new cycle in which the energy of *Keme'* intervenes to make this stage possible; however, when the family of the deceased mourns their death for a long time, the pain turns into a lethargy which prevents the transition from life to death, causing the deceased to suffer for a time (*Tavico,* p. 7, 2005).

Sumpango was recognized as a town when the political constitution of the State of Guatemala was enacted on October 11, 1825. This law stipulated that the territory would be divided into eleven districts for the administration of justice: thus Sacatepéquez belongs to the eighth district and Sumpango falls within the circuit called San Juan (Ajq'ij Gilberto Guarcax, interview 2010*)*.

Indications of the Presence of the Kite in Sumpango

To date, exact recorded references of the kites have not been found. Their existence at the end of the nineteenth century is mentioned within the oral tradition, and several sources from the last few decades mention the presence of the kite on the continent during the Spanish colonization: "The kite came to Mexico during the Spanish Colonial Period (1521–1810). The Chinese and the Greeks claim to have invented it" (*Zavala y Alonzo, CONACULTA.* Museo de Arte Popular México DF, 2011).

Despite being the object of further study, the exact date of the creation of the *Kite of Santiago Sacatepéquez* has not been able to be identified; 1940 is only mentioned as the approximate date of its creation and development according to Roberto Díaz Castillo in his study "Popular Arts and Crafts of Sacatepéquez" in the magazine *Folklore y Artes Populares* at the Center for Folklore Studies at the University of San Carlos in Guatemala in 1976.

As part of this study, a series of interviews were conducted with Sumpango elders, indivuals who in their own lives had spent time making the kites during their childhood and adolescence and who knew other facts because of information they had received orally from their elders.

Born in 1914 and working in the town as *Primer Regidor* [First Councilman] in 1963, Ceferino Acual Chiquitó remarks how his father Ciriaco Acual made him his first kites when he was five years old. According to the conversation he had been able to have with his father, Don Ciriaco had also been involved in this tradition since his own childhood.

Another one of those interviewed, Samuel Ixtín (1963) explains that his grandfather Pedro Cajbón (deceased in 1977 at 81 years old) was the one who passed on the tradition and the reasons for making the kites to him. In the same period, another one of the interviewees Gonzalo Xicón (1953) comments that

his grandfather Fidel Xicón, who was born in 1900, was already making the kites at thirteen years of age. When he asked him about the origin of the kites, he provided no specific information, just the remark that when he was growing up they were already making kites.

The current president of the Standing Committee for the *Barriletes Gigantes* in the municipality, Federico Cristóbal Carranza Sosa (1961) tells the story of the arrival of his great-grandfather Don Federico Carranza Monroy (unknown date of birth) to the town. In 1887, he was contracted by the local Catholic Church as a cabinetmaker and woodcarver for the construction of a cross with the image of the Nazarene in the Parish, and he was the one who began to make the kites for the entertainment of his children. This information is confirmed also by the stories of Austreberta Leonor Carranza (1935), daughter of Don Gerardo Carranza Hernández (1905–1978), who was the son of Don Federico Carranza Monrroy, who recalls that his father made the kites with a paper known as *cellophane*.

The interviewees are in agreement that during the first two decades of the twentieth century, the majority of the population made the kites as a family and as entertainment. These kites were flown in public spaces recognized by the majority of the population as spaces for children's games. Due to the geographic characteristic of the town, flying the kites was quite easy:

> All of my friends, we'd get together and we'd make kites and then we'd fly them in front of the calvary land. There was another spot on the straight street where the Coj family lived. The Coj's were in zone two, and in zone four where Don Buenaventura Meléndez lived there was a wide street. Another place was also by the cross (Ceferino Acual, interview 2010).

According to the town's traditions, the places mentioned by Don Ceferino were spaces for children and young people to get together and play, but today these places do not have the same meaning and some are recognized now with different names: *Avenida Del Niño* and *La Alameda*.

Similarly as with Don Ceferino, the information passed down by Don Pablo Cajbón and Fidel Xicón to their grandchildren confirms that the only ones to commercialize the kites were the Carranza family; this fact was also confirmed by Austreberta Carranza, granddaughter of Don Federico Carranza Monrroy. She remembered how they distributed the kites after taking orders from the towns of Chimaltenango, Mixco, Técpan, San Lucas and Santiago Sacatepéquez.

Due to the large number of orders received by Austreberta's father, Don Gerardo Carranza Hernández, he spent almost the entire year preparing the materials to have them ready by November 1: "There were times when we could not keep up with the demand. The children waited in line with their parents until we finished them so they could take them away immediately." (*Austreberta Carranza*, interview 2010).

On this point, Don Ceferino stresses that his father would only buy his kite when he did not have time to make it himself. Gonzalo Xicón and another one of the interviewees, Eustaquio Acual (1953), son of Don Ceferino Acual, mentioned this same situation. These two experienced the same things when their fathers didn't have the time to make the kites for them.

In regards to the size of the kites at the beginning of the twentieth century, Don Ceferino remembers that the largest ones were almost five feet across; Gonzalo Xicón remembers hearing a similar figure from his grandfather Don Fidel. Don Ceferino also mentions that he was building his own kites until he was eighteen years old, along with friends and neighbors of his generation (1932).

After this point in time alluded to by the interviewee, it could not be confirmed what happened to the kite during the 1940s and part of the 1950s; we can simply suppose that the tradition continued on with similar characteristics and under similar circumstances until the 1960s and 1970s. During these years, which are remembered more clearly, the majority of the families would fly their kites in the yards of their houses during the months of October and November. The younger people would get together in the street, at traditional sites and at the local cemetery to fly them and play with them as a recreational activity for group entertainment.

This entertainment consisted of a series of games around the kite; one that stands out the most was the *q'olis* or *cololiso*, which consisted of attempting to bring down one kite with the other by maneuvering the string used for flying it. Another game was the *Paseo de Barrilete* [Kite Walk]; after lifting off their kites from one of the traditionally recognized points in the town, the groups or individuals would head over to the local cemetery, crossing through the streets, no matter the difficulty of flying above and around the buildings. The young men would use these walks also as a way of getting the attention of young women in the town, as a kind of competition for their affection by passing close to the homes of the young women they fancied (Eustaquio Acual interview 2010).

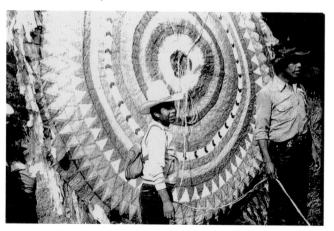

Unknown barrileteros at Sumpango, Sacatepéquez.

About the Meaning of the Kites and their Relationship with the Day of the Dead on the Liturgical Calendar of the Catholic Church

The *Comité Permanente de Barriletes Gigantes* [Standing Committee for Giant Kites] explains the origins of the tradition by means of a legend.

After sharing this information with several of the interviewees, this story was unfamiliar to them; nevertheless, they refer to some other similar topics mentioned in the legend.

In the legend, the origin of the kites is posited to be the result of the observations and suggestions provided by elders after being consulted: the intention was to create sounds through the collision of the wind with the *papel de china* in order to frighten away evil spirits from the cemetery and the streets of the town on November 1.

Two of the interviewees mention a story from the oral tradition passed down to them by their elders: The kite was used as a means to unite and communicate with the spirits of the deceased during All Saints Day and All Souls Day, in line with the celebration of the liturgical calendar of the Catholic Church.

When Don Ceferino was asked about this, he said he did not know about that sort of relationship nor had he heard about any belief like that, but he did mention another similar belief. Mothers would call out to their children when the kites were being lifted off for them to return home before 6:00 p.m., because after that time the spirits of the deceased would emerge to wander the streets of the town. A similar anecdote was passed down from Don Fidel to his grandson Gonzalo Xicón.

A kitemaker for more than thirty-three consecutive years, Bernabé Herrera (1953) remembers the conversations he had with his grandfather Don Marcelino Jutzuy (unknown date of birth). According to him, "The kites served as a way to unite and foster communication between families and their deceased loved ones during the Day of the Dead. The people of Sumpango would visit the gravesite of their late family members, taking them food, *ayote* [hard squash], *jocote* [fruit], and drinks. The edges of the graves were decorated with a fringe made of *papel de china*," which he credits as the origin of the kites.

Nonetheless, Samuel Ixtín shares a different anecdote about his grandfather Don Pedro Cajbón, who had another intention in mind while passing on the tradition of kitemaking. His grandfather emphasized the point that only men were permitted to fly the kites, because they functioned as a courting competition to acquire a *patoja* [girlfriend]. For this reason, the kite was used to get the attention of the woman who the men fancied, flying them close to the house of the young woman and thus winning over her heart.

In that conversation between Ixtín and his grandfather, Don Pedro used the Kaqchikel term for kite, *palot*, which is derived from the Nahuatl root *papálotl*, meaning "butterfly."

Along the same lines, his grandfather also mentioned the relationship it has with death: "At the moment a person passes away, their spirit is transformed into a butterfly to be able to lift up to the heavens. After positioning itself against the light of the sun's rays, it brings out its coloring." This indicates a relationship between the kites and the Day of the Dead.

Within the cosmovision of the Maya culture, life revolves in cycles. One of these is the existence of human beings only to later transcend to another level, remaining in limbo "and the dead warriors descend to earth in the form of a butterfly or hummingbird" (Paul Arnold, *El libro maya de los muertos, Mexico*, 1988).

If we remain within the Maya Cosmovision, it is especially important to note that Gilberto Guarcax, *Ajq'ij Kaqchikel*, explains "El Tx'um" as a transitional phase from life into death interpreted through the *Popol Vuh*, as one of the nine stages in the passage through the underworld of Xibalbá to face death and thus achieve transcendence.

In this sense, for the Maya, death is the passage from one stage to another, of reunion and purification with the assistance of the divine energies of the cosmos, waiting to pass from the form of a hummingbird or butterfly to a new womb and continue on with their cycle and function.

Paul Arnold elucidates this relationship through an analysis of the codices and other Maya texts that survived the book-burning pires of the priests during the colonial period, from the conception of life as a cycle and not as a straight line with an end. In addition, he describes how a practice of this type of veneration and respect for the dead surprised the Iberians during the invasion and subsequent conquest of the peoples of Mesoamerica.

This story from the oral traditions transmitted by the interviewees accounts for these features and their possible derivation from this conception of the kites in Mesoamerican communities, possibly as an act of resistance rooted in their own cultural cosmovision and later transformed into the religious syncretism that prevails in many cultural expressions of these communities to the present day.

The people interviewed also emphasize the value of the *barrilete* as entertainment during the months of October and November, when strong winds blow through the region and the rain season diminishes in strength.

This is the season when the majority of families and the population in general dedicate their time to making and flying kites from the yards of their homes. The kites are built with materials that depend on the conditions and economic potential of each family, *papel de china*, manila paper, bits of plastic or newspaper.

When they mention the kites as an entertainment activity, the interviewees—Gonzalo Xicón, Don Ceferino, Eustaquio

Acual—remember the different traditional games practiced in the town during the different seasons of the year in accordance with the Catholic Church's calendar of celebrations: for Holy Week: *La Cera* [beeswax], for Corpus Christi: *El Trompo* [spinning top], for the Christmas festivities: *Los Piloyes* [a type of bean that comes in different colors], and for All Saints' Day and the Day of the Dead: *Los Barriletes*.

Several of these traditional games are no longer practiced by the children and other young people, while others like *El Trompo* have survived, but are not necessarily played in the season when they would have traditionally been played. In this regard, the kites have a transcendent value and greater relevance for the population.

The Beginning of an Artistic Expression

On February 4, 1976, a powerful earthquake registering 7.5 points on Richter scale shook the territory of Guatemala. Sumpango's infrastructure was completely destroyed, leaving behind more than 240 people dead, a natural phenomenon that had a negative impact on the people of Sumpango.

According to the individuals interviewed, the rebuilding process was quite slow and painful, plunging the town into a period of poverty more extreme than anything they had experienced in their lives and powerfully affecting all cultural life in the municipality.

The tradition of the *barriletes* was effected, decreasing the number of people making kites and flying them between 1976 and 1977. During those first years of reconstruction, a group of young professionals, former students of an indigenous institute located in the state capital of La Antigua, Guatemala, began to organize a group with the goal of bringing together indigenous and nonindigenous youth in the municipality.

The group was born in 1978 with the Kaqchikel name *K'onojel Junan: Todos Juntos, Todos Iguales* [Everyone Together, Everyone Equal]. The organization promoted a series of cultural activities aiming to re-energize the population and shepherd them out of the stage of grief caused by the earthquake in 1976. As part of that series of activities, the organization of a "kite contest" was proposed in order to preserve the tradition; the location where it would be held was set to be the Town Field.

One of the leaders of the group from that period, Juan Cay Ixtamalic, remembers when they released the call for the first contest, directly inviting young people recognized in the town as traditional kitemakers, with the intent to encourage other people to participate. According to the estimation of Cay, the result of that first year (1978) was good in terms of interest shown by the young people and the number of participants in the first contest.

For the organization of this first experience, it was necessary to regulate the event, taking into consideration five aspects for scoring: a) Size, b) Coloring, c) Message, d) Non-traditional forms, and e) Height.

During the first two years, the participants constructed kites that were approximately six and one-half feet in diameter, and the designs presented were traditional and well known by the entire population, based on very simple geometric designs known by names like *Estrella* [Star], *Bolita* [Ball], *Cuchilla* [Blade], *Petate* [Bedroll], *Faja* [Sash], and *Hüipil* [A traditional blouse worn by Maya women]. The participants made their kites in their own individual name, with the support of groups of friends or family members who made their construction possible.

From Folklore to Art

In order to approach and analyze the evolution of the kite as an artistic expression, it is vital to grasp the real meaning and concepts behind a number of general terms related to art in order to understand and establish criteria for why it acquires value as such. This is necessary not to give a lesson to the reader, but rather to situate him or her and all those knowledgeable about the arts. With this information and specific awareness they come to value the work and to consider the practices of conceptualization developed over the years of organizing the festival.

The majority of cultural expressions of the rural populations of Guatemala, especially those of Maya descent, are considered and catalogued as *folklore* and *craft*, within the framework and preconceptions about rural populations and their culture and art. These terms designate their work as being for the entertainment and consumption of national and international tourists, separating this work from the concepts of Art in general or *Arte Culto* [Highbrow Art] for the consumption of certain social strata.

Taking these considerations into account, we situate the kite within the expressions of the *Popular Arts*, using the concept developed by Roberto Díaz Castillo, a researcher with the *Centro de Estudios Folklóricos* [Center for Folklore Studies] at the Universidad de San Carlos de Guatemala in 1979 when he conceptualized culture "not as an abstract entity, but rather the sum of all knowledge transmitted from one generation to another; collective memory; the social inheritance that make it

Catholic Church destroyed by the earthquake that affected the town of Sumpango in 1975.

possible to integrate members of the community, instilling its norms of behavior, values, wisdom and skills, the synthesis of the material and spiritual values of a particular society within the organizing frame of national self-awareness; the social character, the personality of each community; likewise, it should be understood that culture expresses the particular historical experience of each community and embodies its results: it constitutes its specific character, its collective personality."

We should consider the concept fashioned in 1846 by William Thoms; he used the word folklore to refer to all social activity, the result of popular wisdom like myths, legends and more. Using the terms of Raúl A. Cortázar, quoted by Ofelia Columba Déleon, "An event is folkloric if it is collective in the community. It doesn't matter if these events are practiced only by one individual; the important thing is that they are accepted by the community and incorporated into its life and the functional and empirical tradition of an anonymous author" (*Revista Tradiciones de Guatemala Centro de Estudios Folklóricos usac* 1987).

When the organization of the festival began as a contest, the framework of folklorism was emphasized and utilized by the very organizers to score the kites in regards to their *theme*, automatically defining the kite in this category of folklore or craft.

But it differs from and distances itself from these concepts when the kites are identified with the name of their creators. At the same time, they continue to consciously develop and define the content of the message, and, in regards to composition, it requires more and more attention, without becoming a serial production or a copy of previous models. It is an accumulation of experience and knowledge as a space for the education of individuals and the organized groups to implement them, faced with the challenges presented by new forms of design, composition, manipulation of the *papel de china* and designing the message.

In addition, kitemaking distances itself from craftwork since the fabrication process is not based on the production of multiples or mass commercialization. In addition, the participation of the creators is not defined as remunerated or salaried work, or with financial gain as a goal.

We see that qualities and characteristics developed around the kite, taking into consideration the statement of Carvalho-Neto that, "When the creator and the actor are the same person, the event is not folkloric," as quoted by Ofelia Columba Déleon in the *Revista Tradiciones de Guatemala* in 1987.

The Design

Looking at the designs from the first years of the Kite Festival, these were made in traditional, established forms and constructed by the majority of the population, based on simple geometric drawings identified with specific names, commonly used in the everyday language of the town.

Of primary importance for the participants was the issue of *size*, which became increasingly significant as a principle for competition as the years passed and the sizes constantly grew.

The designs initially were very basic: "The first years, the drawings were very simple," remembers Enrique Toribio, one of those interviewed and also founder of *K'onojel Junan*, the group behind the festival.

Each person on their own moved to add their own particular elements, as it had been during the years prior to 1976, when the young people would gather in the streets and traditional public spaces, where each person would show their work, highlighting the particular features of their kite.

"Felipe Burrión was one of the famous kitemakers, he made them in a special way and all of us would wait for him to arrive to marvel at his work," remembers Eustaquio Acual, referring to the kites in the 1970s.

The promotional work carried out by the organizers stirred up greater interest from the participants and the people of the town more generally. When a much broader audience arrived from outside of the local area, it motivated the participants to develop and build new design ideas that moved away from the traditional ones.

In the past, separate images were incorporated into the overall design of the kites, but this has changed; now groups view the entire kite as one design from the beginning—bringing importance to the design as a "means of expression."

Left: The first participants in the first kite contest with basic geometric designs held on November 1, 1979.

Right: Kite with basic geometric designs and drawings submitted in the contest of 1982 kites.

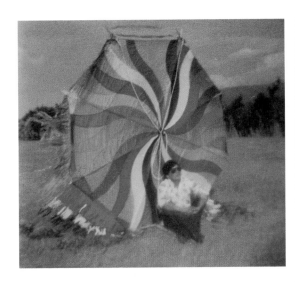

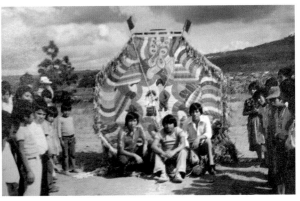

In order to achieve these designs and their composition, the main drawing is done on a paper known as "manila," using it as a pattern to transform and color later with the *papel de china* strip by strip, color by color to give it shape and life. The paper is placed in only one layer and is supplemented by pictorial elements like a marker or a pen to outline and to create a certain feeling of volume in the drawings, since they are very simple pictures based on empirical work.

Samuel Ixtín, Napoleón Burrión (deceased), and Bernabé Herrera are three of the first individuals to undertake these new projects, but Herrera also incorporates relief drawing into his work, which was no larger than six and one-half feet in diameter, a kite size which was maintained during the first five years of the 1980s.

In this sense, the *papel de china* is essential as it acquired a new value and dimension which each group began to discover through experimentation: the qualities and possibilities presented by the paper, especially when faced with the limited variety of colors and quality present in the market. In essence, these artists found new intensities and shades through the combination of the different colors, all of which buttresses the intention of the messages on each kite.

In 1986, the group *Happy Boy's*, which had emerged as an organization in 1983 largely comprised of adolescents between the ages of twelve and fifteen, built a kite that was almost twenty feet in diameter; their work showed innovation in aspects of composition and design, emphasizing the intensity of the color tones.

This new color palette was achieved by using the strips of paper in two or three layers; these characteristics of their work were shown prominently during the period between 1986 and the end of the 1990s. This group developed the composition to the greatest extent, by combining the *central message with the decorations* in a complete package and using the *papel de china* in new, creative ways.

At the same time, the composition is innovative in that it combines the *drawing* or *central theme* with the decorative elements, an integration complemented by the harmony of the colors and the intensity achieved through the use of the paper strips in two or more layers, which additionally provides increased support and strength to the entire kite structure.

The composition is normally designed by taking the *geometric drawing* as the main foundation with a trim around the edges and separated by repetitive, minutely detailed designs, harmoniously combining a variety of colors.

Samuel Ixtín also develops the composition; nevertheless, the concern for the intensity of colors was still too basic as he continued to use the pieces of paper in only one layer.

In order to make these displays, each group or individual person had the assistance of between five and ten members between the ages of twelve and twenty years old, who played different roles depending on the skills possessed by each one of them: the designer, the one in charge of drawing and coloring; everyone working together to build the kite.

The application of this new form of construction and composition was also developed by *Gorrión Chupaflor* [Sparrow Hummingbird], a group that emerged in 1986 and focused in their own work on developing the *central message* from a new point of view beginning in 1990.

During the 1990s, this point was developed even further, a necessary step to improve the quality of the technique; they worked on the *message* and the *composition* jointly with the intention of moving towards *realist art* on each kite with the exclusive use of *papel de china*.

Size and the Raising of the Kites into the Air

On another note, raising the kites into the air begins to present difficulties for everyone due to the dimensions reached: both the size of the kite and the weight of the physical structure of the *armazón* [the kite frame].

Left: Samuel Ixtín with his kite *Tecum Uman*, Indian national hero, 1982.

Center: *Hombres de Maíz* presented by *Happy Boy's* in 1984.

Right: In 1986, Happy Boy's their barrilete to *Los Pitufos* [Smurfs].

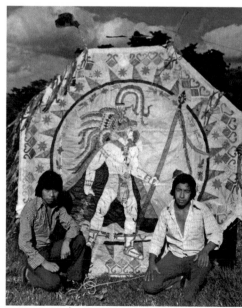

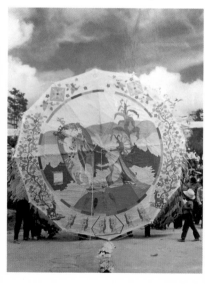

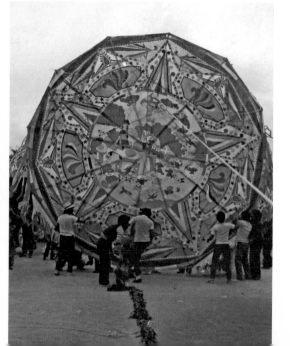

Between 1986 and 1990, the majority of participants reached a maximum of thirty-six feet in diameter. With these dimensions, it became increasingly difficult to attempt to fly the kites, particularly due to the risk of physical safety on the public and the wear and tear on the kites. At the same time, considering the value of the work invested in each kite, in 1989 an accord was reached among the participants not to continue flying those kites larger than twenty-six feet in diameter in order to protect the artworks and so that the public could move closer to the kites in order to appreciate them further. After considering the experience of the groups, this decision was supported by the organizers of the festival.

In this period, additional organized groups begin to participate in the festival, among them prominent groups like *Corazón Juvenil* [Young Heart] and *Internacionales Audaces* [Audacious Internationals]; as one of their first challenges, these groups proposed to increase the size of the kite, fifty feet being the largest one recorded to date.

Nevertheless, faced with the difficulty and the risks that this size implied for the festival, there was a tacit agreement reached that the most appropriate and advantageous size for the kite was approximately forty-two feet long.

The Physical Structure of the Kite

As long as anyone can remember, the material used for the construction of the physical structure of the kites has been a bush growing wild in the local forests, which is known by the name of *cola de coyote* [coyote tail] and is currently in the process of extinction.

In previous decades, this bush was found easily and reached a size of almost five feet around; as Don Ceferino Acual (1914) remembers, this was the approximate size of the kites he would build.

Due to the near-extinction of this bush and the gradual increase in the size of the kites, it was necessary to incorporate the *caña de castilla* or *caña veral* (*Arundo donax*) [Spanish cane, wild cane] and bamboo (*Phyllostochys bambusoides*). Due to their size (often as long as twenty feet), these plants provided increased possibilities and enabled kites to be built at the sizes seen to date.

In the oral tradition shared in the individual interviews, the most common frames have been the hexagon and the octagon made with three or four canes each. Only in sporadic instances have there been different designs known as *payasito* [little clown], *zopilote* [vulture], and *farol* [streetlamp]; these physical structures are always built using the cane varieties *caña de castilla* or *caña veral*, attempting to form a human figure in the case of the *payasito*, a bird in the case of the *zopilote*, and the *farol* is a kind of kite in the shape of a box, like a replica of an electric streetlamp.

On occasion, some other individuals have worked to construct other, more difficult shapes, like airplanes, quetzals, etc. These structures were attained through the use of the same materials: *papel de china* and wild cane or bamboo in small sizes; in recent years at the festival, some people have entered designs with similar structures but now in larger dimensions.

The flat frame has been the common element, without any further significance beyond the concern and care necessary to have on hand the bamboo or the wild cane on the day of the festival. Normally, this cane is acquired and transported from the southern coast of the country.

In 2002, *Gorrión Chupaflor* built a kite in the form of a streetlamp that was more than twenty-six feet tall using PVC piping, with the intent to surpass the size of the traditional kites, all the while conserving the style in the use and application of the *papel de china*.

Nevertheless, within the *Happy Boy's* group a series of tests were undertaken with structures different from the traditional flat ones; in 2006, they presented a kite with an undulating

Left: Samuel Ixtín presents "la Boda en Sumpango" (the Sumpango Wedding) contest in 1984.

Right: Bernabe Herrera's barrilete "El Baile del Torito."

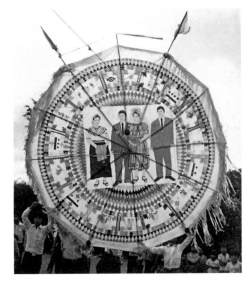
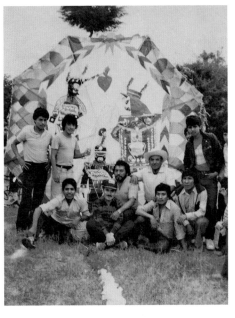

outline, innovating and promoting a new shape for the kite outside of the circular polygon.

This project once presented in the festival lead other participants to alter their designs and to begin to develop new shapes for the outline of the kite, unlike the traditional circular structures. Several of them started using information technology as an additional tool for the design of these new structures.

According to Carlos Xoquic, one of things that helped to popularize these new shapes was the fact that the changes gave life, movement and voice to the kite with the use of well-known materials: the *papel de china*, the wild cane or bamboo. Xoquic states, "For us, the thing is learning, working beyond what is traditional and responding to the demand to evolve and re-create ourselves as artists." According to Xoquic, this process of discussion and education took five years to culminate in its first phase in 2007 when they presented a new structure that radically broke away from the circular polygon of previous work. The intention of its creators was to make three kites of twenty-five feet each that would function as a fan to transport them to the location of the festival, with open spaces in a lattice form and with diamond-shaped outlines or flags.

With this structural model, different groups develop and experiment with new forms of their own design, turning the kites in some case, into a kind of artistic installation by combining complementary elements related to the kite and *papel de china*, while others played with the construction of volume as a feature of figurative art.

Roberto Cabrera, a painter and a leading authority on visual arts, says of these structures in an interview, "With architectural aspects specific to the kites of Sumpango, if the use of traditional materials in their construction is neglected, they would cease to be a specific cultural expression and become a type of expression that could be developed in any part of the world."

The Message: Soul of the Kite

Due to its content and development during the three decades of the Festival of Sumpango, the message in recent years has become a fundamental element of many of the presented works, due to the process that each group undertakes in order to define itself.

In an examination of the topics raised during the 1980s, they seem to evoke heroes from Maya culture during the Spanish conquest of Guatemala, ornamental drawings, and traditional pictures: weddings, baptisms, and the social life of the indigenous communities. Classified as a kind of *costumbrismo* [regional traditionalism], these kites attempted to emphasize and transmit the traditions of Sumpango and Guatemala as established in the specific rule related to the message. Samuel Ixtín, Bernabé Herrera, the Xicón family, Napoleón Burrión and the *Happy Boy's* stand out in this regard.

In 1990, the group *Gorrión Chupaflor* presents a message in their work, titled *Conciencia de Nuestra Identidad* [Conscience of Our Identity]. In three main scenes, they developed the vindication of the values of indigenous identity. They completely changed the relationship with subject matter prevalent throughout the history of the kites.

In subsequent years, the same *Gorrión Chupaflor* group tackles the topics *500 Years* (1991) related to the commemoration of 500 years of the invasion of the American continent by the Spanish; *Pop Wuj* (a kite from 1992) in commemoration of the International Year of Indigenous Peoples declared by the United Nations; *Return* (1993) as a sign of welcome for the Guatemalan refugees on their way back from Mexico after being persecuted and forced into exile there during the internal armed conflict at the beginning of the 1980s.

Several other organizations also began to put similar or related themes into their work, having to do with the contemporary history of the country. Though the creators are not known, another was made to commemorate the awarding of the Nobel Peace Prize to Rigoberta Menchú Tum, an activist for the rights of indigenous peoples. In the following years, both Samuel Ixtín and the group *Herencia Maya* took on themes related to Maya identity and culture in their work.

Many of the kites between 1995 and 1998 also deal with the negotiations that put an end to the internal armed conflict in Guatemala.

From that period until more recent years, the majority of the messages have revolved around the demands for recognition of Maya culture and identity or the period of violence and insecurity that Guatemalan society generally is living through today,

Left: Bamboo canes.

Right: Bamboo canes for the physical structure of the frame, 2000.

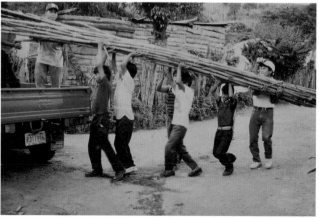

often providing evidence of the cruelty of deaths caused by the violence. With equal vigor, the kites have taken on the topic of environmental destruction, combined with elements particular to the Maya cosmovision.

Since its emergence as a group in 2001, the *Cerbataneros* [Blowgunners] have developed and successfully integrated graphic elements and composition based on the values of the Maya cosmovision in each of the kites they have presented until now, and always on a large scale.

At the same moment in 2003, *Corazón Maya* [Maya Heart] featured scenes that highlighted the religious syncretism of Maya and Catholic traditions in their work.

Independently, Henry Felipe and his fellow kitemakers developed themes related to the environment and Maya cosmovision in his work, like the kite presented in 2007 titled *Vida y muerte* [Life and Death], dramatizing the death of a princess and the removal of her soul by *El Tukur*, messenger from the underworld.

By dealing with themes related to history and identity, the content of the kites makes them even more valuable as a means of expression. As is the case with artistic work, they invite reflection and discussion with the public and thus transcend from a playful or contemplative festival into an opportunity for exchange and reflection with the spectator.

For Juan Cay, the festival organizer in its first years, the soul of the kites is found in these important elements because, "It's not just color, and it's not just *papel de china*. When the groups do research, looking in documents and books for the content of their message, it invites reflection and increased awareness, thus constituting the authentic philosophy of the kites."

By tackling issues of this type, the different participants begin to define the essence of the message collectively through analysis, discussion and initial proposals in order to reach a consensus later on a final topic.

Creation of Collective Art

For years, the creation and construction of kites has been a space for growth and learning where people involved have spontaneously developed a rhythm organically out of the need to know and to learn.

From an anthropological or sociological perspective, these discussion circles that developed in the process of creating the central message and physical structures of the kites have given rise to a process of knowledge generation and social evolution within the different groups, by appropriating the kite as a means of expression.

But like other traditions both inherited and emergent during the colonial period, they were imposed as a mechanism of domination and control. These traditions passed through periods of assimilation, adopting new values derived from the cosmovisions and customs of the dominated group, creating spaces and means of resistance against that very imposition.

These practices gradually were transformed into religious syncretism, as is the case with many traditions in Mesoamerican cultures, related to Catholicism and local cosmovisions of this region of the continent.

In this sense, the discussion and analysis generated through the construction of the kites established the principles of a cultural and artistic movement belonging to the town itself. They appropriated the kite, not as a traditional event, but rather as a means of expression with the capacity to induce change in their surroundings.

These changes also established parameters for a certain level of organization for the protection and promotion of their work as a collective and intervened in community-wide, social decision-making. This generated changes on the level of subjective awareness and organizational structure as far as it involved a large number of official institutions and other groups for its organization and development.

This cultural and artistic movement began with the kite as an instrument for self-recognition and self-appreciation, distancing it from a folkloric activity or craftwork. The scenes presented are designed using images that reclaim their own culture and consciousness in order to display them widely; this is in addition to the insistence on mastering the essential resource, the *papel de china*.

Left: Kite by the group *Palot, Espanta Espiritus*, 2009.

Right: *Guardian del Tiempo*, by *Gorrión Chupaflor*, 2004.

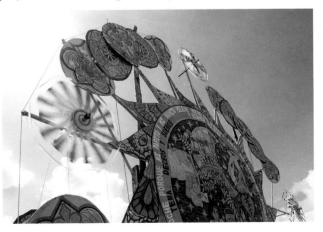

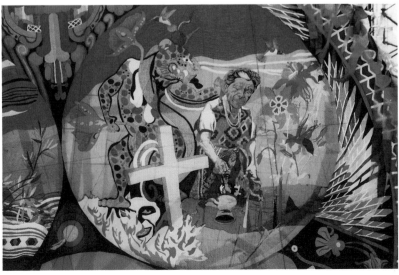

This Gallery of Kites includes more than twenty years of Sumpango artistry. Earlier kites, without paper backing, are easily identified, but the artistic sophistication of all comes through clearly: detailed backgrounds, realistic depictions of human and floral forms, and startling themes reflecting life and death in Guatemala.

1. *Corazón Maya*, 2008.

2. *Happy Boy's*, 2006.

3. *Gorrión Chupaflor*, 1987.

4. *Farol*, 2002.

5. *Happy Boy's*, 2007.

6. *Happy Boy's*, 1986.

7. *Nimalaj Balam*, 2007.

8. *Pop Wuj*, 1992.

9. *La Paz*, 1996.

10. *Sueños de paz*, 1997.

11. *Henry Felipe Xicón*, 2006.

12. *Grupo Cerbataneros*, 2009.

13. *Corazón Maya*, 2009.

14. *Herencia Maya*, 1999.

15. *Gorrión Chupaflor*, 1990.

16. *Nim Kachi'il*, 2007.

17. *Protección del ambiente, Gorrión Chupaflor*.

18. Kitemakers unknown, 2003.

19. *Herencia Maya*, 1999.

20. Kitemakers unknown, 2003.

21. Detail of the kite *Sumpango en feria*.

22. Barrilete of the group *Herencia Maya*.

23. *Happy Boy's*, 2007.

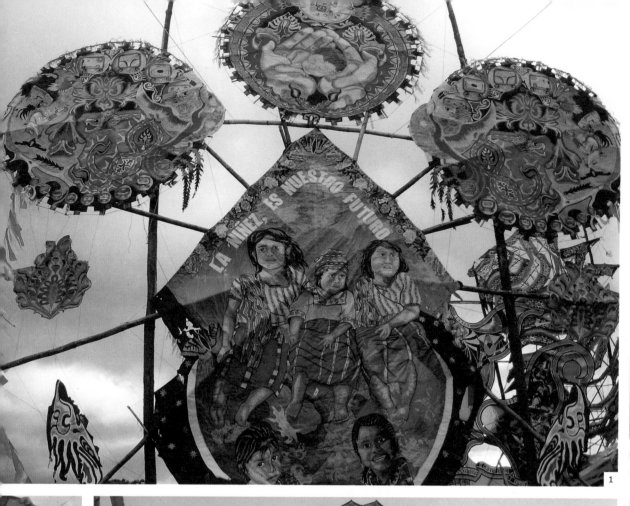

1

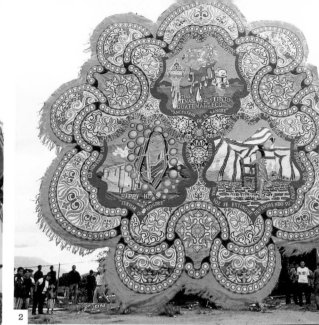

2

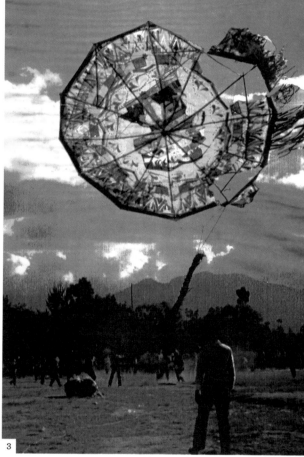

3

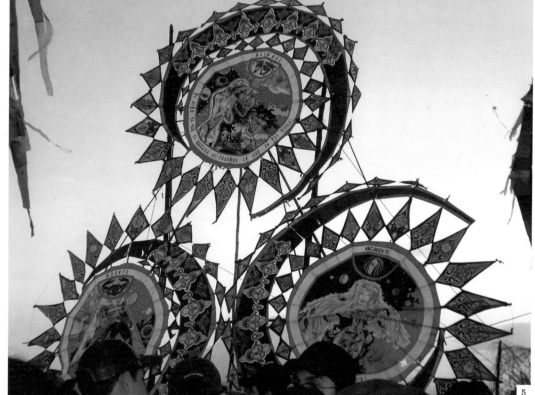

5

4

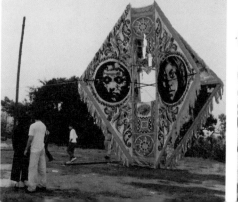

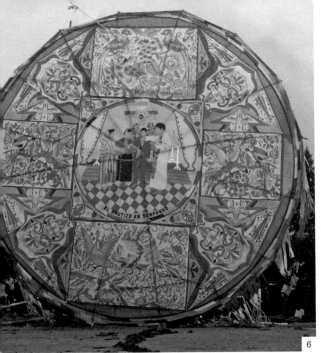

6

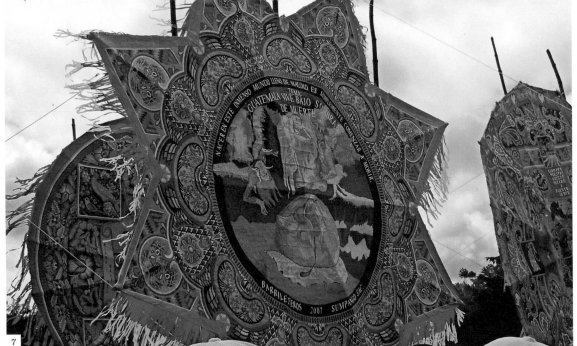

7

15

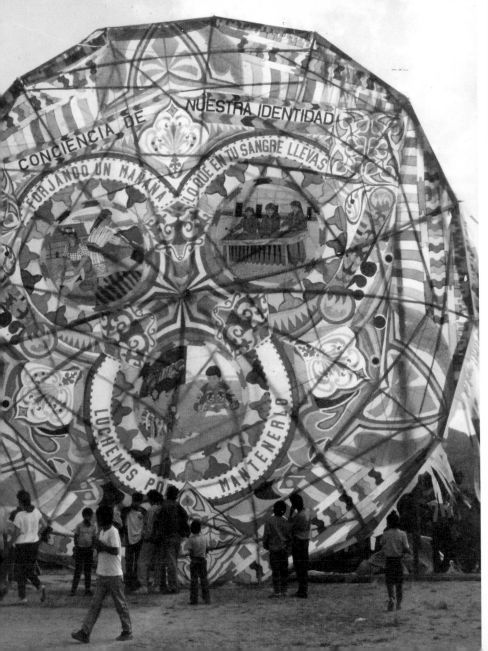

CONCIENCIA DE NUESTRA IDENTIDAD

FORJANDO UN MAÑANA LO QUE EN TU SANGRE LLEVAS

LUCHEMOS POR MANTENERLO

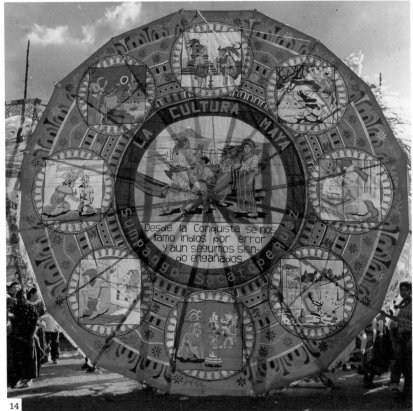

14

LA CULTURA MAYA

Sumpango, Sacatepéquez

Desde la Conquista se nos llamo indios por error y aun seguimos siendo engañados

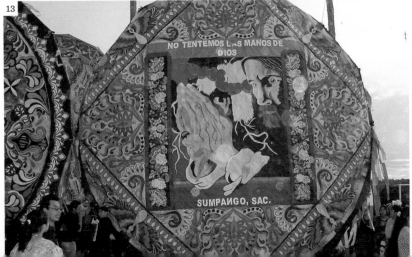

13

NO TENTEMOS LAS MANOS DE DIOS

SUMPANGO, SAC.

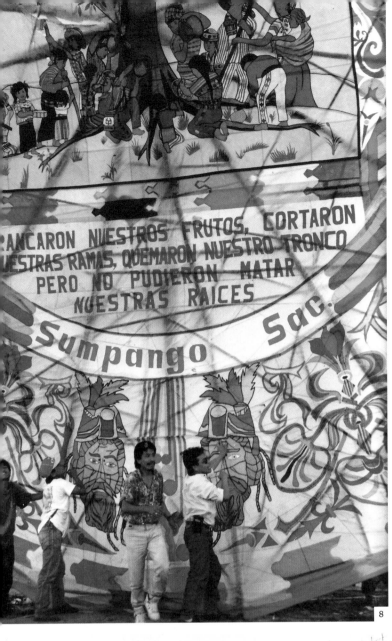

ANCARON NUESTROS FRUTOS, CORTARON
UESTRAS RAMAS, QUEMARON NUESTRO TRONCO
PERO NO PUDIERON MATAR
NUESTRAS RAICES

Sumpango Sac.

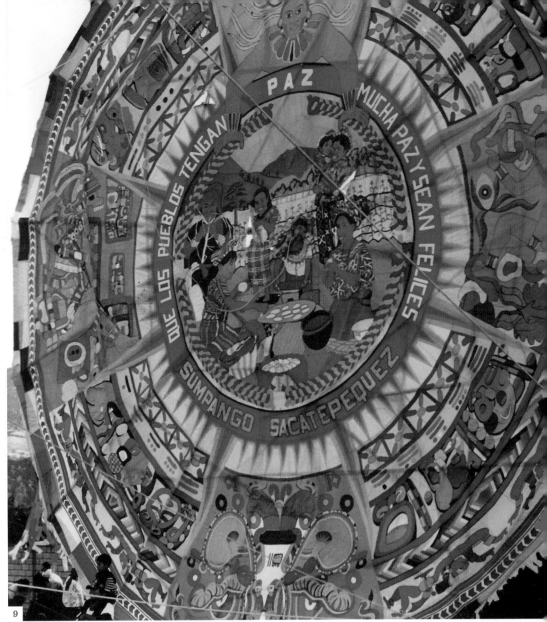

PAZ

QUE LOS PUEBLOS TENGAN MUCHA PAZ Y SEAN FELICES

SUMPANGO SACATEPEQUEZ

8 9

12 10

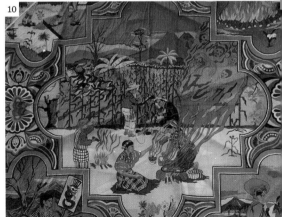

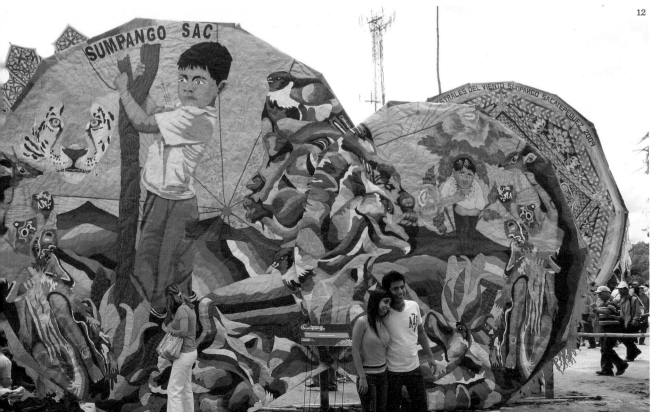

SUMPANGO SAC

STRALES DEL VIENTO SUMPANGO SACATEPEQUEZ 2009

11

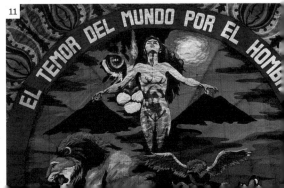

EL TEMOR DEL MUNDO POR EL HOMB

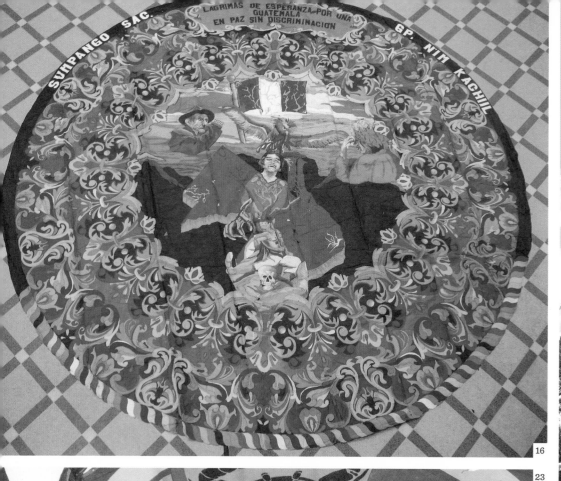

16

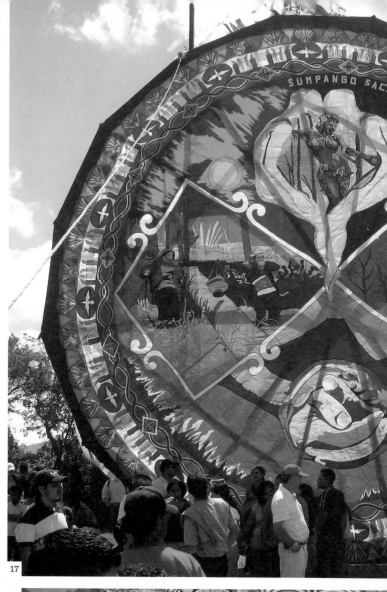

17

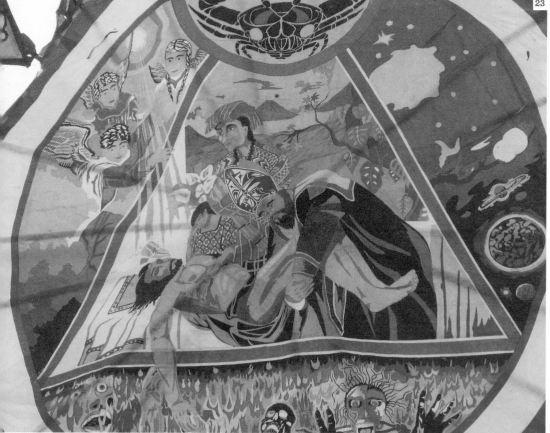

23

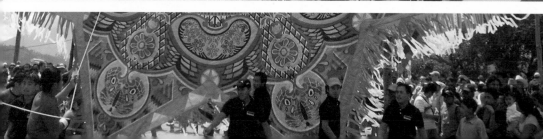

22

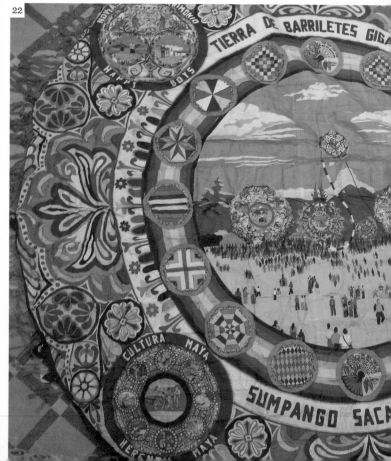

18

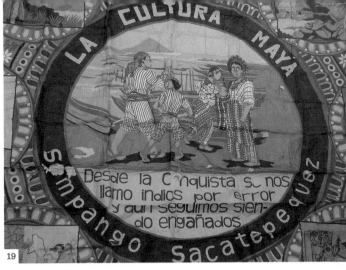

LA CULTURA MAYA

Desde la Conquista se nos llamo indios por error y aun seguimos sien-do engañados

Sampango Sacatepequez

19

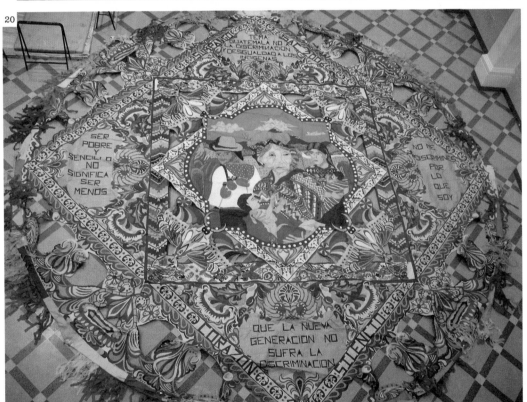

20

TEMA GUATEMALA NO A LA DISCRIMINACION DESIGUALDAD A LOS INDIGENAS

SER POBRE SENCILLO NO SIGNIFICA SER MENOS

NO ME DISCRIMINES POR LO QUE SOY

QUE LA NUEVA GENERACION NO SUFRA LA DISCRIMINACION

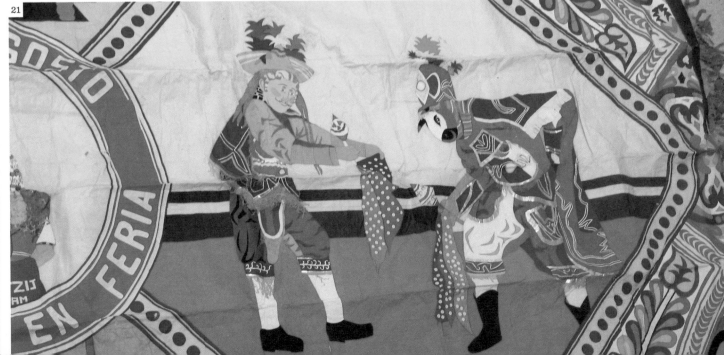

21

During the creation of the central message and the search for a holistic composition, these spaces have allowed for discussion based on proposals from each member. Knowledge is acquired collectively and consensually as those with more advanced skills assume the responsibility to direct the different stages of the kite's construction.

In this way, knowledge, which many of the members already possessed or acquired in the classrooms of the primary and elementary school, can be shared with those who were not able to have access to the basic education imparted in local schools.

Building off of their own lived experience, each individual provides elements of knowledge and solidarity during the construction process, reaching decisions about their creations through consensus and without any theory related to art.

As was stated by a number of group representatives during the interviews, these are important elements of the experience of kite-building: the construction of knowledge generated in an organic way through trial and error; the interpersonal relationships between the members themselves and the population in general as they anticipate the work that each collective develops separately; and the inclusion of that same public in diverse ways.

This participation emerges on different levels: from the concern of the parents and neighbors for their children spending hours each night working on their kites; the support supplied to guarantee the performance of the groups as well as the solidarity and economic support from many of them; the exchange of ideas and discussions to improve the work in all its different facets and the logistical support received on the day of the festival. All of this necessitates a public capable of exchange and collective growth, which is a characteristic of a society with a defined identity and cultural practices that bring out community cohesiveness.

As the public becomes increasingly involved in the construction process, the kite takes on the characteristics of popular art. That is, a mass of people has accepted it as their own through its construction and collective practice, yet it does not become an anonymous production as it is identified with a particular group or individual and the record that is made for each of the works.

Realism and Other Kinds of Expression

With the emergence of new groups, the new collectives adopted certain defined styles, especially in regards to the use of *papel de china* and the search for realism in central messages with much more elaborate content.

The *Happy Boy's* integration of designs inspired by Maya weavings in Guatemala defined a style that was adopted by several groups. On their own, *Gorrión Chupaflor* reclaimed pre-Hispanic Maya designs and drawings, integrating them into the composition to devise the meaning of the central message; these were the groups that developed realism most fully in their kites.

The attempts to reach *realism* in the kites emerged through the discovery of the qualities, value and perspective of color in the *papel de china*. They began to create volume and movement in the images through the figurative work developed on the human body and its surroundings.

In 1997, these characteristics were developed through processes of experimentation within *Gorrión Chupaflor* with their kite titled *Construyendo la Paz* [Building Peace] and in the groups *Kukuy* and *Herencia Maya* in the "B" category.

Due to the manipulation of the technique in the paper and the composition of this period, the work can be catalogued as part of the trend of Native Art with the characteristic and the difference that the *papel de china* replaces the pictorial elements in the drawings with cutouts that replicate the images in the drawings.

Outside of the innovative work done by both of these groups, other collectives largely continued their work within the scoring parameters defined by the Organizing Committee: *costumbrismo* [local customs] and local traditions.

In the majority of the most important works, the drawings are done collectively through a collage of images taken from tourist postcards, replicas of oil paintings or work resembling Native Art. Beginning in the mid-1990s, this style was largely developed in the "B" category, where the participating kites are no larger than about twenty feet in diameter.

By the first decade of the twenty-first century, realism is attained by several groups, primarily lead by *Gorrión Chupaflor*

Left: Kite presented with the title "*Corazón del cielo, corazón de la tierra, cómo puedo sanar tus heridas*" [Heart of the Sky, Heart of the Earth, How Can I Heal your Wounds], 2007.

Right: Detail of *Corazón Maya's* kite, 2008.

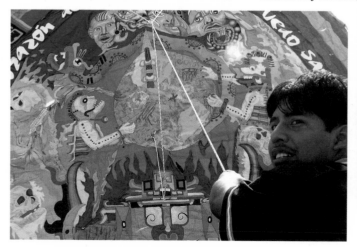

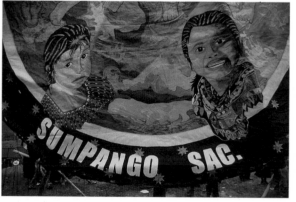

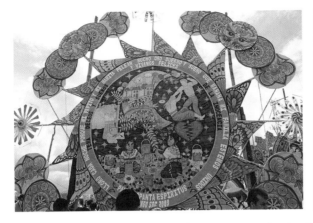

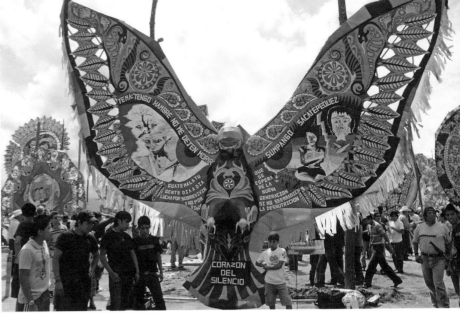

Left: Additional elements of a polygonal structure by the group Palot, 2009.

Right: Representational structure discussing environmental protection by the group *Corazón del Silencio*, 2009.

in the "A" category and in the "B" category by the *Cerbataneros* [Blowgunners], *Palot Espanta Espíritus* [Palot Scary Spirits], *Corazón Maya* [Maya Heart], *Nim Kachi'il* [Great Friends], *Nimaläj Balam* [The Great Jaguar] and *Henry Felipe*, among others who with subtle differences and very distinct themes are able to reach this level of expression with the *papel de china*.

Using wheatpaste as a binder and paintbrushes to trace out the shapes of each drawing, the artists layer soft colors on top of other dark ones to achieve volume and subtle shades in each scene, thus achieving the expression of realism in each artwork.

Sumpango: the Open Gallery

In this way, the kites surpass Popular Arts and move into a wider category of Art to be appreciated at a mass level with a heterogeneous public: both rural and urban, of indigenous descent and nonindigenous with some seeing the work as Art and others as Tradition.

The artwork does not fit into the preconceived idea of *Arte Culto* [Highbrow Art] for the consumption of a particular audience united by Western theorists; nor does it fit the stereotype of a folkloric, craft product for the consumption of tourists or for ornamental use as decoration.

The display and appreciation of the kites on the day of the Festival on November 1 has made it possible for some of the groups to take their work out of the community and mount exhibitions of their work in art spaces, using photos to explain the work more fully. In other cases, they have been exhibited in malls as a decorative element for the shoppers to appreciate.

Nevertheless, since the malls are spaces dedicated to consumption, the kite functions as a decorative element for an audience not necessarily interested in art; the exchange and the appreciation of the artwork and the attempt to understand the intentions of its creators is lost. During the Festival or in designated art spaces, there is an exchange and an attempt on the part of the audience to learn about the intentions of the artists and the content of the kite from a more critical perspective.

The Kite and Local Identity

The kite became part of some of the values of the cosmovision of the Mesoamerican peoples when faced with the ideological imposition during the Spanish invasion. The inclusion of the kite is based on new values constructed out of the practices of Cultural Resistance, and in many cases transformed into a religious syncretism that prevails even today. This is the case of the kite, though it has not been confirmed by any particular evidence specifically which values of the Kaqchikel culture are the foundation for its appearance in the town of Sumpango.

The learning and growth of the youth has been fostered by the organization of the Festival of Giant Kites in Sumpango Sacatepéquez. For the population more broadly, the identity of the town is still centered on this event, in which the kites are taken up time and time again as a site for the continual rediscovery of their own identity. The Festival is a constant investigation process to recreate themselves and to discern in their surroundings the process of changes from the perception of ideas.

The approach to technology and modernity that is continually present in the kites has not been a means to distance the community from their ancestral roots in a kind of transculturization; rather, it has been the thread which unites them with their root sense of belonging and their definition of pride in their heritage. All of this work is a reflection of the level of development this particular society has been able to attain.

To this end, the visual artist Ángel Poyón emphasizes the value of technology as a tool for the development of art, but due to the level of appropriation and consciousness of identity, it always leads them back to their real values as an authentic expression of the community (interview 2010).

Conclusion

The evolution of the kite as a means of expression has had different aspects, determined by details that are above and beyond its significance: from the moment they are conceived to the care taken in their construction and materialized in the physical structure of the frame. The kites moved from being a playful expression and a pleasant kind of folklorism into a deep reflective process and an authentic aesthetic production.

As Emma Sánchez Montañés has said about "Art" from a perspective far removed from Western concepts, "It is simply a classificatory category of human behavior, like a process, like a series of models for behavior in which nothing having to do with art should be ignored" (*Contemporary Indigenous Art,* Universidad Complutense de Madrid, 2003).[16]

With an understanding inherent in human beings, we have seen the evolution of the Kites of Sumpango; with obvious traditional aspects, these constructions have been practiced by the community for many years and yet continue to incorporate new skills, which emerge out of the need to solve problems. The artists put these new skills into practice in the construction process of the kites, which are themselves a means of expression, though they remain to a certain degree an entertainment value, even though this is not the most important factor in their continued production.

The kites are an amalgamation of contemporary elements and ancestral roots that seek to continually create artistic expressions that reflect the generational changes registered in their cultural, political and social surroundings. They are evidence of a living culture and elements of a multicultural society.

In this examination of the three decades of the Festival's existence, the recorded images are the living testimonies of the artists' evolution and their deep engagement with their resources and the materials used for the kites' construction.

The drawings and the issues tackled during the first years of the Festival were the antecedent to that growth. The *papel de china* was mastered and was manipulated to such an extent as to use the strips to produce various levels of pigment through the layering of the colors on top of one another. This is both a simple drawing as an approach to realism and figurative art as the result of a process of experimentation and constant learning.

Ángel Poyón characterizes the work as an authentic expression of human beings and specifically of the people of Sumpango, outside of the established canons of the Western mindset. The entire community expresses itself in this way, through a well-known medium, but with societal changes reflected in it, providing this quality of evolution to the culture itself.

Recent generations have provided evidence of that step forward through their mastery of the techniques developed by the groups: *Cerbataneros* (2001) *Corazón Maya* (2003) *Nimaläj Balam* (2006) and the ephemeral participation of *Henry Felipe* (2005–2007). All manipulated the *papel de china* in their own way, developing a comprehensive composition for the kite, communicating a story, the feelings of their generation influenced

Left: Structure representing the *"Pájaro Serpiente"* [Bird Serpent], one of the new structures developed by *Happy Boy's* in 2009.

Right, above and below: *La destrucción del medio ambiente* [The destruction of the environment] is the theme presented by *Hijos Ancestrales del Viento* (above) and *Corazón Juvenil* (below) in 2009.

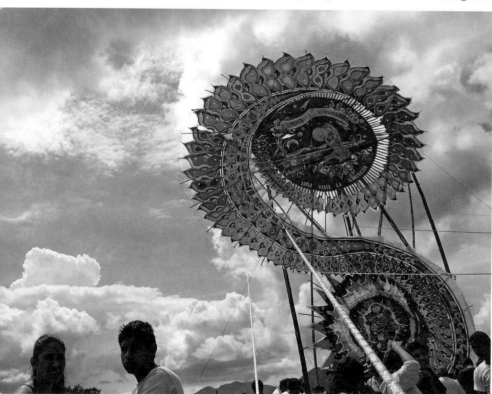

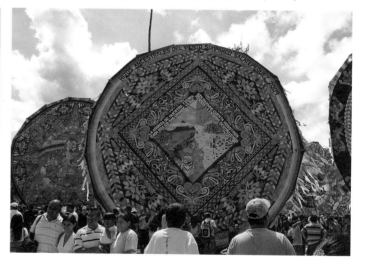

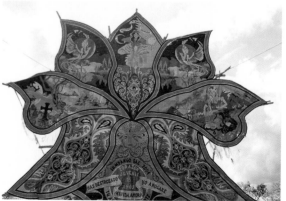

by their environment and driven by the very need to express themselves through creation of the kite.

They communicated that root, that cultural heritage with the elements and characteristics of their own cosmovision, by enclosing the compositions in the conception of time within Maya culture, like the kites built by the *Cerbataneros*.

We see this different conception of time in the structure of the frame developed by *Happy Boy's* with the *Pájaro Serpiente* [Bird Snake] in 2009 and *Keme'* [Death] in 2010 after the killing of one of the kite-builders, Ernesto Quisquinay. Also, it is apparent in the Figurative Art volume developed by *Corazón del Silencio* in the last two years.

Religious syncretism is prevalent in many of the works, with Catholicism intermingling with Maya symbolism.

The kitemakers approached the material problems of the people as a reflection of a society: children's rights, child abuse, family violence, historical memory, Maya culture, environmental destruction and the uncontrollable violence that broadly afflicts Guatemalan society.

The learning and understanding of a tradition has been relayed from the creators of the first displays—Bernabé Herrera, Napoleón Burrión, Samuel Ixtín—which they inherited from their ancestors in order to continue building a living culture for those kitemakers active later, for example, *Gorrión Chupaflor, Internacionales Audaces, Happy Boy's, Corazón Juvenil, Hijos del Maíz, Herencia Maya, Kukuy, Orquídeas*.

Now the kites are built by a number of different groups: *Palot' Espanta Espíritus, N'im Achi'il, Ruk'ux Ulew, Hijos Ancestrales del Viento, Cotorros Audaces, Descendencia Kaqchikel, Halcones, Lucero de Mañana, Guardianes de la Tierra, Herederos, Hijos Barrileteros, Flor Sumpanguera, Maulú-Neblina del Amanecer, Nueva Generación, Hijos del Pueblo, Falcones, Poder de las Estrellas, Los Ángeles,* and *Pequeñas Orquídeas,* who have created a movement of contemporary art in the form of the Giant Kites of Sumpango Sacatepéquez.

Bibliography

Boesche Rizo, Ernesto. "Reflexiones sobre el mundo actual del Arte". *Revista Tradiciones de Guatemala No. 46*. Centro de Estudios Folklóricos, Universidad de San Carlos de Guatemala, Guatemala City 1996.

Déleon Meléndez, Ofelia. "Criterios fundamentales para la comprensión y valoración de la Cultura popular o culturas populares." *Revista Tradiciones de Guatemala No. 27*. Centro de Estudios Folklóricos, Universidad de San Carlos de Guatemala, Guatemala City 1987.

Anleu Díaz, Enrique. "Reflexiones sobre el arte contemporáneo guatemalteco en el siglo XX." *Revista Tradiciones de Guatemala No. 59*. Centro de Estudios Folklóricos, Universidad de San Carlos de Guatemala, Guatemala City 2003.

Lara Figueroa, Celso A. "Globalización cultural e identidad nacional en la Guatemala contemporánea." *Revista Tradiciones de Guatemala No. 62*. Centro de Estudios Folklóricos, Universidad de San Carlos de Guatemala, Guatemala City 2004.

J. Robinson, Eugene "Reconocimiento de los municipios de Alotenango y Sumpango Sac. Informe final, del proyecto, encuesta Arqueológica Kaqchikel." Instituto de Antropología e Historia de Guatemala" cirma Antigua Guatemala 1990.

Díaz Castillo, Roberto. "Artes y artesanía popular de Sacatepéquez." *Revista Folklore y Artes Populares*. Centro de Estudios Folklóricos Universidad de San Carlos de Guatemala . Guatemala City 1976.

Díaz Castillo, Roberto. "Lo esencial en el concepto de Arte Popular." *Revista La Tradición Popular*. Centro de Estudios Folklóricos Universidad de San Carlos de Guatemala . Guatemala City 1979.

Vásquez González, Guillermo A. "Expresiones culturales de Todos los Santos y Santos Difuntos en Guatemala." *Revista La Tradición Popular*. Centro de Estudios Folklóricos Universidad de San Carlos de Guatemala . Guatemala City 2008.

Díaz Castillo, Roberto. "Folklore y Artes Populares." *Colección Problemas y documentos*. Centro de Estudios Folklóricos Universidad de San Carlos de Guatemala . University Press 1978.

Sánchez Montañés, Emma. "Arte indígena contemporáneo. ¿Arte popular?" *Revista Española de Antropología Americana, Extra Volume 69–84*. Universidad Complutense de Madrid, 2003.

Castro, Sixto J. "Reivindicación estética del arte popular." *Revista de Filosofía, vol. 27 No. 2*. Universidad de Valladolid. 2002.

Morales, Mario Roberto. "Tesis para una agenda de critica cultural y literatura latinoamericana." *La insignia*. Guatemala nov. 2007.

Morales, Mario Roberto. *La Articulación de las diferencias o el síndrome de Maximón*. 2ª edición ed. Palo de Hormigo. Guatemala City 2002.

Matos Moctezuma, Eduardo. *Muerte a filo de obsidiana, Los nahuas frente a la muerte*. Fondo de Cultura Editorial ed. 4 Second Reprint. Mexico 2000.

Arnold, Paul. *El libro maya de los muertos*. Ed Diana. 4ª. Printed in Mexico 1998.

Borg, Barbará E. "Los Cakchiqueles," *Historia General de Guatemala tomo I*, Asociación Amigos del País, Gobierno de la República de Guatemala. Guatemala City 1999.

People Interviewed
Ceferino Acual Chiquitó
Eustaquio Acual Rabay
Austreberta Leonor Carranza
Federico Cristóbal Carranza Sosa
Juan Cay Ixtamalic
Berardo Bernabé Herrera Jutzuy
Samuel Ixtín
Berta Quisque Solís
Enrique Toribio Díaz
Gonzalo Xicón Rabay
Sara Xicón Rabay
Pedro Yol

Interviews with Representatives of Organized Groups
Román Anona Rajpop, *Gorrión Chupaflor*
Oscar Asturias Yac, *Cerbataneros*
Jerson Asturias Yac, *Cerbataneros*
Carlos Cajbón, *Nimaläj Balam*
Heber Felipe Alquijay, *Corazón Maya*
Willy Xicón, *Internacionales Audaces*
Carlos Eduardo Xoquic Cay, *Happy Boy's*

Consulted Websites
http://www.arts-history.mx/banco/index.php?id_nota=18022008170531
http://rae.es
http://www.drachen.org/
http://www.museohernandez.org.ar/blog/

APPENDICES

A BRIEF HISTORY OF KITES

SCOTT SKINNER

Aeronautical historian Clive Hart, in the first sentence of his incomparable *Kites: an Historical Survey,* states, "the place of origin of the kite is fairly certain: China." Bamboo and silk were both cultivated and used as many as four thousand years ago, and it is not unlikely that the two materials came together in early kites at least two thousand years ago. The earliest unambiguous written reference to kites in China was in 200 BCE, when General Han Hsin is said to have flown a kite over palace walls to judge the distance between his army and the walls. As a popular amusement, kites became common approximately 1000 years ago during the Sung Dynasty (between 960 and 1126 CE), and for centuries they were flown on Kites Day, the ninth day of the ninth month.

There is an alternate theory of the invention of kites, though, and it is one based on a common theme of kite evolution; the marriage between environment and necessity (form and function). In the maritime cultures, which today includes those of Malaysia and Indonesia (and others), people learned early on to harness the wind for their boats, to make rope and line for sailing and fishing, and understand their coastal environments so they could provide food and shelter for their families. A kite tradition that survives today is that of "kite fishing"; using a kite to carry line and bait far from the fisherman so that fish are not "spooked" by movement or shadows. A fisherman on shore might send his kite, made of local leaves, far out, past the breakwater to smooth water where fish lie. Is it unlikely, that these knowledgeable people might have taken that large leaf, allowed it to dry, attached a line and flew it as a kite, perhaps many thousands of years ago? The wealth of kite traditions, from New Zealand, to Hawaii, and the very likely marriage of environment, abilities, and necessity may well have led to the invention of the first kite many thousands of years before the Chinese.

The history of kites in the last 1000 years is far more certain, yet still somewhat obscure in the details because of the very nature of this ephemeral object. Kites followed the trade routes of the day and spread from China to Korea, Japan, Thailand, Cambodia, (to or from) Malaysia, Indonesia, and on to India. Kites arrived in Japan approximately 1000 years ago, at about the same time as the introduction of *washi* (handmade paper) from Korea. In Malaysia, where leaf-kites may have predated introduction from elsewhere, we know that kite contests were well documented by the fifteenth century. And Clive Hart makes the point that, the kite "probably played a more important role in Polynesia than it has ever done in any other civilization, serving, as it did, as religious symbol, aid to fishing, weapon of war, object of divination, and instrument of meteorology."

The unique history of kites in Japan is a reflection of its feudal society; as merchants, craftsmen, and leaders paid yearly

Left: A modern leaf kite from Indonesia.

Right: A fishing kite from the early 1800s—these could have been the world's first kites.

visits to Edo (Tokyo) to pay taxes and express fealty to the shogun, interchanges of ideas and techniques also took place. Craftsmen from the far reaches of Japan were introduced to the new ideas of the capital and then brought those ideas to their own towns and regions. Kites were one of these craft items, and because environments are different, even in cities of close proximities, kites evolved differently in every city and region of Japan. Today, hundreds of kite shapes decorate the Japanese landscape, each the product of local wind, climate, artistic temperament, and access to material (usually bamboo and *washi*). Perhaps the best example of environmental impact upon a local kite is the *Tsugaru* of Aomori. It is made with a rigid, spruce frame because bamboo is not as available in the cold, heavy-snow region.

The kite traditions of Thailand and Cambodia are worth noting as they undoubtedly appeared at approximately the same

Far left: A contemporary Edo (Tokyo) kite made by Mikio Toki with ten bamboo "bones."

Left: A *hata* [flag kite] from Nagasaki, in the colors of the Dutch flag, probably introduced to the city from India.

Below: A Tsugaru kite from Aomori Prefecture, made with a heavy spruce frame.

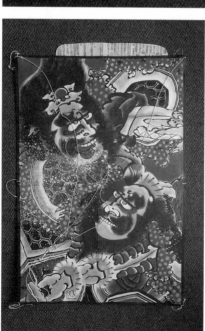

time. In Thailand, kites were flown to encourage the seasonal monsoon, blow rain clouds away, and abate the yearly floods so that fields could dry and crops could be planted. This humble tradition has evolved into a royal sport in which two dissimilar kites are flown in combat. The *chula,* a large, star-shaped kite depicting the male is flown against the *pakpao*, a smaller, diamond-shaped maneuverable kite said to represent the female. The *chula* is equipped with a long, barbed, bridle used to ensnare the faster *pakpao,* while the *pakpao* has a long tail used to lasso the larger kite and drag it to earth.

In Cambodia, early kite tradition was probably exactly the same as in Thailand (indeed, the empires of both countries overlapped over time) where kites were used in the agrarian societies to usher in good weather and to celebrate great harvests. The kite remained a much more humble object in Cambodia but evolved in many forms throughout the country. Today's *khleng ek* [musical kite] is unique in the world kite landscape; its bamboo frame is in front of the paper sail, its hummer can make up to nine distinct notes in flight, and its organic shapes can represent fertility, vigor, humor, or sadness.

Making its way across southern Asia and into Arabia as many as 1500 years ago, in India, another unique kite culture was established. The *patang* of India is a simple, two-stick kite,

Right: Three male *chula* kites with a number of female *pakpao*, to be used in Thailand's aerial battle of the sexes.

Far right: A Cambodian Moon, Parasol, and musical *Khleng Ek*.

Below: Afghani kite.

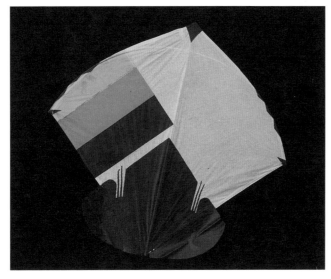

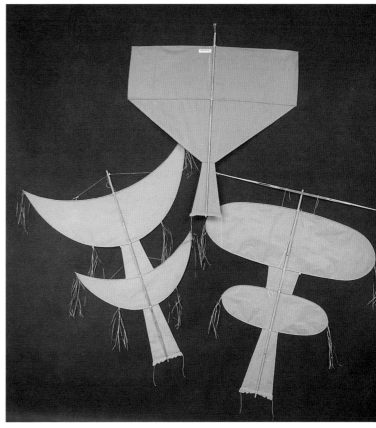

almost square, but flown point up, as a diamond. The innocent-looking *patang* is precisely built; perfectly balanced in weight and structure, so that it is instantly responsive to movements of its flyer. Flown using *manjha,* abrasive, glass-coated line, the completely maneuverable kite is flown in one-on-one tangles; aerial fights that leave one kite flying, and the other sailing free. Regardless of its date of origin, the *patang* is flown today in Northern Indian cities like Jaipur, Jodhpur, and Ahmedabad during the festival of Makar Sankranti, where tens of thousands of kites are in the air at the same time. Similar kites are flown in Pakistan (where governments have tried to stop the sport because of injury to birds and people), and Afghanistan (where kites were banned by the Taliban and then became a visible symbol of their having been overthrown).

The time of the kite's migration or introduction to Europe is far from certain. Certainly, by the time of trade routes established by the Dutch, Portuguese, and English, kites would have made their way to Europe from India, China, or elsewhere. But European kites may have developed independently after the tradition of *draco*, windsock banners, that were a familiar sight in Europe in the later days of the Roman Empire. Perhaps the earliest mention in European literature of an actual kite was in Conrad Kyeser's *Bellifortis* (1405), but almost two centuries passed before Della Porta (1535–1615) wrote, in 1589 of the *Magia naturalis* [natural wonders] of Renaissance times. Here, he describes a plane surface dragon kite, but almost fifty years

pass before a lozenge kite (a flat hexagonal or rectangular kite) is shown in detail in an English book, John Bate's *The Mysteryes of Nature and Art* (1634).

Lozenge and pear-shaped kites were flown throughout the 17th Century and increased in popularity in the 18th. But in addition to their very popular use as a toy, they now attracted the attention of scientists. England's George Pocock, in 1822, described the use of kites for signaling at sea, lifesaving, and, most notably, as the 'engine' for his Char Volant, kite-powered carriage. In 1749, Alexander Wilson used a train (or series) of kites to lift thermometers to different heights, the first known exploration of the atmosphere with kites. Soon thereafter, in 1752, Benjamin Franklin describes the most famous scientific experiment with kites, finding that lightening was, indeed, electrical matter. Flying his kite during a thunderstorm, and keeping the conducting silk ribbon and key dry, he stated, "*as soon as any of the Thunder Clouds come over the Kite, the pointed Wire will draw the Electric Fire from them, and the Kite, with all the Twine, will be electrified, and the loose Filaments of the Twine will stand out every Way, and be attracted by an approaching finger.*"

The full potential of kites as a tool for meteorological or aerodynamic exploration came toward the end of the nineteenth century with two important developments; American, William Eddy's bow kite (a diamond-shaped kite with fixed bow, or dihedral, essential to stability), and Australian, Law-

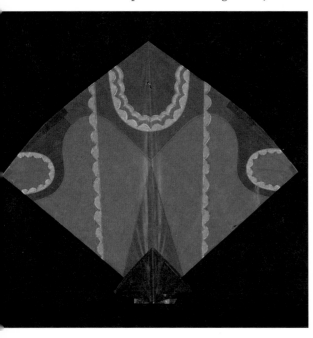

Left: An Indian *patang* with striking paper appliqué sail.

Center: Pocock's kite-powered Char Volant, patented in 1826.

Above right: William Eddy's tailless Malay kites were some of the earliest used at the Blue Hill Observatory for atmospheric investigation.

Below right: Detail from a United States Postal Service first day cover.

rence Hargrave's invention of the cellular, or box kite. Eddy's kites were used in train at Boston's Blue Hill Weather Observatory in 1894 and made some of the earliest kite aerial photos. Quickly, however, Hargrave's box kites or variations became the standard for meteorology. Modified Hargrave kites were used at seventeen American weather stations and were quickly adopted as the standard for international meteorological research. Hargrave's box kite and his own aeronautical research led others, including the Wright Brothers, to see kites as an important step to understanding manned flight. The Wright Brothers' patent is based upon their use of a four-line, warping, biplane kite.

In these exciting times, as man was first learning to fly, kites were used militarily as aerial observation platforms, they were used by Alexander Graham Bell to study stability and as the basis for aircraft design, they were used as lifesavers (like Woodbridge Davis' two-line dirigible kite), and they were used for aerial photography, most notably by George Lawrence as he captured the amazing images of San Francisco after the 1906 earthquake.

After the invention of the airplane, kites in Western societies returned to their place as toys; however, important technical advances were made in the twentieth century. Kites were used in World War II as barrage protection, aerial observation, sea survival, and target practice (Sauls Barrage Kite, German autogyro, Gibson Girl, Garber Target kite). Domina Jalbert's parafoil

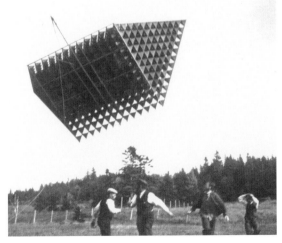

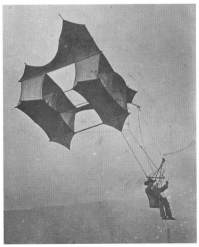

Above left: The inherent stability of the tetrahedral sail and structure characterized Bell's kite experiments.

Above right: George Lawrence's spectacular panorama of San Francisco after the earthquake, taken from a camera lifted by kites, 1906.

Left: Samuel Franklin Cody below his man-lifting kite.

design that radically changed the sport-parachute industry, and Francis Rogallo's flexible wing which became the basis for the first hang gliders are two examples from the 1950s and 1960s. Today, at kite festivals around the world huge, air-inflated kites are flown safely above crowds since they have no rigid frames that could cause damage. New Zealand's Peter Lynn has been at the forefront of this very important development, and with the invention of the portable kite buggy, he was one of the leaders to develop kite traction as a new sport. In this kiting arena, kite surfing, especially, has become a major industry around the world, with enthusiasts on all the continents.

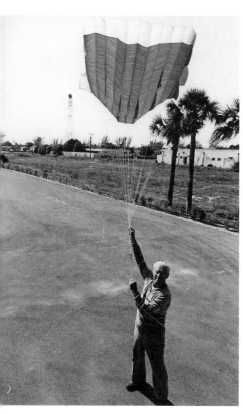

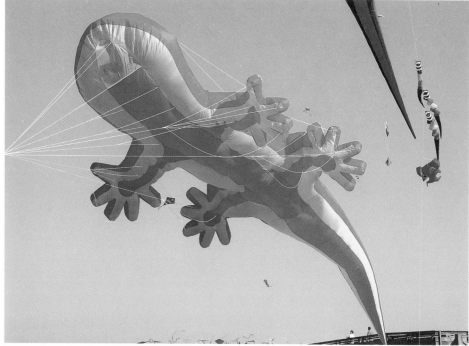

Clockwise from far left:

One of the generic kite forms of the twentieth century, Jalbert's parafoil.

A large inflatable gecko by New Zealand's Peter Lynn illustrates today's state-of-the-art kite.

Another generic kite form of the twentieth century, Francis Rogallo's Flexikite.

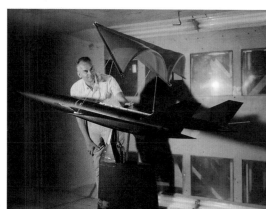

IN THEIR WORDS

Why do you make kites?

"What I like most about making kites is the *convivencia* [living together]. Because of the question of having to get all the bamboo we end up spending a lot of time together. . . . One feels very proud about everything, very happy to have done something so beautiful that is renown in all of Guatemala."

Alex Tajín, age 20, a member of Agrupación Barrileteros

"We are here to demonstrate to people the beauty that exists in Sumpango. We especially want to show foreigners that Guatemala has a lot of culture. We hope that the culture is not lost. We hope that young people come. Here we are open to everyone."

Victor Cajbón Apén, a member of Agrupación Barrileteros

"This is the second time that I have participated in the fair. I like to participate because the kites are very beautiful. . . . I was in a small group last year called *Creo*. I decided to join this group because my friends are in it."

Oscar Gil, age 12, a member of Corazon Juvenil

"I like kites because they are very colorful. When I was little, I learned how to make kites from my friends. One day somebody said, 'let's make a kite'. So I said, 'yeah let's do it.' That's how we began. Starting out one does not know anything, but that is how you learn: by making one."

Armando Santos Quisquinay, a member of Kulul Kan

I feel very happy doing this work. It is inspiring—it's something good. The group has been together for twenty years. We are the third generation. The original members left and the second generation took over. Then the second generation left and the third generation took over. The first generation gave the next generation their knowledge, and the second generation taught us. That is how it goes—one generation learns from the next.

Anonymous member of Gorrión Chupaflor

Why is the kite tradition important?

"The kites were a tradition, but it is now a real art form. At first, it was hard for people to acknowledge the kites as art. But all of the groups are now in agreement that it is a real art form. People now identify with the kites. . . . It identifies us as a group. Within that, race does not enter, politics doesn't enter, and religion doesn't enter."

Luis Tejaxún, a former member of Gorrión Chupaflor

"We are continuing the tradition of the kites. Making kites is about sharing an experience with various friends. When we arrive on All Saints Day, the first of November, there is satisfaction to show people the skills, the know-how of each person, and the excellence of the kites. Even to this day it does not compare to any other kite from any other part of Guatemala, as much as in size as in style, with images and ornamentation. Everything is made with *papel chino*."

Oscar Geronimo, a member of Kukul Kan

"Before we used to publish a text to explain what the kite meant and what the symbolism was. But I think it is more interesting when a conversation happens. When somebody comes to us and tells us about what the kite means to them—that makes us happy. Sometimes people see the same message that we imagined. But other times, it is completely different from what we had thought. But that is what is beautiful—that everyone has their own interpretation."

Anonymous member of Gorrión Chupaflor

An Explanation of a Barrilete Gigante with Members of Gorrión Chupaflor

"The theme for this years kite is about the life which has formed around the group over the last twenty one years. It is related a little to the environment because the theme is a flower. There are four petals in a flower. It is in the air. There is no stem or roots, just floating in the air. There is a dawn, late afternoon and dusk. In one petal there is a colony of humming birds in a tree, but the tree also resembles the figure of a woman.

Well, our group name is called Gorrión Chupaflor [the Spanish word for Sparrow Hummingbird]. That is why the kite is based around the petals of a flower. The images depict the life that we have spent together. In one scene there is a woman who is covered by a giant leaf. That represents the duties and chores of our mothers and sisters in our work in the fields.

The other image is of a hand transforming into a world. The part on top represents a woman in a forest—she is like a mother, at the head of the kite. So there are four petals of a flower floating above the universe. It is about living in the night; that is why the night is represented more.

Some people might ask, "why celebrate the night?" Our parents and grandparents told us many stories about how the night is bad. To go out at night is bad, and there are evil spirits that come out at night. But our experience is completely the opposite. We have lived a great part of our lives at night. There is mysticism and romanticism to the night, really living with the night. For us the night in our kite . . . the petals of a flower cannot be seen at night, but they can be imagined. In four petals of a flower, we imagine the life that we have lived together."

Members of Gorrión Chupaflor

CHRONOLOGY

OVERVIEW

BCE

1800–900 Early Preclassic Maya

900–300 Middle Preclassic Maya

300 BCE–250 CE Late Preclassic Maya

CE

300–600 Early Classic Maya

600–900 Late Classic Maya

900–1500 Post Classic Maya

1527–1821 Colonial Period

1821–today Independent Guatemala

DETAILED TIMELINE

Pre-Columbian Period

BCE

1000 Earliest evidence of monumental architecture found at La Blanca, Guatemala. Earliest traces of settlement found at El Mirador and Copán.

250 The lowland Maya cities of Tikal and Uaxactún begin to flourish.

CE

600–900 Achievements in art and architecture reach a pinnacle during this period. The cities of Copán, Uxmal, Kabah, and Piedras Negras flourish and build elaborate acropolis structures.

900 Classic Maya Civilization collapses.

1000 Chichen Itzá develops into a major power center in the Yucatán.

1263 Chichen Itzá is abandoned for unknown reasons.

Post-Conquest Period

1521 Hernán Cortéz conquers Tenochtitlan, the capital of the Aztec Empire.

1524 The Spanish conquest of the Maya highlands begins under Pedro de Alvarado.

1821 Guatemala declares independence from Spain.

1838–1840 United Provinces of Central America dissolves in civil war.

1871 Justo Rufino Barrios leads the "Liberal Revolution."

1898–1944 Dictatorships of Manuel José Estrada Cabrera and Jorge Ubico.

1944 Democracy established in Guatemala. Juan José Arévalo elected first president.

1954 President Jacobo Arbenz, the second democratically elected president in Guatemalan history, is overthrown in a coup engineered by the CIA.

1960 Civil war in Guatemala begins when a large portion of the army attempts an unsuccessful coup against a government backed by the United States. Young army officers take to the countryside to wage guerrilla war. A counterinsurgency campaign supported by the United States leads to the deaths of some 10,000 civilians in the next decade.

Feb. 4, 1976 A 7.5 magnitude earthquake hits central Guatemala leaving 23,000 dead, approximately 76,000 injured and thousands homeless.

May 29, 1978 Dozens of unarmed Q'eqchi peasants are massacred while petitioning for land titles in Panzós.

Nov. 1, 1978 Sumpango begins its first kite competition.

Jan. 31, 1980 Thirty-six protesting Maya peasants from El Quiché are firebombed in the Spanish embassy in Guatemala City.

1982 Military coup in Guatemala. General Efraín Rios Montt, an evangelical protestant, takes power. Worst human rights violations of the civil war period take place during his regime.

Early 1980s Images of Maya customs begin to appear on the kites.

1983 The group *Los Happy Boy's* is formed.

1986 The group *El Gorrión Chupaflor* is formed.

1986 Vinicio Cerezo elected first civilian president in thirty years.

Early 1990s Political messages begin to appear on the kites.

1991 The Permanent Committee for the Preservation of Kites (El *Comité*) is established to organize the Festival and guarantee its continuation into the future.

1992 Rigoberta Menchú, a leading advocate for indigenous Guatemalans' rights, wins the Nobel Peace Prize.

1994 Historical Clarification Commission (CEH), a UN-sponsored truth commission for Guatemala, is established.

1994 Recovery of Historical Memory Project (REMHI) established.

1995 Last known massacre by Guatemalan Army, in Xamán, Alta Verapaz. Twenty-five Maya peasants are killed.

Mid-1990s Political messages on the kites expand; the *barrileteros* openly protest against a host of social problems including inequality, the war, violence, and poverty.

Dec. 1996 UN-monitored Peace Accords for Guatemala are signed.

Apr. 1998 REMHI report, "Guatemala: Never Again," formally presented.

1998 The Ministry of Culture of Guatemala declared the kites of Sumpango a National Patrimony.

Feb. 1999 Final report of the UN Historical Clarification Commission, "Memory of Silence," is published.

Dec. 1999 Alfonso Portillo, a populist, wins runoff election for president. General Ríos Montt is elected president of the legislature.

2000 UNESCO declared the kites an Impermanent Cultural Patrimony of the world as part of the International Year for the Culture of Peace

Mid-2000s Images depicting violence and dead bodies begin to appear on the kites.

2007 Álvaro Colom is elected president, the first left leaning candidate to become president since democracy was restored in 1985.

2009 A new organization known as *Asociación Barrileteros* [the Association of Kitemakers establishes a separate kite festival with the support of the National Unity of Hope (UNE), the political party of President Alvaro Colom.

GLOSSARY

amapantli. Flags made of paper (Nahuatl).

amapatlachtli. Stretched paper that was attached to brightly colored quetzal birds and tied with red strings (Nahuatl).

armazón. The kite frame (Spanish).

barrilete. Kite (Spanish—regional) this is the most common term for kite in Guatemala, Argentina, El Salvador, Honduras, and Nicaragua. The origin of the term is uknown, but it is possiby derived from *barril*, or barrel, perhaps in reference to its octagonal shape. There are over fifteen different terms for kites in Latin America, including *cometa, chiringa, pandagora, pizchucha* etc.

barriletero. Kitemaker (Spanish—Guatemalan). In Sumpango, this term usually applies to members of official kitemaking groups, such as *Los Happy Boys, Los Internacionales Audaces, Gorrión Chupaflor,* etc.

barriletes gigantes. Giant kites (Spanish—Guatemalan); in Guatemala this term is most commonly used in reference to the giant kites made for the Day of the Dead in Sumpango and Santiago Sacatepéquez.

CEH. Historical Clarificaiton Commission (*Comisión para el Esclarecimiento Histórico*); United Nations–sponsored truth comission mandated by the Peace Accords.

cempasúchil. Marigold (Spanish via Nahuatl); flowers typically used to decorate altars and graves for the Day of the Dead.

chiguate. A game to steal someone's kite (Spanish—Guatemalan).

Comité. The Standing Committee for the Preservation of Giant Kites (El *Comité* Permanente Para la Preservación de Barriletes Gigantes).

Florentine Codex. "The General History of the Things of New Spain" (*La historia general de las cosas de la nueva españa*); compiled by Beranbé Sahagún, a Franciscan monk, from the accounts of indigenous converts in the sixteenth century, this twelve volume work constitutes the largest account of pre-Colombian culture at the time of the conquest

cola de caña. A kite tail made of dried sugarcane stalk (Spanish).

cosmogony. A theory of the origin of the universe. See *Cosmovisión*

cosmovisión. A merging of "cosmogony" and "cosmology" by ethnoastronomers; for Meso-Americans this is a worldview that integrates the structure of space and rhythms of time into a unified whole, a structured and systemic worldview; Maya cosmovisión is marked by various types of knowledge, traditions, and institutions that provide a template of movement in which human existence and the cosmos are interrelated and harmonic.

Día de los Difuntos. See Día de los Muertos.

Día de los Muertos. Day of the Dead (Spanish); a festival to welcome and remember the spirits of the dead who are said to return to the earth. Widely celebrated in Mexico and Central America, the holiday takes place on November 1 and 2 in conjunction with the Catholic holidays of All Saints' Day and All Souls' Day. In Guatemala, November 1st, All Saints' Day is also referred to as Day of the Dead. Traditions connected with this festival include making home altars, decorating them with sugar skulls (ornaments molded of sugar), marigolds, and offering foods and beverages in honor of the deceased.

flecos. Colorful strips of paper that are attached to the sides of Guatemalan kites (Spanish).

hüipil. Traditional blouse worn by Maya women, usually handmade and intricately woven with floral and geometric designs (Spanish via Nahuatl).

Kaqchikel. One of twenty-one language/ethnic groups in present-day Guatemala that trace their roots to the ancient Maya civilization.

K'onojel Junan. The name of the original kite group that founded the Sumpango Kite festival in 1978. The name means "We are all equal" in Kaqchiquel. It was later changed to *Grupo Tikal.*

maguey. An agave plant, especially one used for pulque; the sturdy fibers of this plant were also used to make kite string (Spanish via Taino).

Nahuatl. The language of the Aztecs.

papalote. Kite (Spanish—Mexican); originally derived from *Papalotl*, the Nahuatl term for butterfly.

papalotl. Butterfly (Nahuatl).

papel de china. Tissue paper (Spanish); literally meaning "paper from China," this is the traditional paper used to make kites in Guatemala.

papel picado. Decoratively cut tissue paper, typically used in Mexico for special occassions, especially the Day of the Dead (Spanish).

patzunga. Kite tail made from scraps of the cloth (Spanish—Guatemalan).

REMHI. Recovery of Historical Memory Project (*Proyecto Interdiocesano de Recuperación de la Memoria Histórica*); truth comission report sponsored by the Human Rights Office, Archdiocese of Guatemala.

syncretism. The fusion of two distinct traditions, religions, cultures, or schools of thought to produce a new and distinctive whole.

URNG. National Revolutionary Union of Guatemala (*Unidad Revolucionaria Nacional Guatemalteca*); the umbrella group comprising four guerrilla factions (EGP, FAR, ORPA, PGT), founded in 1982.

zumbadora. A piece of paper attached by string to the top of the kite (Spanish—Guatemalan); it stuck out like an antenna and made a *zum* or vibrating sound when flown.

KITE GROUPS

Agrupación Barrileteros [Participating Kitemakers]

Bernabe Herrera (and family)

Cerbateneros [Blowgunners]

Corazoncitos del Cielo [Tiny Hearts of the Sky]

Corazón del Cielo [Hearts of the Sky]

Corazón del Silencio [Heart of Silence]

Corazón Juvenil [Young at Heart]

Corazón Maya [Maya Heart]

Cotorros Audaces [Audacious Parrots]

Descendencia Kaqchikel [Descendents of Kaquchike]

Espiritu del Viento [Spirit of the Wind]

Falcones [Falcons]

Flor Sumpanguera [Flowers of Sumpang]

Friends

Gorrión Chupaflor [Sparrow Hummingbird]

Grupo Friends [Group of Friends]

Grupo Nim Kachi'il [Group of Great Friends]

Grupo Relampago [Lightning Group]

Guardianes de la Tierra [Protectors of the Earth]

Halcones [Falcons]

Happy Boy's

Henry Felipe

Herederos Maya II [Heirs of Maya II]

Hijos Ancestrales del Viento [Ancestral Children of the Wind]

Hijos Barrileteros [Sons of Kitemakers]

Hijos del Pueblo [Sons of the People]

Internacionales Audaces [Audacious Internationalists]

Kukuy [Boogie Man]

Kulkulkan [The Passage]

LOCREO

Los Angeles [The Angels]

Lucero de Mañana [Morning Star]

Maulú-Neblina del Amanecer [Maulu Dawn Mist]

N'im Achi'il [Good Friends]

Nimaläj Balam [Great Jaguar]

Nueva Generación [New Generation]

Orquídeas [Orchids]

Palot' Espanta Espíritus [Palot Scary Spirits]

Pequeñas Orquídeas [Tiny Orchids]

Poder de las Estrellas [Star Power]

Raiz Maya [Maya Race]

Ruk'ux Ulew [Heart of the Earth]

Snoopy Club

BY CATEGORY

Category A: kites 10–13 meters [~33–43 feet] in diameter

Corazón del Cielo [Hearts of the Sky]

Corazón Juvenil [Young at Heart]

Corazón Maya [Maya Heart]

Descendencia Kaqchikel [Descendents of Kaquchike]

Gorrión Chupaflor [Sparrow Hummingbird]

Grupo Friends [Group of Friends]

Grupo Nim Kachi'il [Group of Great Friends]

Happy Boy's

Internacionales Audaces [Audacious Internationalists]

Kulkulkan [The Passage]

Nimaläj Balam [Great Jaguar]

Ruk'ux Ulew [Heart of the Earth]

Category B: kites 3–6 meters [~10–20 feet] in diameter.

Bernabe Herrera (and family)

Cerbateneros [Blowgunners]

Corazoncitos del Cielo [Tiny Hearts of the Sky]

Corazón del Silencio [Heart of Silence]

Cotorros Audaces [Audacious Parrots]

Espiritu del Viento [Spirit of the Wind]

Falcones [Falcons]

Flor Sumpanguera [Flowers of Sumpang]

Friends

Grupo Relampago [Lightning Group]

Guardianes de la Tierra [Protectors of the Earth]

Halcones [Falcons]

Henry Felipe

Herederos Maya II [Heirs of Maya II]

Hijos Ancestrales del Viento [Ancestral Children of the Wind]

Hijos Barrileteros [Sons of Kitemakers]

Hijos del Pueblo [Sons of the People]

Kukuy [Boogie Man]

LOCREO

Los Angeles [The Angels]

Lucero de Mañana [Morning Star]

Maulú-Neblina del Amanecer [Maulu Dawn Mist]

N'im Achi'il [Good Friends]

Nueva Generación [New Generation]

Orquídeas [Orchids]

Palot' Espanta Espíritus [Palot Scary Spirits]

Pequeñas Orquídeas [Tiny Orchids]

Poder de las Estrellas [Star Power]

Raiz Maya [Maya Roots]

Snoopy Club

THE EVOLUTION OF A BARRILETE GIGANTE

Barrileteros work for many months of the year to create a giant kite that will live for only one day. A variety of tasks ensure that team members will all participate and contribute: cutting, transporting, and storing bamboo; buying paper, glue, and tape; visualizing and drawing the year's design; and, finally, bringing the sail to life.

Step 1: Creating the Design

The design is the heart of a *barrilete gigante*. Kitemakers first decide collaboratively on a central theme. They then design a sketch or a collage illustrating that theme. Sometimes one artist will create the design for the entire kite. In other cases, several artists work together to create different vignettes.

Step 2: Tracing the outline

The small-scale designs are then blown up and traced onto an inexpensive paper. Some groups use grids to transfer the images to large scale, while others use projectors. Still others prefer to rely simply on the naked eye. Once the outline is transferred to paper, it is then traced a second time on white tissue paper.

Step 3: Cutting and Pasting

The sail of each kite is fabricated using thousands of sheets of brightly colored tissue paper.

Cutting and pasting these sheets is the most intensive and time-consuming part of the kitemaking process. The kitemakers painstakingly manipulate tissue paper to figuratively paint and illu-

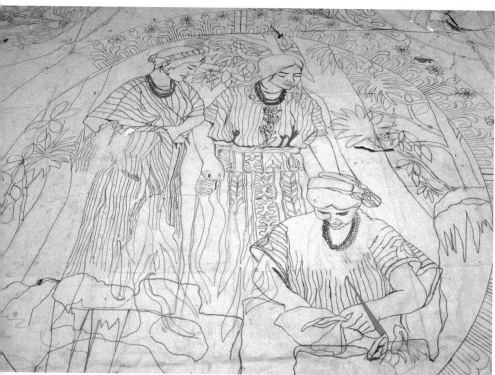

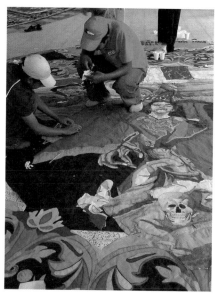

minate their designs. By overlapping multiple colors they can produce an endless range of color variation and intensity. The groups are constantly inventing new techniques and styles for creating realistic images with painterly qualities. This work begins at least a month and a half prior to the kite festival. The teams usually divide the kite into sections that are later pieced together. The finished sail is backed with a layer of backing paper to lend support.

Step 4: The Frame

The frame is constructed the night before the Festival during all-night work sessions known as *Lunada del barrilete* [moonlit night]. The frame is made of bamboo or Spanish cane from the tropical jungles of southern Guatemala, usually cut by the *barrileteros*

themselves; it can weigh 200 pounds. The poles are lashed together with rope. On the day of the festival, the frame is lifted and gently placed onto the sail. The kitemakers then paste the sail to the frame and add *flecos* [colorful strips of paper], to the edges of the kite.

Step 5: The Unveiling

The design of each kite is a secret. The kites are kept hidden until the moment they are lifted up on the day of the Festival. The unveiling is a moment of glory for the kitemakers and an epiphany. It is the first time they have see their work in its entirety, fully erect and illuminated by the sun. The kites come to life with the whirl of the wind and the cheers of the crowd.

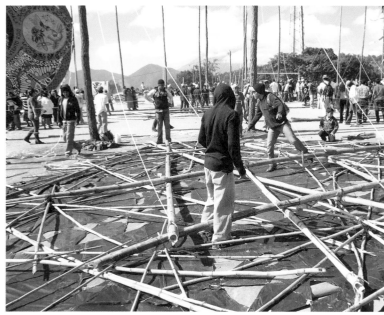

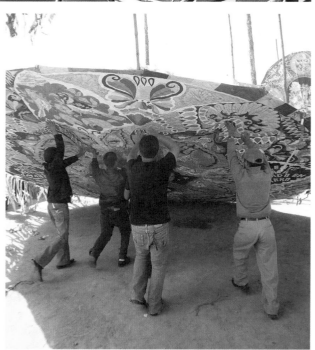

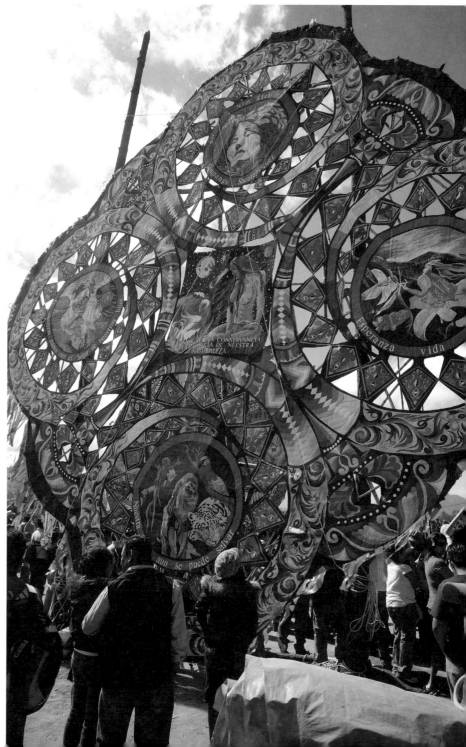

PORTRAIT OF A KITEMAKING FAMILY

The group *Cerbataneros* are renown for their artistic mastery. This kitemaking family began competing in the Festival in 2001. Over the years, they have won numerous awards for best design and best message. Their work illustrates Maya *cosmovisión* and contemporary subject matter with bold and provocative imagery.

The family lives in a humble cinder block house with a tin roof. The group is comprised mostly of family members and a few old friends who "we've known since we were babies," exclaims Gerzón Asturias, age sixteen. He formed the group along with his brother, Oscar Asturias, and Carlos Gill in 2001. "Our grandparents made kites," he says, "if they could do it, how could we not do it?" This idea gave rise to the group. Today it comprises eight members.

The *Cerbatanero's* kites are imbued with respect for the heritage and traditions of their Maya ancestry. Their kites show vignettes laden with symbolic imagery taken from Maya mythology. Although the messages on the kites are not overtly political, the kitemakers choose images that reclaim and vindicate their indigenous history. "We take a bit of the old tradition," says Gerzón, "and part of what we see day to day, the state of our nation, the social problems, and we illustrate it. Sometimes we don't say explicitly what we want in words, but we can explain it through our work."

In the week before the fair, Gerzón and Carlos work feverishly on their kite to get it ready on time. Oscar, who is studying to be an architect, is busy with school and comes home late at night. The floor of the house is littered with boxes and scraps of tissue paper. A large scale drawing of a Maya girl dressed in a black skirt and holding a white calla lily hangs from a wall. In stark contrast to the previous image, another drawing depicts two faceless men in the act of kidnapping a third man. Another image laid out on the floor shows the naked body of a man contorted in pain.

The title of the kite is *Time*. "This year we are making a clock," explains Gerzón, "only an abstract clock. For us life is a clock. It always changes. There is a moment when the battery goes out and we no longer exist." The kite depicts figures revolving around a clock. In the upper right hand corner a girl holds a bouquet of flowers; her serene face is outlined by a bright blue sky. She is surrounded by glyphs making up the notches of the Maya calendar wheel. Below her, a man with a bare chest holds the minute hand up, and the clock begins counting in roman numerals. In the bottom left hand corner, the two faceless men carry away a man by the arms and legs. Above him, the naked man appears. In the top left hand corner the face of a corpse appears in black and white.

The imagery on the kites weaves together several narratives about time, the conquest, and contemporary social problems into a single whole. Maya conceptions of time clash with a western style clock, a proxy for the Spanish invasion. Beyond this rupture, the dystopian present is depicted in dark and menacing colors. Images depicting kidnapping, torture, and death allude to the war

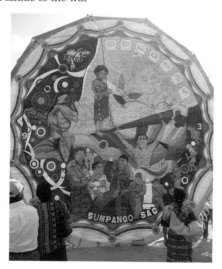

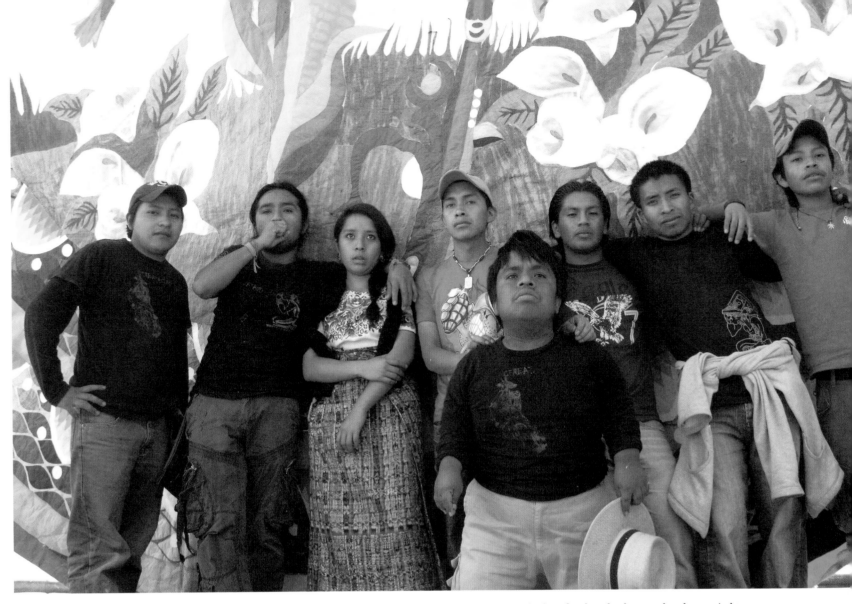

or, perhaps, to the rampant violence of postwar Guatemala. Monkeys holding weapons accompany the early numbers on the clock. As the numbers progress, the monkeys evolve into men and so do their weapons.

The narrative of the kite seems bleak and fatalistic. But Gerzón reassures me that this is not the case. The clock cannot be read linearly, but only as a cycle in which there is destruction and renewal. "The clock shows that sometimes we suffer and that sometimes we don't, but life continues," says Gerzón. "The idea of seeds is important because it is a symbol of a connection to the ancestors. We are the ones to carry on the traditions." In this quote, Gerzón refers to stalks of corn growing alongside the girl holding flowers. This scene represents the promise of the future. In it we see the renewal of Maya culture from the seeds of the ancestors.

The importance of tradition is manifest in the words of Esperanza Yac, the matriarch of the family. Yak has a soft-spoken but resolute presence. She encourages her children to make kites. She is brimming over in her eagerness to explain the importance of the kite tradition:

For the last five hundred years they have tried to erase us—to disappear us—but they could not. . . . That is why I tell my children—even though they are university graduates and they like modern music—I tell them: don't forget how to dance the *son* [a dance of national identity], because that is our tradition. Like with my daughter. She fights a lot. She loves wearing pants because she likes to play sports. But I tell her, no my daughter, you can't lose our tradition, because that is what counts in the end.

The teachings that she gives to her family about Maya traditions and culture resonate in the work of the *Cerbataneros*. Her children reflect her passion.

When her oldest son, Oscar, arrived home from a long day at school, he was keen to share his reasons for making kites. "For me the kite is like our life," he said. "Here, sometimes we cry. Sometimes there is not enough to eat. Sometimes we stay up late. Sometimes we laugh. Here all of our sentiments are expressed. . . . We want our traditions to live on, so that what the ancestors gave us might never die."

A GALLERY OF PHOTOGRAPHS

RITUALS

Prayer, music, and ancient ritual characterize activities in and around the cemeteries on the Day of the Dead. Families clean and decorate ancestors' graves and gather to eat, drink, and fly kites. Maya spiritual guides make offerings with fire, food, and flowers while marimba bands add a celebratory vibe to the serious ritual.

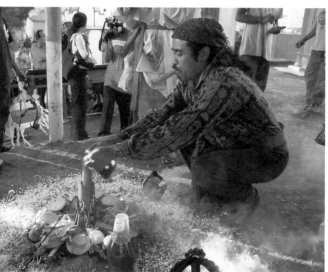

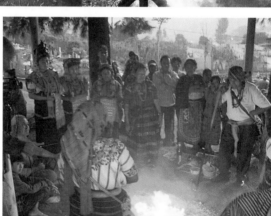

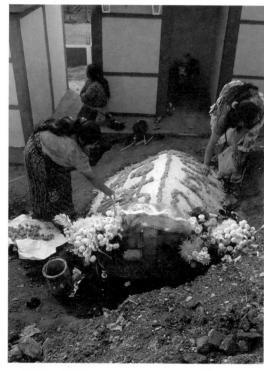

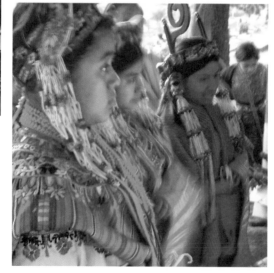

THE COMPLETED KITE BEFORE SPARRING

The fragile tissue paper used to paint the *barrileteros'* picture is often backed with black construction paper and a grid of clear plastic tape. The resulting kite sail is surprisingly durable and can be rolled and folded for transport to the kite field. Top and bottom are clearly labeled, as proper placement of the frame onto the sail is critical. A misaligned sail cannot be corrected once the giant is lifted, and a mistake is impossible to hide.

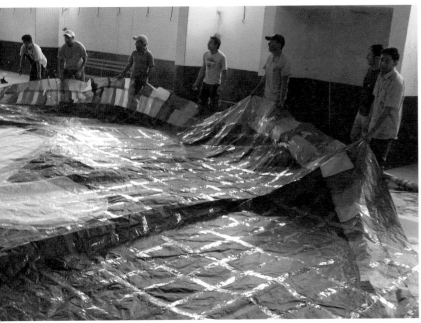

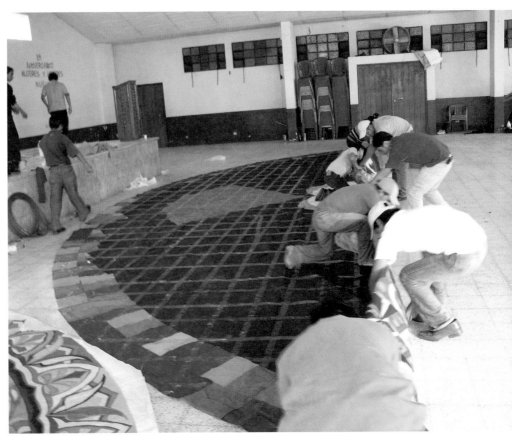

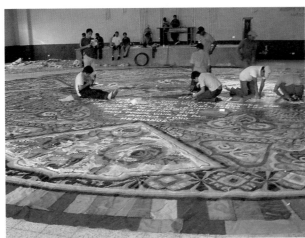

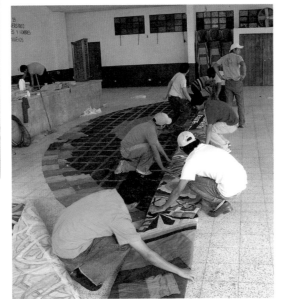

THE FACES OF A PROUD CULTURE

Serious themes of the kites are complemented by the colors and patterns of everyday life in Guatemala. Flower motifs, clothing patterns, and proud families will all appear in the final kite designs.

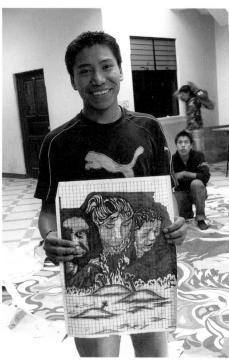

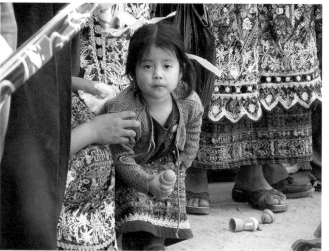

THE CELEBRATION OF KITEFLYING

The giant kites represent an extreme in size, organization, and participation, while the simple act of kiteflying goes on for weeks before the Festival. Children fly inexpensive and simple hexagons, octagons, or homemade creations and family teams collaborate to make beautiful kites that are flown during the Festival.

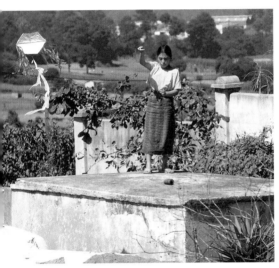

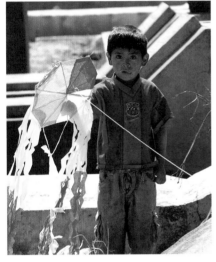

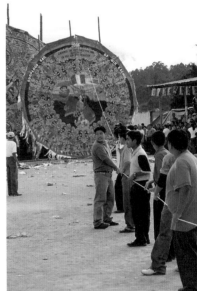

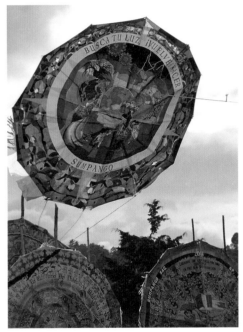

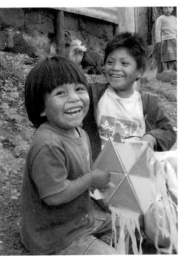

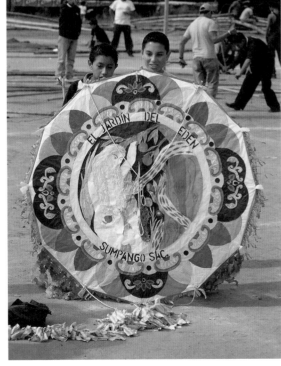

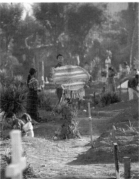

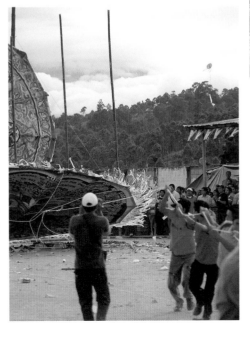

IF YOU WANT TO GO

Airfare. Guatemala City with return via Houston is in the $700–800 USD range, depending upon where you live.

Health. See your physician or go online: www.cdc.gov/travel/destinations/Guatemala.

Accommodations. There are very few accommodations in the Sumpango area and none in the village itself. A clean, adequate hotel in Antigua is your best affordable choice and is a good base from which to explore. There are wonderful restaurants and shops; hotels are abundant and start at $70 USD per night, which includes breakfast. Antigua is about twenty minutes from Sumpango, and is easily accessible by taxi or chauffeur.

Transportation. Car rental is possible, but be warned: driving in Guatemala is not for the faint-hearted. We suggest hiring a chauffeur; this can easily be done through your hotel. Pickup from the airport and use of a chauffeur the day of the Festival is the easiest and most affordable choice. Remember to arrange for pickup; whether you use the chauffeur or the taxi, there will be no way to get back to Antigua unless you have arranged for a pickup and ride. Bus service works and is cheap, but some Spanish is necessary.

Food. Budget $25 USD per day. Tasty international and Guatemalan-style food is readily available. Expect tortillas rather than bread. Black beans and rice are the local staple. Ears of corn roasted from the grill is a treat. Fruit is superb, particularly the pineapple and watermelon. There are fancy expensive restaurants to try as well as more budget-minded ones.

Water. Drink only bottled water, and use it to brush your teeth. Refuse ice served in drinks.

Guidebooks. A wide range is available. Excellent, up-to-date travel information is also available online. Few guides mention the kite Festival.

Time needed. To see the giant kites, figure on one day of travel from the United States to Guatemala, one day (Nov. 1) in Sumpango, one day (Nov. 2) in Sacatepéquez, one or two days for side trips to old, beautiful Antigua or the Indian market (Thursdays and Sundays) at Chichicastenango, or to Lake Atilan, and one day to return home. If you want to go to faraway Tikal, the great Maya temple complex in the jungle up north, add two days. You must fly to Tikal, stay overnight at least one night, then fly out the next day. The most affordable way to do this is to purchase a tour, which will include all your costs: transportation from the airport in Flores, and one night in a good hotel. Unfortunately, increasing levels of violence make Guatemala City unsafe for travel; we strongly recommend travel directly to Antigua from the airport.

Shopping. Beautifully made small kites are readily available in the kite villages for sixty cents and up. Bring your own line to fly them! (It is inappropriate to the Festival spirit to fly Western kites. This is the time to leave your kites at home.) Shopping everywhere is wonderful. There is an enormous range of folk crafts available at inexpensive prices. Bargaining is customary.

Weather. Kiteflying takes place at the end of the rainy season, so be prepared. It can be quite hot during the day, but cool or even cold at night. Bring a sweater and jacket. Sturdy walking shoes are a must.

Photography. Exceptional opportunities. Be ready to shoot!

Language. Little English is spoken. Consider joining a tour or hiring your own guide. The hotels in Antigua can help you.

Further information. Visit the Sumpango website: www.festivalsumpango.com

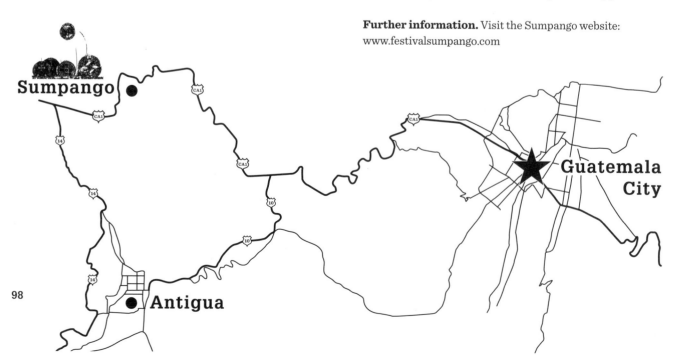

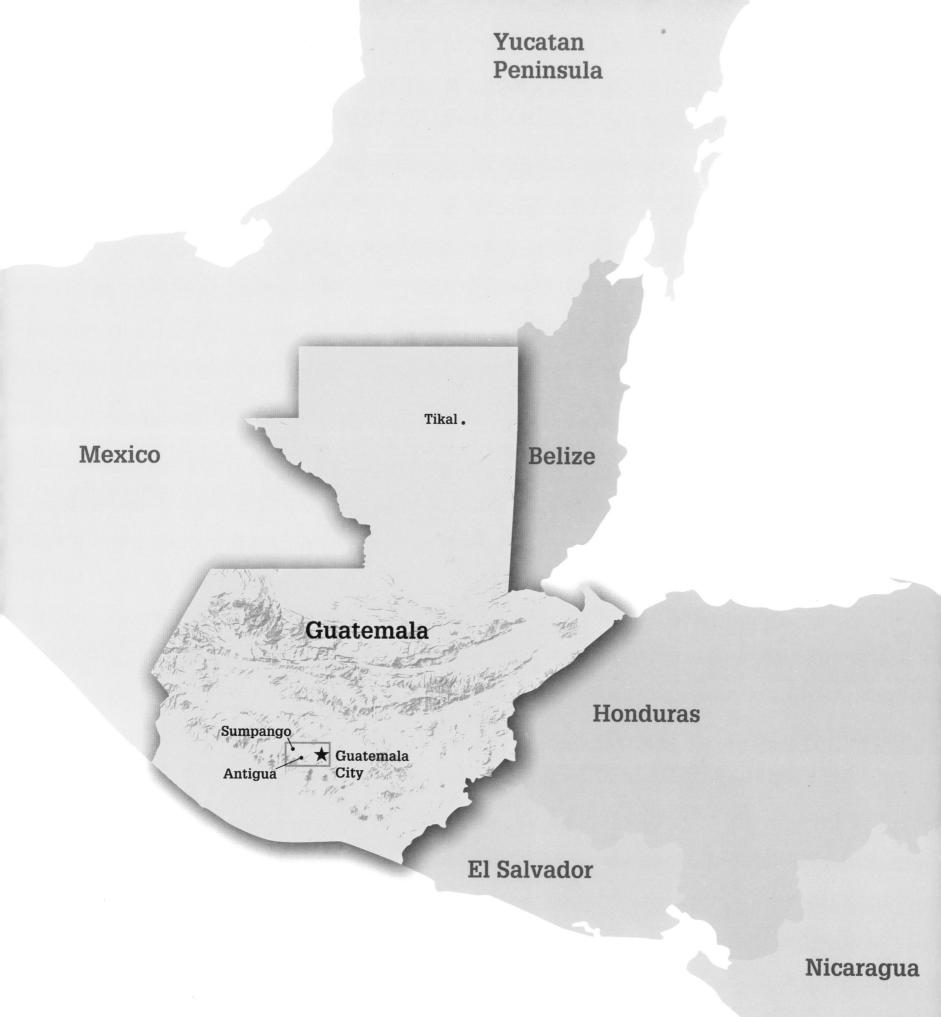

AUTHORS

Christopher Ornelas, San Antonio, Texas is a graduate of Yale in Latin American studies and practicing artist who has lived and traveled extensively in Guatemala. Fluent in Spanish, he has interviewed *barrileteros* and watched them in every step of the kite-creation process. He has helped to document other kite traditions in the country, heretofore unknown.

Scott Skinner is founder of the Drachen Foundation and has been making, collecting, and documenting kites for over thirty years. An accomplished kite artist and author, he has observed kite cultures around the world and has shared his experiences in books, lectures, and online.

Victorino Tejaxún Alquijay, Sumpango, is a member of the kite team *El Gorrión Chupaflor* and has been involved in every facet of kitemaking in Sumpango. He is an accomplished kite artist and has introduced and popularized a number of creative techniques that produce realism and beauty in his kite sails. He is a professional journalist based in Guatemala City.

RESEARCH & DOCUMENTATION

Ali Fujino is the administrator of the Drachen Foundation and was responsible for research and production of this book. With extensive museum and kite backgrounds, and Spanish fluency, she coordinated the efforts of all involved. Her first trip to see the *barriletes gigantes* was in 2003.

Jose Sainz is an accomplished and decorated Mexican-born kitemaker, fluent in Spanish and indispensible as photographer, interviewer, and fellow traveler. In the field, his language skills and friendly personality helped the team to get a closer view of all the kite activities in Sumpango.

Top row, left to right: Christopher Ornelas, Scott Skinner.

Bottom row, left to right: Victorino Tejaxún Alquijay, Jose Sainz, Ali Fujino.

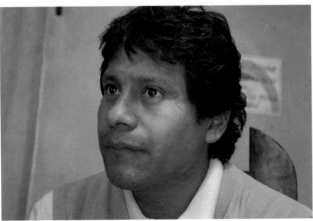

100

ACKNOWLEDGMENTS

For the Drachen Foundation, the discovery and research of *barriletes gigantes* of Sumpango began in 2003, with Drachen Journal writer/editor Ben Ruhe and myself. After years of "hearing" about the glory of the Guatemalan kites, we set out with notebooks and film cameras to see if we could find the source of the kites.

Two thousand three was a time when there was little apparent political unrest, but with three years as a Peace Corps volunteer I knew better. Guatemala was always in political unrest, and it was a very black and white situation, Maya Indians vs. the Government. Ben and I flew into Guatemala City at night, found a reasonable hotel and planned to start our research the next day. Our thought was to find the Department of Culture and see if we could locate the small village or villages that made the kites.

As the story goes, while walking down the street of Guatemala City, we saw a mother and small child coming out of a building, the child proudly holding on to a string, which was tethered to a paper and reed kite. We dove into the building, and found Federico Cristóbal Carranza Sosa, a resident of Sumpango, finishing up a kite workshop for children. Conversing in Spanish, I discovered that Federico was one of the committee members of the *Sumpango Barriletes Gigantes Kite Festival,* the Festival that Ben and I were sent to find.

The next day we were in our rental car and navigating our way to the village. There we met Federico, who graciously opened up the world of Sumpango kites, which ultimately resulted in this book.

Several years of Drachen research teams continued. We went back in 2006, 2007, and 2010, monitoring and documenting the movement of these phenomenal kites through the Guatemalan kitemaking teams, the festival committees and the festivals themselves. Our material was so abundant, that we produced a six minute film, several articles and now this book. Over those years, we not only researched material for a glorious film and book, but we made a lifetime of friends and a commitment to the Maya culture.

My list of gratitude to those who worked with us and continue to work with us is terrifically long and complex but there are those who need a special mention. On the Guatemalan side, we could not have done it without the friendship and commitment of Federico Cristóbal Carranza Sosa, and the *Comité Permanente de Barriletes Internacionales*, Luis Tejaxún Alquijay, kitemaker and schoolteacher, Victorino Tejaxún Alquijay, kitemaker and journalist, the Asturias family, all the teams of Sumpango, and the Maya community of Sacatepequez. At home and on the road Team Drachen was a collaborative effort of many including Scott Skinner, Jose Saniz, Christopher Ornelas, Ben Ruhe, Katie Davis, Mark Wiener, Matthew Stubbs, Anton Fürnhammer of Austria, and all of our Publishing Patrons. A special thanks to Jeff Wincapaw, who led the team at Marquand Books with his calm, creative eye.

The story of the *barriletes gigantes* does not end here, this is just the beginning.

Ali Fujino, Drachen Foundation

PUBLISHING PATRONS

Stuart Allen, Janet A. Alvares, Michael G. Alvares, Rod Beam-guard, Margaret Bechard, Josh Benditt, Gill and Jon Bloom, István Bodóczky, Nelson Borelli, Robert & Tracey Brasington, Kay Buesing, Helen Bushell, Andrei Chichak and Dorothy Guch, Marv Cohodas, Dieter Dehn (deDrache), Richard & Marti Dermer, Courtney DeRouen, Gretchen Dingman, John Dobson, George Emmons of Into The Wind, John and Allegra Ernst, The Fujino-Sutton Family, Anton & Marianne Fürnhammer, The Grumpy Old Gits, Leslie Grace, Joe & Kirsten Hadzicki, Pat Hammond, Gary Hinze, Henry & Cheryl Jebe, Laura and Mark Jennings (in loving memory of Margo), John and Julie Kane, Alexa King, Greg Kono, Dave and Jane Lang, Martin Lester, Ron & Charm Lindner, Chuck Lund, Barbara Mason, Jackie Matisse, Bob Matteo, Kurt Maurer, James A. Minson, Richard A. Neumayer, Austria (in appreciation of the work of Centro Cultural, Momostenango), Allen B. Norris, Kiyomi Okawa and David Baldwin, Christopher Ornelas, Henry & Linda Ornelas, Robert & Dolores Ornelas, Sal Ornelas, Golden Parker, Carlton & Leslie Parks, Cliff & Gerry Pennell, Rob Pratt, Clifford J. Quinn, Sheila Ragan, Dale R. Reed, Paul and Natalie Reynolds, Carol & Jose Sainz, Raul & Sara Sandoval, Christine & Bill Schurtman, Scott Skinner, John Stevenson & Cynthea Bogel, Nop and Michèle Velthuizen, Ernie Wagner and Darcie Richardson, Craig Wilson, Gayle Woodul, Nobuhiko Yoshizumi, Anacortes 4 Arts, Brighton Kite Flyers, United Kingdom, ConnectiKITERS Kite Club, druid labs, Hiromi Paper, Inc., SKYCANDY-ART.COM, South Jersey Kite Flyers, Kite Flyers of Tasmania, Westport Windriders, Wings Over Washington Kite Club, www.kiteguys.ca

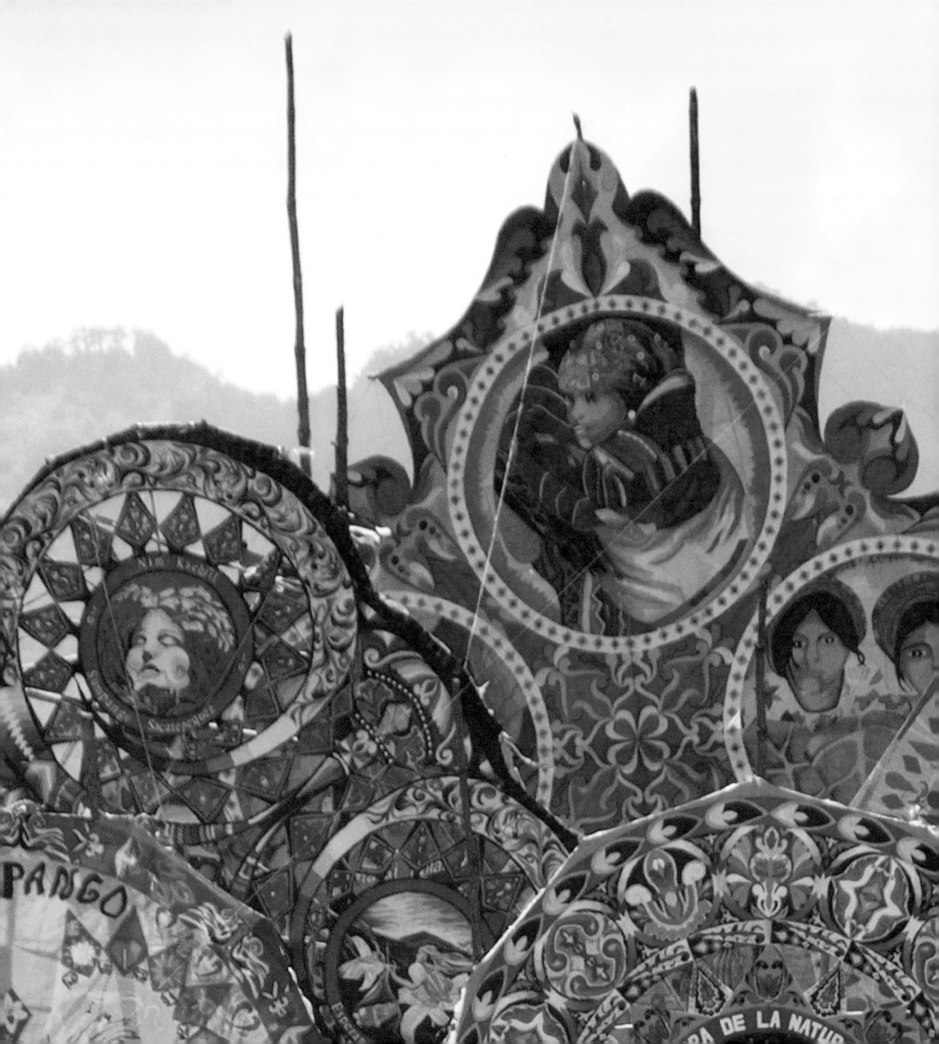

PHOTOGRAPHIC CREDITS

Alexander Graham Bell Historic Site Museum, 83 (top left)

Victorino Tejaxún Alquijay, 43, 55, 57, 65, 67 (no. 1), 68 (no. 14), 69 (nos. 9–12), 70 (no. 17), 73, 74

The Archive of Antonio Asturias, 61 (right), 63 (right)

The Archive of *Corazón Maya,* 68 (no. 13)

The Archive of *Gorrion Chupaflor,* 67 (nos. 3–4) 68 (no. 15), 69 (no. 8)

The Archive of the *Happy Boy's,* 33, 62 (center, right), 67 (nos. 2, 5), 68 (no. 6)

The Archive of Samuel Ixtín, 62 (left), 63 (left)

The Archive of *Nimalaj Balam,* 68 (no. 7)

The Archive of Federico Cristóbal Carranza Sosa, 64 (right)

The Archive of Enrique Toribio, 61 (left)

Blue Hill Observatory, 82 (top right)

Nico Chortier, 14, 16 (left)

City of Sumpango, 60

Courtesy of Artes y Artesanias Populares de Sacatepéquez, 34

Drachen Foundation Archive, 4–8, 21 (right), 22–26, 28, 30, 44, 47, 54, 64 (left), 70 (nos. 16, 22), 71 (nos. 18–21), 72, 78, 79 (left), 80–81, 82 (left), 83 (bottom left), 84 (left, top right), 90–97, 100, 103

Anton Fürnhammer, 2–3, 12, 27

Illustration by Henry Balfour, 79 (right)

Illustration from *Aeropleustic Art or Navigation in the Air by the Use of Kites or Buoyant Sails,* 1927 by George Pocock, 82 (center)

Library of Congress, 83 (right)

National Aeronautics and Space Administration, 84 (bottom right)

Christopher Ornelas, 32, 35–36, 39, 40

Martson Ranno, 21 (left)

Skinner Collection, 15, 16 (right), 17, 19, 20

source unknown, 58, 70 (no. 23)

United States Postal Service, 82 (bottom right)

ISBN: 978-0-615-55154-8

Published by the Drachen Foundation
www.drachen.org

Produced by Marquand Books, Inc., Seattle
www.marquand.com

Distributed by University of Washington Press, Seattle
www.washington.edu/uwpress/

Designed by Jeff Wincapaw
Typeset in Sentinel by Brynn Warriner
Maps by Jeremy Linden
Color management by iocolor, Seattle
Printed and bound in China by Legend Color.